AUDREY HEPBURN

AN ELEGANT SPIRIT

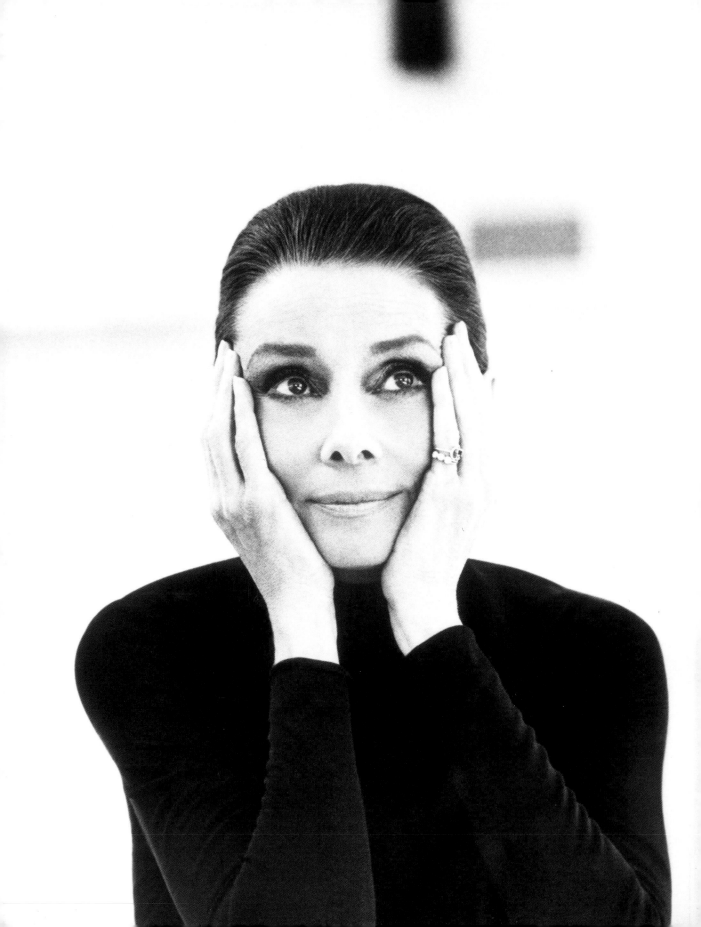

AUDREY HEPBURN
AN ELEGANT SPIRIT

SEAN HEPBURN FERRER

PAN BOOKS

to audrey's grandchildren

First published 2003 by Atria Books,
an imprint of Simon and Schuster, 1230 Avenue of the Americas, New York, NY 10020

First published in the United Kingdom 2003 by Sidgwick and Jackson

First published in paperback 2005 by Pan Books
an imprint of Pan Macmillan Ltd
Pan Macmillan, 20 New Wharf Road, London N1 9RR
Basingstoke and Oxford
Associated companies throughout the world
www.panmacmillan.com

ISBN 0 330 42687 7

A CIP catalogue record for this book is available from
the British Library.

ATRIA BOOKS is a trademark of Simon & Schuster, Inc.

Designed by Julian Peploe
Title page photo: Steven Meisel, New York City, 1991.
© Steven Meisel/A & C Anthology.
Printed by Butler and Tanner

All Pan Macmillan titles are available from www.panmacmillan.com
or from Bookpost by telephoning +44 (0) 01624 677237

ACKNOWLEDGMENTS

Thank you to:

Kirk, for being the first to encourage this book.

Alan Nevins, my agent, your support and guidance were invaluable to a first timer like me, and to Mindy Stone, your right hand.

Mitchell Ivers, my senior editor at Atria Books, you were the first to make this a reality—your vision, taste, and wisdom are surpassed only by your patience, considering that I was three years late delivering this work, and to Joshua Martino, your editorial assistant.

Judith Curr, Executive Vice President and Publisher, Atria Books and Washington Square Press; and Karen Mender, Vice President, Deputy Publisher, Atria Books and Washington Square Press; as well as Seale Ballenger and Louise Braverman, Atria Publicity.

Linda Dingler, Twisne Fan, Linda Roberts, Linda Evans, Dana Sloan, and Davina Mock in Production and Design; and Julian Peploe, Paolo Pepe, and Jeanne Lee for a beautiful layout and cover.

Jessica Z. Diamond, my visual consultant and photo curator, your careful and tasteful work have immensely contributed to the beauty and longevity of this book; and Ellen Erwin, the Audrey Hepburn Children's Fund executive director, for being my right hand; and Paul Alberghetti, my partner and counsel; and Caroline Bloxsom, his right hand; and Ronnie.

Allied Artists Pictures Corporation, Richard Avedon, Ron Avery/mptv.net, Stephanie Belingard/Camera Press, Steve Bello, Lina Bey, Alessandro Canestrelli/Reporters Associati, Elisabetta Catalano, Columbia University Oral History Project, Howell Conant II, Fiona Cowan/Norman Parkinson Ltd., Sue Daly/Sotheby's London, Foulques De Jouvenel/Colette Estate, Andrea Denzler, Werther Di Giovanni, Mel Ferrer, Foto Locchi S.R.L. Firenze, David Green and Tina Calico/Corbis, Irene Halsman, Yvonne Halsman, Jeremy Hartley, Hearst Corporation, Marcel Imsand, John Isaac, Mrs. Yousuf Karsh, Sally Leach/Performing Arts Collection at University of Texas at Austin, Kate Lillienthal, Carmen Masi/Photo Masi, Steven Meisel, Ruby Mera, James Moffat/A & C Anthology, Leigh Montville/Condé Nast Publications, Ellen Ornitz, Paramount Pictures, Irving Penn, Betty Press, Stephania Ricci/Ferragamo, Vincent Rossell, Andre Schmidt/Colette Estate, Larry Shaw/Shaw Family Archives, Martin Singer/Irving Lazar Trust, Kevin Smith/Splash News, Bruce Stapleton/Playbill, Inc., Bert Stern, Norma Stevens, Michael Stier/Condé Nast Publications, John Swope Trust, Twentieth Century Fox, UNICEF Photo Library, United Nations Photo Library, Universal Studios Licensing, Connie Wald, Warner Brothers, Bob Willoughby, and Robert Wolders. Although you are all listed above alphabetically, you should all be in first position for your contribution of photographs to this book, and your extreme generosity to the fund is invaluable.

All who have read and shed a tear showing me with your heart that I was on the right path.

My wife, Giovanna, and my children, Emma and Gregorio, who are my life, and my father and mother to whom I owe it.

To you.

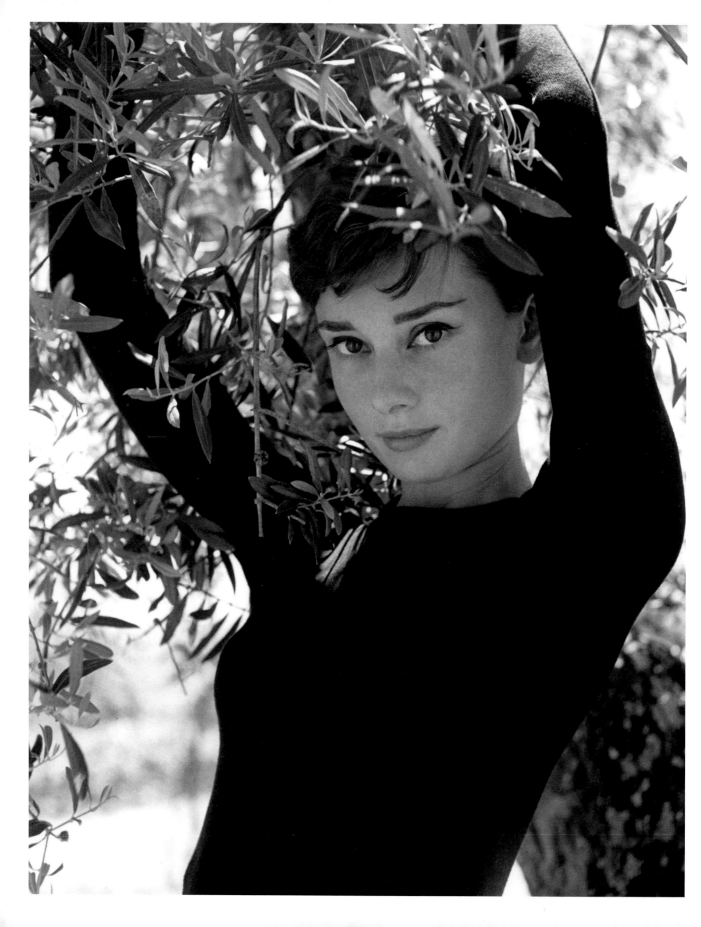

CONTENTS

PREFACE: THE SECRET IX

INTRODUCTION: KISSED ON THE CHEEK XIII

CHAPTER 1. EMOTIONAL HUNGER 1

CHAPTER 2. "I CAN RECALL . . ." 29

CHAPTER 3. UNFORGETTABLE 81

CHAPTER 4. ONE OF THEM 143

CHAPTER 5. THE SILENCE OF THE SOUL 177

CHAPTER 6. TOGETHER THERE IS NOTHING WE CANNOT DO 188

CHAPTER 7. THE PRICE OF FOREVER 205

opposite "La Vigna" outside of Rome, 1955. Photograph by
Philippe Halsman. © Halsman Estate.

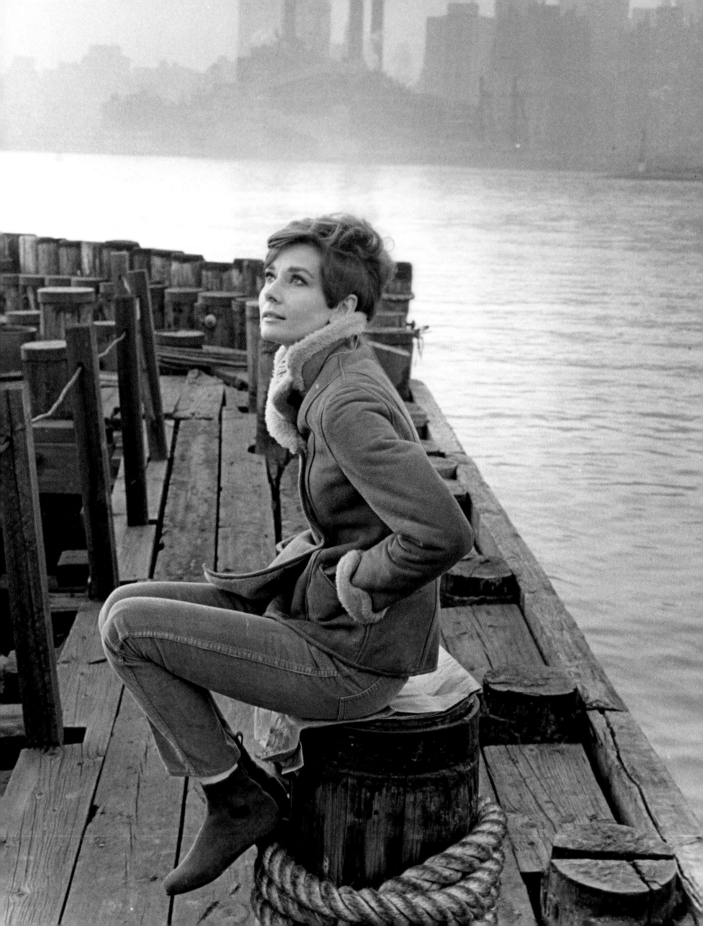

I am writing this preface almost nine years after Audrey Kathleen Hepburn-Ruston left us. She was—or should I say, is—my mother. I started writing this little book on January 21, 1993, the day after she passed away. It took me roughly four years to put the first words to paper.

The actual writing took maybe a few months. It's what happened before and in between that took some time. I am quite sure by now that everyone who loses a parent, as we all do sooner or later, could write a book. As it did for me, it might feel like the only book you'll ever write. Weeks, months, years may pass between writing sessions. You too may experience something that can no longer be called writer's block. You see, it's not about you. It is about the one person in the world who is more than you! And in my case, it is about someone who was most dear to me, the very person who brought me here and saved me time and time again, when I needed her for my survival. Yet she was someone whom I couldn't help or save in the end. So I find myself endlessly rolling these few words like pebbles in the river of my story so that the smooth stones that emerge will be worthy of your time and her spirit. I want you to know . . . what truly counts, yet in a way that won't ripple her peace.

As one theory has it, our organs have varying life expectancies. For example, our lungs, the meekest and the most useful, have the shortest life span: roughly 60 years. Our brain, of which we use less than 10 percent and therefore the least useful of our organs, as well as our

greatest liability, has an expected life span of somewhere over 150 years. In writing this book, I have discovered something new and exciting:

My memory will outlive all of them.

Long after I'm dead, and long after my brain dies—much later, of course (which is why I'm planning on being either cremated or buried with a chessboard), I will remember all this . . . and the scents. I close my eyes and remember, through the noise, her scent: powdery, elegant, safe, strong, the scent of unconditional love. I look down and see her delicate hands, their skin so thin I can faintly see their veins, her nails round, soft, and clear. Yet these are the hands that have held me, carried me, talked to me. They caressed me, they walked me to school, and I held on to them when I was scared. Oh, how I miss them! What I would give to feel them running through my hair . . . in my sleep, once more.

What happened? My head is still spinning. Wouldn't yours be if your mother was Audrey Hepburn? My mother died in 1993, and still . . . she's everywhere: on television all the time, at the video store, in magazines, in bookstores, on huge billboards in airports and on freeways, downtown on a bus stop shelter, in every conversation I have sooner or later with everyone, in my work and in my thoughts, especially since I started writing this book, and in my dreams . . . sometimes.

Talk about larger than life. She weighed 110 pounds and measured five feet seven.

How fortunate that our memories of her are good. They leave a gentle wake, like a sunny empty room that feels good. It's there, at times stronger, at times gentler—the perfect combination of sweet and sad. The sweetness of her, the sadness of her.

I have thought much about this book—endlessly agonized as to whether this should be revealed. After nine years I have come to terms with it. I am telling it to you because there is little to be ashamed of, and because it may be helpful to others.

My mother had a secret.

I don't think she would mind my saying it. We see things much more clearly . . . after. So here it is, the great secret.

She was sad.

Not that life treated her badly, and therefore she was sad. Life was tough but good. My

mother was sad because of what she saw happening to the children of this world. I think we all made her a little bit sad. Yes, you did as well as I. Not because we were bad, but because we couldn't help. If she hadn't done the work for UNICEF at the end of her life, I wouldn't be so sure. I've now done some work for the children, and I'm sad too. So this book will have to be about this as well: sadness and children. Not a great combination, but there you have it. I think if you got the full picture, you would be sad too. So I'm not going to do that. I'll spare you the whole picture about sadness and children. But I'll give you a little bit of it, just enough.

Don't worry, you'll smile as well. A smile is the perfection of laughter. And you may cry a little too. But crying is good for your eyes and for your soul. It beautifies.

below Sean at home in 1960, only a few weeks old. Photograph by Mel Ferrer.

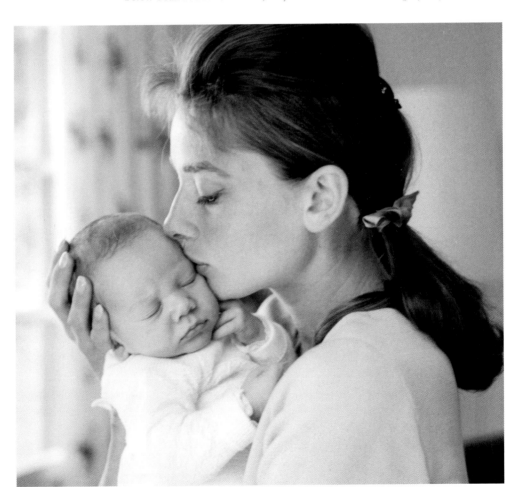

This is the story of a little girl with a powerful mother who instilled in her the values of hard work and honesty.

This is the story of a little girl with a father who left the family when she was six.

This is the story of a child who grew up during World War II with little food and no money and who remembered what it felt like for the rest of her life.

This is the story of a young woman who through a lot of hard work and much good fortune was discovered, surrounded by the best actors, writers, and directors, and became a success because of their vision and talent.

This is the story of an actress who got up early in the morning, usually between four and five, and worked harder than the others to compensate for her shortcomings.

This is the story of a star who couldn't see her own light. Instead she saw herself as too thin, with a bump on the arch of her nose and feet too big for her size. So she felt honored and thankful for the attention, which is why she was always on time, she always knew her lines, and she always treated everyone around her with courtesy and respect.

This is the story of a grown-up daughter who decided that she respected the fact that her father never contacted her after she had become well known, a father whom, although he had been absent from her life for twenty years, she took care of until the end of his days. He was also a man whose political views she strongly disagreed with.

This is the story of a wife who was disappointed twice in marriage, in part because she couldn't mend the hurt of her father having left her, a hurt that had broken her heart so early in life.

This is the story of a woman whose deep desire was for her family to be together, who loved her dogs, her garden, and a plain plate of spaghetti *al pomodoro* (the recipe will follow, on page 33). This is a pretty straightforward story—which is why my mother never wrote a book about her life. She felt that it would be all too plain, too simple.

So how do you write and market a "Hollywood" biography without the public scandals or lurid secrets? Barry Paris, her last biographer and probably the most conscientious, wrote in his foreword, "Audrey Hepburn is a biographer's dream and nightmare simultaneously. No other film actress was so revered—inspired and inspiring—both for her on-screen appearances and for her passionate, off-screen crusade. She remains so beloved that virtually no one has a bad word to say about her. The worst thing she ever did, it seems, was forget to mention Patricia Neal at the 1964 Oscars. She left no lurid secrets or closet cruelties to be exposed. Beneath her kind, warm surface lay more kindness and warmth to the core."

Also very much at the core of why my mother never wrote, herself, or participated in an autobiography is the fact that she didn't want to expose the private lives of others. Had she done it, she would have had to be completely honest and probably in so doing taken a chance of hurting someone. She couldn't have lived with that. She wrote and, after a career built upon it, spoke beautifully. Yet she was so self-effacing that she may have left out certain aspects of her life that seemed to her so plain, so obvious, so unimportant. She would have unintentionally skipped over them. Yet in their simplicity, they are the secrets of life.

I haven't had the pleasure of reading any of the seven biographies written about my mother, except for parts of the Barry Paris one, yet two minor points that I keep hearing about should be rectified. Although neither is of vital import, they are indicative of the research quality put forth by the writer who originally coined them and the willingness of other biographers to propagate them.

Several of these biographies stated that my mother was born Edda Kathleen Hepburn-Ruston and later changed her name to Audrey. To a writer faced with the already difficult task of building a story around a life basically devoid of juicy conflicts, this was a prize morsel, the much-needed proof that she had done something disingenuous early in life. But I have her birth certificate, and it reads, "Audrey Kathleen Ruston." After the war, her father, Joseph

Victor Anthony Ruston, found documents about his ancestors, some of whom bore the name Hepburn. This is when he added it to his name, which caused my mother to have to legally add Hepburn to her name as well. The actual "Edda" story is quite different. My grandmother temporarily changed my mother's name from Audrey to Edda during the war, feeling that "Audrey" might indicate her British roots too strongly. During the war, being English in occupied Holland was not an asset; it could have attracted the attention of the occupying German forces and resulted in confinement or even deportation. My grandmother Ella came up with the name Edda by simply exchanging the two *l*'s in her own name with two *d*'s. Since most documents were handwritten at the time, Ella may have had one that could easily be doctored so that my mother could carry it with her whenever she left the house. Just add two *c*'s to the lowercase *l*'s. Change the birth year a bit—Ella was born in 1900, my mother in 1929—and you have Edda Van Heemstra. My grandmother was a strategic woman.

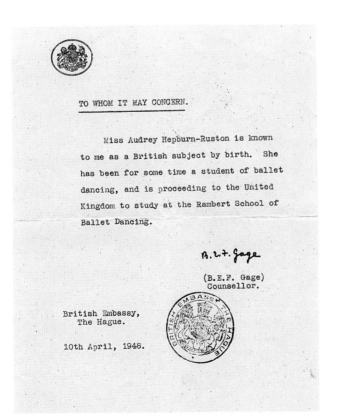

X V

TO WHOM IT MAY CONCERN.

Miss Audrey Hepburn-Ruston is known to me as a British subject by birth. She has been for some time a student of ballet dancing, and is proceeding to the United Kingdom to study at the Rambert School of Ballet Dancing.

B. E. F. Gage

(B.E.F. Gage)
Counsellor.

British Embassy,
The Hague.

10th April, 1948.

Top certificate

BIRTHS within the District of the British *VICE CONSULATE* at BRUSSELS

No.	When and Where Born	Name.	Sex.	Name and Surname of Father.	Name and Maiden Surname of Mother.	Rank, Profession or Occupation of Father, and claim to British Nationality.	Signature, Description and Residence of Informant.	When Registered	Signature of Consular Officer.
Columns:— 1	2	3	4	5	6	7	8	9	
41	Fourth May 1929. 48. Rue Keyenveld. Ixelles. Brussels.	Audrey Kathleen	Girl	Joseph RUSTON.	Ella RUSTON formerly VAN HEEMSTRA	Company director. British subject by birth at London on 21st November 1889.	Ella Ruston Mother 48. Rue Keyenveld. Ixelles. Brussels	Eighteenth July 1929.	M.S. HENDERSON. ACTING BRITISH VICE-CONSUL

Insert in this margin any Notes which appear in the original Entry

In entry N° 41 column N° 6 for "London" read "Onzic Bohemia on 21st November 1889, his father having been born at London on 10th July 1860". Corrected on the fifth day of January 1952 by me, A. Lansdowne, British Vice Consul on production of a statutory declaration made by Baroness Ella van Heemstra, mother, of 65 South Audley Street, London, W.1.

I, W.C.R. Aue, British *Consul* at Brussels, do hereby certify, That this is a true Copy of the Entry of the Birth of *Audrey Kathleen RUSTON* kept at this Consulate, No. 41 in the Register Book of Births

Witness my Hand and Seal, this *fifth* day of *January* 1952

H.M. CONSUL

Bottom certificate

CERTIFIED COPY of an **ENTRY OF BIRTH**

within the District of the British Vice Consulate at Brussels

The statutory fee for this certificate is 3s. 9d. Where a search is necessary to find the entry, a search fee is payable in addition.

Application Number 578016

1929 BIRTH within the district of the British Vice Consulate at Brussels

No.	When and where born	Name	Sex	Name and surname of father	Name and maiden surname of mother	Rank, profession or occupation of father and claim to British Nationality	Signature, description, and residence of informant	When registered	Signature of consular officer
	(1)	(2)	(3)	(4)	(5)	(6)	(7)	(8)	(9)
41	Fourth May 1929 48, Rue Keyenveld Ixelles Brussels	Audrey Kathleen	Girl	Joseph Ruston	Ella Ruston formerly Van Heemstra	Company Director British Subject by birth at London on 21st November 1889	Ella Ruston Mother 48 Rue Keyenveld Ixelles Brussels	Eighteenth July 1929	M.S.Henderson Acting British Vice-Consul

In entry No.41 column No.6 for "London" read "Onzic Bohemia 21st November 1889, his father having been born at London on 10th July 1860". Corrected on the fifth day of January 1952 by me, A.Lansdowne, British Vice Consul on production of a statutory declaration made by Baroness Ella van Heemstra, mother, of 65 South Audley Street, London W.1.

CERTIFIED to be a true copy of the certified copy of an entry in a Register of Births in the district above mentioned.

Given at the GENERAL REGISTER OFFICE, SOMERSET HOUSE, LONDON, under the Seal of the said Office, the 2nd day of December 1968.

Cons. EA 016736

This certificate is issued in pursuance of the Births and Deaths Registration Act, 1953 (as applied).

Section 34 (6) provides that any certified copy of an entry purporting to be sealed or stamped with the seal of the General Register Office shall be received as evidence of the birth or death to which it relates without any further or other proof of the entry, and no certified copy purporting to be given in the said Office shall be of any force or effect unless it is sealed or stamped as aforesaid.

CAUTION.—Any person who (1) falsifies any of the particulars on this certificate, or (2) uses a falsified certificate as true, knowing it to be false, is liable to prosecution.

Form A503 (5.12/66) Dd.48815 500 1/68 Hw—KE.42

xvi

DESCRIPTION
SIGNALEMENT

		Wife - Femme
Profession } Profession }	Name Nom	
Place and date } of birth }		Brussels
Lieu et date } de naissance }		11th May 1929
Domicile } Domicile }		BRUSSELS
Height } Taille }	4 ft. 4 in.	ft. in.
Colour of eyes } Couleur des yeux }	Brown	
Colour of hair } Couleur des cheveux }	Brown	
Special peculiarities } Signes particuliers }	None	

CHILDREN - ENFANTS

Name Nom	Date of birth Date de naissance	Sex Sexe

CANCELLED

PHOTOGRAPH OF BEARER

(photo)

CANCELLED

SIGNATURE OF WIFE. ET DE SA FEMME.

WIFE FEMME

BRITISH CONSULATE GENERAL
2 3 MAY 36
ANTWERP

Audrey Ruston

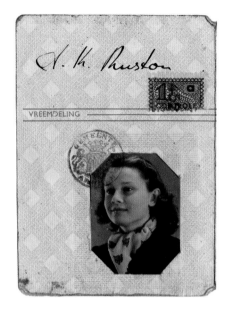

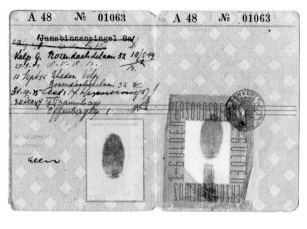

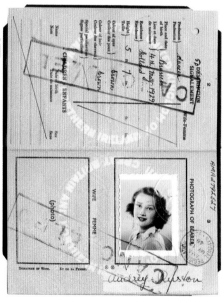

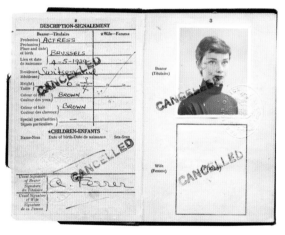

xviii

top Audrey's 1944 National Identity Card, issued during World War II.

bottom right Audrey's 1955–65 British passport.

bottom left Audrey's 1946–51 British passport.

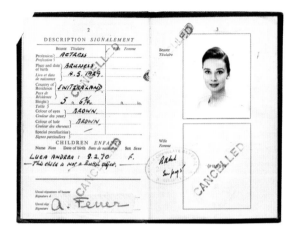

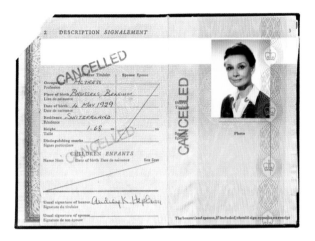

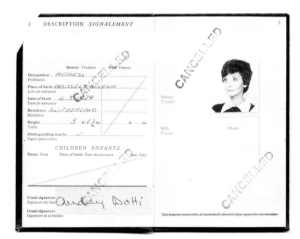

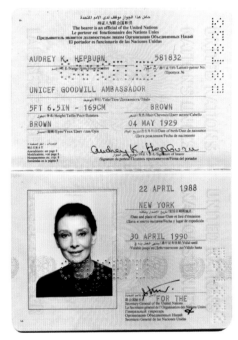

top left Audrey's 1964–74 British passport.

top right Audrey's 1982–92 British passport.

bottom left Audrey's 1974–84 British passport.

bottom right Audrey's 1988 United Nations passport.

xix

The name Audrey was also an unusual one, even in England, and anything unusual might possibly be considered Jewish. Because at the time the "authorities" had a tendency to "relocate" any unusual individual, I find my grandmother's decision to protect my mother wholesome and reasonable.

Of even less import is the statement in one of the earlier biographies that, "Audrey was elated when her son Sean was born on January 17, 1960." Most subsequent biographers repeated this error of fact. Apart from the fact that my travel agent and good friend Janet was delighted in the notion that we shared a birthday, and gravely disappointed when I told her otherwise, this information is of no consequence. Nevertheless, July, not January 17, 1960, is the day that I was graced with the honor of being born to this great woman.

My mother would definitely cringe at the word *great*. Yet I can find no other word that encapsulates how proud I am of her and of her overall contribution to our society.

So, she never wrote her biography. She was considering toward the end of her life writing something for my brother and me about the family—a kind of record of all the extraordinary people and events that came before us. But she couldn't find the time away from her work for UNICEF.

On May 9, 1991, Irving "Swifty" Lazar, the legendary literary agent, wrote her this final plea. Rather than quote from it, I prefer to include the whole letter. It shows how close their friendship had become, as well as how persuasive he could be.

IRVING PAUL LAZAR

May 9, 1991

Ms. Audrey Hepburn
ToLochenaz Vaud
1131 Lausanne
Switzerland

Dear Audrey,

I cannot remember ever witnessing such an onslaught of affection and admiration for anyone, since the day Abraham Lincoln arrived at the White House. I am only reminded about that because the headlines in the New York Daily News says, "Audrey is Cheered at Lincoln". From then on it describes how Eliza Doolittle finally got her just deserts. "The film society of Lincoln Center paid tribute to the screen star of "My Fair Lady" where they gave living legend Audrey Hepburn its annual award last night".

Well, it went uphill from there. What makes it all remarkable is that none of it was perpetrated by paid press-agents whose job it is to get their client space. You don't have any press-agents, you don't have any regiment of public relations people, pressing everybody for recognition of their client - it just doesn't exist with you. You are just offering yourself for a worthy enterprise, be it this film festival or be it for a great charity, and you are acclaimed.

While it seemed to me more intense this particular time than before, that in itself is quite extraordinary because generally people who are around long enough don't get "lovefests", as described by Variety. You are honored with a tribute that encompassed not only your film career but your humanitarian efforts on behalf of UNICEF.

It really is extraordinary and as your friend I was not only impressed, but vicariously enjoyed the spotlight you engender. Nothing new about

this, I've told you this before. I remember very well the tribute at the Museum of Modern Art, where there was a similar display of affection and admiration for you. Even when you are an innocent bystander attending somebody else's tribute, you somehow steal the spotlight without any effort on your part. For those who also love you and admire you, this will always be the case.

I want to put in writing some of the things I have to say so that you will have a chance to think about it and not be so willing to dismiss my reasoning with you about doing a book.

In the first place, the article in <u>Vanity Fair</u>, as usual, was spectacular. I inquired of Tina Brown, who is a great friend of mine, how the magazine went that issue and she said better than ever. People bought the issue because of this glorious face on the cover and I very much like the interior pictures too. The story itself was very well done and could very well be one-third of your book. If you extract from it an elongation of some of the things that you don't talk about at length, it is practically your book. The fact that you would submit yourself to doing this article at that great length, gratuitously, seems unfair.

The nature, intent and content of the article is pretty much what your book would be. I have told you this many times, nobody expects you to write a book which would be different than what appears in that article, it is not intended for you to do kiss and tell. It is not intended that you lash out at anybody, just be yourself which is exactly how the article portrays you. There is no reason why the book shouldn't do the same. The only difference being that you would get very close to $3,000,000 instead of doing it for nothing. The fact is, you could work out something in relation to your fee and undoubtedly in addition to that, a gift to UNICEF from the Publisher that would be quite important. It would serve several purposes.

I have read several books about you and they are always glorious joiners of the Audrey Hepburn Admiration Society. By the way, there is a way of doing your book which would not be altogether your speaking and your dictation. We would have

interviews, where other people would describe their impressions of you and their observations of you as an actor, mother, as a worker for your charities, and as a role model for other actors. There is so many areas where you are unique that would be described by other people so that you would not in first-person be obliged to say things about yourself you would prefer not to. Let others say it. This would be incorporated in the book in such a manner that you would not be embarrassed. However, its your story as being rooted about by others, and told in their version of what they think rather than what you think. It so happens that in the _Vanity Fair_ piece, the intelligence of the writer is such that he was able to actually capture you quite successfully.

You could have a voice of your own to describe or reflect on life as you see it. In form the book would be more "reflections" rather than all biography and your life and your reflections on the mores of the societies you have observed. Your personal reflections on actors you admire, or directors you admire. In other words, a book with a philosophical content, not just an autobiography.

What is wanted in the book is your reflections in all aspects of your life - or as much as you wish to talk. After all, you are not meeting with anybody, you're not promising anything or disclosing anything that you are going to say. A book signed Audrey Hepburn, with the same information but a little more in depth, as you see fit, that was in the _Vanity Fair_ article is just about what the whole book would be about. It shouldn't take more than six months or less to do

it, and it doesn't have to be done consecutively, you can do it over a period of time. We would get a writer who you like, perhaps the same person who did the _Vanity Fair_ piece and it would be quite simple and not cause you any hardship at all. It would have your charm. Enough said.

Think about it my dear. Love to you and Bob.

Sincerely,

IPL/cc

A book about "philosophies"! In a way, this is what I'm attempting. I have often been asked, over the last few years, what this book would be about. I would always answer, "It uses the last few months of my mother's life and conversations we had during that time as a springboard to revisit some of her philosophies and beliefs."

Since she never got a chance at even starting the book she was considering writing on her family, her life, and her experiences with UNICEF, and therefore never collected the $3 million that I am sure she would have donated in part or all to charity, I have assigned all of my modest advances (in comparison) and nevertheless generous royalties from this book to the Audrey Hepburn Children's Fund.

I thought long and hard before sitting down to write this. If she didn't write the book herself, for all the reasons that I listed above, then maybe I shouldn't either. It was her life and her privacy. I didn't want to write about others and tell tales. First, there aren't any, and if there were, she didn't tell them to us. I wanted to write about her, about who she really was. She really was like those characters you saw in the movies: emotional, courageous, delicate, romantic. Yet it's always nice to get confirmation.

So, instead of being a "tell all" book about others, this is an "others tell all" about her.

This book might not interest those who are addicted to the tabloids, but instead is directed to those who strive, as she did, to achieve a happy and simple life.

This will be our journey into a gentle heart and a loving son's reflection of thirty-three years lived with one of the best mothers and friends one could hope for. What you saw and felt when you watched her on the big screen was not only the clever presentation of characters brilliantly written, directed, shot, and edited into a performance, but a clear view of a truly magical human being who deserves the warm feelings that still transport audiences worldwide today.

Billy Wilder, the wondrous director and one of my mother's closest friends, said it best: "God kissed her on the cheek and there she was."

above Photograph by Irving Penn. Audrey Hepburn, Paris, 1951.
Copyright © 1951 (renewed 1979) Condé Nast Publications.

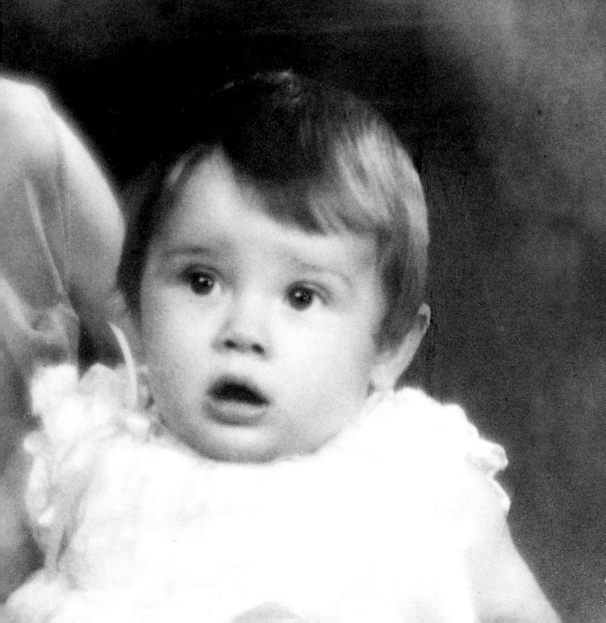

CHAPTER I EMOTIONAL HUNGER

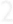

"If I were to write a biography," my mother once
told me, "it would start like this: I was born in Brus-
sels, Belgium, on May 4, 1929 . . . and I died six
weeks later."

When six-weeks-old baby Audrey caught a bad case of whooping cough, her mother, Ella
Van Heemstra, a Christian Scientist at the time, didn't take her to a doctor. Instead, she prayed.
Unfortunately the condition got worse, and finally, after a severe coughing attack, baby Audrey
stopped breathing.

For years, like all children who love to hear stories told to them over and over, she would
implore her mother Ella to tell her about the time she had died: how, as the baby was slowly
turning blue, Ella revived her by spanking her repeatedly on the bottom. What an interesting
case of faith that presented: A position could be taken, based on modern medical knowledge,
that it was unreasonable for Ella to keep Audrey from conventional care. Nevertheless, a little
spanking and a lot of faith brought her back to life.

But apart from this incident, my mother felt that her life had been rather straightforward
and therefore not worth much writing about. Her Victorian upbringing dictated that you
never call attention to yourself: "You!" as her mother would probably have chided, "are not
very interesting."

So she worked hard, she was a good mother, and she got on with the rest of it.

Every few years someone—in most cases Irving Lazar—would come up with an ever more
attractive offer, as you just read in the previous pages, for her to write an autobiography in
which, he would say, she could talk about anything and everything she wanted to.

He would refer to a television interview she had given for one of her films or on behalf of her work for UNICEF. In it she would have talked about her life, her work, or what she had experienced in the field. Questions about her youth or her motivations for joining UNICEF would always bring her back to World War II and the hardships she had seen her family and friends live through, the loss of everything we take for granted: peace, freedom, and democracy. She told us about how her brothers ate dog biscuits when there was nothing else to eat, how others ate tulip bulbs, and how bread was green because the only flour available was made from peas. She would sometimes spend the whole day in bed reading so as not to feel the hunger.

She remembered vividly the fear she felt as a child when German troops invaded the city of Arnhem, in the Netherlands, where she spent most of the war. At some point there was so little food in the city, they moved to her grandfather's home in the suburbs.

Her grandfather had been the mayor of the city of Arnhem. Although at the time that would have been more of a liability than an asset, they felt that it would be a far safer place when the heavy bombing started. This also put them closer to the farmlands. The neighboring farmers had a few crops and a few farm animals and were squeaking by, sharing their meager produce with the city folk. She remembered how the rich traded their most precious valuables in exchange for food. Later, of course, those who had overcharged were branded as profiteers, but at the time a pearl necklace couldn't feed anyone.

Although they never met during that period, Robert Wolders, the Dutch man with whom she lived the last twelve years of her life, also spent the latter part of the war in a neighboring

suburb of Arnhem. They shared the memory of the following anecdote: One of the farmers, who had collected many valuable items in exchange for the products of his farm, built himself an underground storage and filled it with precious art and antiques. When the liberation came, he went to collect his riches, but they had all become completely waterlogged and ruined.

For my mother the liberation was also her first contact with UNICEF. "I was in Holland during the war, during the German occupation, and food dwindled," she said. "The last winter was the worst of all. By then, food was scarce, and whatever there was went to the troops. There's a big difference between dying of starvation and malnutrition, of course, but I was very, very undernourished. Immediately after the war, an organization, which later became UNICEF, instantly came in with the Red Cross and brought relief for the people in the form of food, medication, and clothes. All the local schools were turned into relief centers. I was one of the beneficiaries with the other children. I've known about UNICEF all my life."

The Netherlands experienced one of the longest occupations of all the European countries. It was one of the first countries to be invaded and one of the last to be liberated. One of the battles that finally freed the Netherlands was fought by the Allied forces in Arnhem and later inspired the film *A Bridge Too Far.* Years later, during the filming of my father's production of *Wait Until Dark,* in which my mother played the role of a blind woman being persecuted by a psychotic gangster, the film's director, Terence Young, well known for having directed the first few Bond pictures, found out she had been in Arnhem during the war. A tank commander for the British Army during the war, he had been responsible, only two

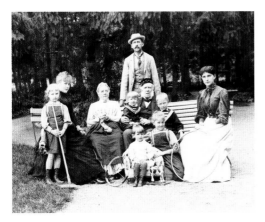
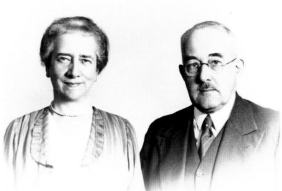

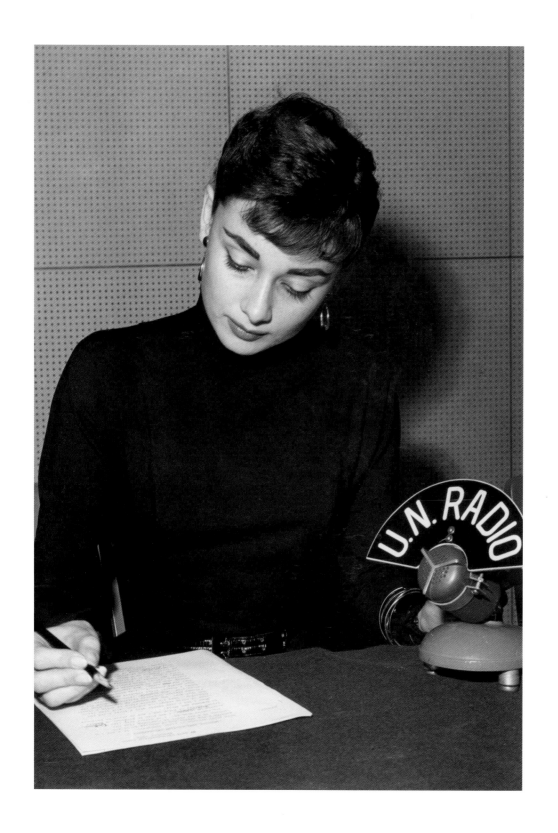

decades prior, for the majority of the shelling that devastated the city and the neighborhood where she lived.

This link between my mother and Young solidified into a lifelong friendship as well as the source of many jokes: "If I had aimed slightly to the left," Young would say, "I'd be out of a job right now." But in her heart my mother much preferred the intense few days of shelling, which brought freedom, to the languishing fear she felt every time she stood by waiting for the Nazi troops and later for the SS to march by, singing their songs of victory and supremacy.

I am often asked the same questions about those war years: Did Audrey Hepburn really help the resistance? Is it true that her father was a Fascist? My mother would answer the first question in her usual self-effacing way. Yes, like everyone else, she did as much as a child could do to help the resistance. Yes, she carried secret messages in her shoes because children were less suspicious and soldiers therefore less likely to stop and frisk them. I remember her telling us about how she had seen families of Jews being loaded onto trains, and how she could never forget the vision of one little girl wearing a red coat disappearing into the gaping doors of a cattle car. Years later, as I watched *Schindler's List,* Spielberg's masterful and moving film about that era, it reminded me of this story. *Schindler's List* was in black and white, but in the opening scene there was a little girl wearing a red coat—the only color in the scene. And as to the second question she would also answer, yes, her father was a Fascist, and so was her mother, for that matter. But that was before the war. One of the reasons that fascism ascended to

opposite Audrey at the United Nations, December 21, 1953, recording a program for United Nations Children's Fund (UNICEF) over UN Radio. UN/DPI photo.

left Joseph Victor Anthony Hepburn-Ruston before my mother was born. Family photo.

power so quickly was that it was considered socially elegant to support this new way of government. Communism and fascism were born out of frustration with an establishment that still knew royalty and possessed very few of the characteristics we commonly attribute to democracy today. The rebellious thinkers who reinterpreted these movements can be acknowledged for their revolutionary instincts and vision, even as we condemn what those movements became. Once the war started, my grandfather went to England, where he was under house arrest on the Isle of Man, and then to Ireland, but not to Germany. In no way did he, or my grandmother for that matter, ever support either the war or the Holocaust. They may have supported certain Fascist ideologies and belonged to the appropriate parties, but they never hurt anyone or knowingly supported any system that did. My grandfather wrote a book about the Celts, in which he described them as the first true Fascist thinkers. I tried to read it, but it went right over my head.

Yet that was enough for my mother to resent both her parents for their political and social views, which is also why she let all of the family's titles of nobility die and be buried with my grandmother. So they moved to Ella's father's house. I never met my great-grandfather: he died three years before I was born. My mother seldom spoke of her past, but she spoke of her grandfather as the male figure that had provided much of the affection she missed by not having her own father present for a large portion of her life. Even after a twenty-year absence, when she was reunited with her father, he was unable to show or express the deep admiration and love he felt for her.

It was my father, Mel Ferrer, who tracked my mother's father down through the Red Cross. He and my mother talked about it often, and he came to feel—correctly so—that this was a huge unresolved issue in her life. Finally, news came that the Red Cross had found him living in Ireland. My father clearly remembers making the call: when my grandfather answered, he immediately knew who my father was. He had been following his daughter's life and career from afar through the newspapers. He listened carefully as my father explained that he thought that a meeting between them might resolve, for both him and my mother, the void that this long separation had created. Anthony Joseph Victor Hepburn-Ruston responded that he would be very happy to see Audrey again, and they agreed on a date and a place: the Shelbourne Hotel

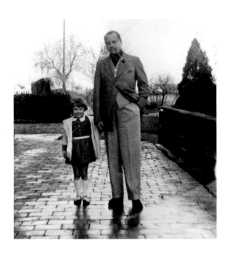

lobby in Dublin. My parents flew in from Lucerne, Switzerland, where they had been living since they had been married, drove to the hotel, and checked in. The phone rang, as had been arranged, right before lunch.

The last time my mother had seen her father was at the beginning of the war. She was spending the summer on a farm in England. The day the war was declared, he came for her and rushed her to a small airport, where she boarded one of the last planes out of England. She remembers the plane was orange, the national color of the Netherlands, where the plane was destined. Holland, as a neutral country, was perceived to be a safer place, although, unfortunately, the Germans would march into the country without any notice three days later. The plane flew low over the channel as the process of crystallizing this dramatic last vision of an al-

ready distant father started in little Audrey's heart.

So, my father and mother went downstairs, and there he was, standing in the lobby, looking much older yet elegant in his somewhat tattered tweeds. It took my mother only a fraction of a second to understand. The man was frozen. He couldn't take a step, or lift an arm, let alone hug her. Not because of too much emotion—he was totally disconnected, as he had been for most of his life.

The man she had longed for her entire childhood was in reality an emotional invalid. And so my mother did it: She

stepped forward and hugged him, knowing full well that was going to be it. She chose to forgive him, instinctively, in one instant. She chose to take away the inhibitions that had to do with his regrets toward her. There were no tears of joy at the reunion—knowing full well that those would have made him uncomfortable, she held them all in. The rest of the day—the lunch, the afternoon—consisted of polite pleasantries. My father used the pretext of visiting some antique shops to let them have some time together.

When my father returned, he found my mother waiting in the lobby. They were done, and my grandfather had left. All she said was, "We can go home now." There was nothing left to say or do. During the flight home, she thanked my father, saying that this trip had somehow resolved the issue for her. And she didn't need to see her father again, she added. Her mother had spent the war spewing poison about him, about his disappearance, about his lack of support of any type. She had to see for herself, and when she did, indeed there was nothing there.

Knowing my mother, I don't think she ever had "that good cry" about it. She saved it. Unknowingly, maybe she saved it for those moments on the screen.

Nevertheless, she supported her father financially until the end of his life, her way of being a notch above his lack of support for so many years. Her principles were strong, and she always lived by them: One does what one should do, regardless of one's crushed feelings.

Years later, soon after my mother and Robby Wolders had begun seeing each other, the news came that my grandfather was very ill, and close to death. She had only seen him once after their meeting in Dublin, when he came to La Paisible, our home in Switzerland, for a day or two. I believe it may have had something to do with my mother's desire that he meet me and see where we lived. I barely remember him: a rather stern and somewhat impressive figure.

So she went a second time to Dublin, this time with Robby. She knew that her father's health was deteriorating quickly, and they spent some time visiting in his room. Yet he still couldn't address those important life issues. Instead, he spoke of his horses, although he didn't have any by that time. He is often referred to in my mother's many biographies as a banker, yet the sad truth is, he never really hung on to any job. He was a true dilettante and a brilliant one at that: An achieved horseman and glider pilot, he spoke thirteen languages, possessed a humanistic knowledge of many subjects, and had a passion for originality. Still unable to connect with his daugh-

ter, he told Robby how much she meant to him, how he regretted not having been more of a father figure, and how proud he was of her.

My mother and Robby left Ireland a few days before her father died. This time she never looked back. She didn't stay for his funeral because they didn't know how long he would last, and she didn't want it to be complicated by the press's attention. As far as she was concerned, "her" father had died long before, and she had buried him then.

In many ways my mother's marriages, the first to my father, Mel Ferrer, and the second to Andrea Dotti, Luca's father, were a continuation of the same dynamic. Both men had been emotionally scarred by equally powerful and brilliant mothers who, as a result of their backgrounds, their education, and the societal rules of their times, didn't connect with their children at a profound emotional level. The "emotional hunger" that "food cannot alleviate," which is how she often described children she met during her UNICEF years, was something she knew how to recognize. After all, they were of the same tribe, the same make. Having experienced it herself, she had an instinctual desire to share it with her husbands and help heal that missing link. How disappointing it must have been for her not to be able to complete these men. We all find such different ways to adapt: Like trees growing in the shade, our trunks and our branches contort in varied ways to reach the sun. The voice of her inner child calling out for that embrace was so all-encompassing that she never understood how others might have processed that hunger differently. Yet her deeply romantic nature prevented her from demanding, from asking for that quenching. She wanted it to come freely, like flowers that are sent and not requested.

I believe that the first relationship with a parent, the love and the trust it builds—or fails to build—is what colors and supports our emotional world throughout the rest of our lives. It is the trust we share—or don't share—with our parents that makes it possible to choose whom we will love later in life. If that first relationship is incomplete, we suffer from that hunger our whole lives and end up blaming others for not fulfilling it when, after all, they can't. If the parent is absent, then how do we deal with it at all? She understood this all too well: How can we heal our world without first caring for our children, without giving them a starting chance? We aren't taught how to deal with our feelings, how to recognize the issues that have the potential to as-

sassinate our real chances at relationships; instead, we all make do with what tools we have. We all learn clever ways to divert the issues, to project our emotional pains onto others, often labeling these as their fault.

Yet there were many years of happiness in both marriages.

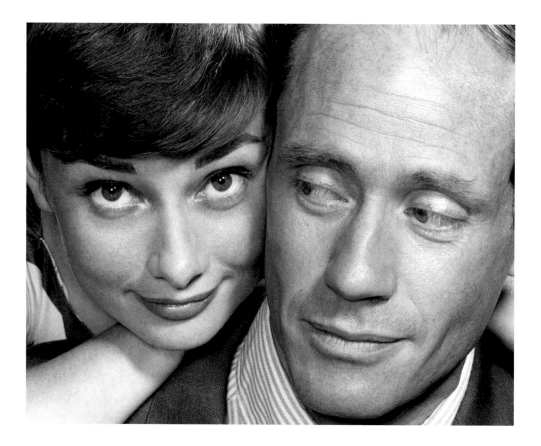

Although too young to remember my parents together, I was told of romantic evenings, of candlelight and soft music. My father has often been mislabeled as the Pygmalion of her life, probably because he was a perfectionist and, although graced with a great mind and heart, he had a difficult and temperamental personality. Yet his taste is impeccable, and he advised her well when it came to material and filmmakers.

I know of the deep nurturing love they both felt for each other. And I know of the great pain they both experienced when their dreams of love and happiness fell apart. "Love is action," she said later in life; "it isn't just talk, and it never was." How true that is. "We are born with the abil-

ity to love," she also said, "yet we have to develop it like you would any other muscle." It was the cumulative effect of the disappointments of those two marriages, coupled with a newfound hope in her relationship with Robby, that motivated her, that enabled her to face the arduous task of helping the less fortunate children of the world. If she hadn't been able to heal grownups, who had hardened, maybe there still was time for the children.

I also remember the happy days of our life in Rome, when she was married to Andrea Dotti, her second husband and my brother Luca's father: coming home to family lunches where everything and nothing was discussed with great humor and lightheartedness. I treasure those memories, not just because Andrea was a wonderful second father, as the Chinese so correctly refer to a stepparent, but because we were a truly happy family. My "second mother," Lisa Soukhotine, my father's present wife, taught me this lovely expression, as well as how loving and enriching the relationship it describes can be. My mother and Andrea remained friends after their marriage ended. Maybe the disappointment wasn't as acutely felt as it had been with my father, with whom she had only a limited number of contacts over the years. The first time around breaks the dream and always hurts the most. She very much wanted to keep a friendship with Andrea so that they could both continue to coparent Luca.

Anyway, no one is to blame. There is only sadness when two souls cannot merge. The snarling void left by her father's absence bore an equal share of the responsibility in the failure of both her marriages. All that is left is what we can learn from it. It is a little like the myth of Sisyphus, rolling his rock to the top of the hill. The last few feet cannot be overcome, no matter how hard you push, if you don't understand the laws that are at play. Yet it was precisely this yearning, this sincere need to be loved, that made her the frail fantasy that both women and men loved and wanted to hold.

My mother loved her husbands completely, and she hung on to the marriages for as long as she could. What she didn't do was to speak up and be heard when she needed to, and she didn't put up healthy boundaries. Exhausted by an authoritarian mother, she wished for a world where caring and love came freely, but she had chosen two men who had to learn to cope with their feelings on their own, just like the children she would later fight for, those children who in one way or another hadn't benefited by the simple right to their own childhood. Her emotional

world was simple: If you love with all your might and take care of the other, he or she will do the same in return. How disappointing it is when we realize that the world isn't that way.

I remember my brother Luca telling me about the time he went with my mother to the funeral of one of her best friends. Luca was fourteen, and she had asked him to be one of the pallbearers. As they were leaving, she tried to talk about her feelings, to explain death. He just looked at her and hugged her and told her he understood. She was very emotional because her friend had died of cancer, knowing that the man she had spent her life with had betrayed her. She was so emotional because she feared an old age, not of wrinkles, but of disenchantment.

Yet she emerged from her own life as a powerful person: strong-willed and sure of what she wanted. She was, as some liked to describe her, a steel hand in a velvet glove. She spent the last twelve years of her life with Robert Wolders. They had so much in common and, although their relationship was not without small tensions and disagreements, what they had shared through the UNICEF years would probably have been enough to carry them through to the end of their lives.

So Irving Lazar encouraged my mother just to tell her story the way she had in the interview. But she was an avid reader, with too much respect for good writing to indulge in what she felt could be a collection of seemingly meaningless vignettes. Each time we talked over lunch about his latest offer, she would usually conclude that by the time everyone realized how plain her life had been, the editors would insist that she give them "something about someone" to spice it up! So she never did. She wanted her own privacy respected; as soon as she could, she moved away from Hollywood's limelight to Switzerland, where she could enjoy a simple life and be treated like everyone else. Switzerland is also a neutral country that hasn't been at war in over six hundred years, and that meant a lot to her. She would have been devastated to learn of the frozen assets of the wartime Jews, that some Swiss companies had also made special steel products for the Third Reich, or that the Swiss government had turned away thousands of Jews from the country's borders, knowing full well what would happen to them when they returned to their home countries. What a price to pay to keep your neutrality, if you can even call it that! It seems to prove that true neutrality doesn't really exist.

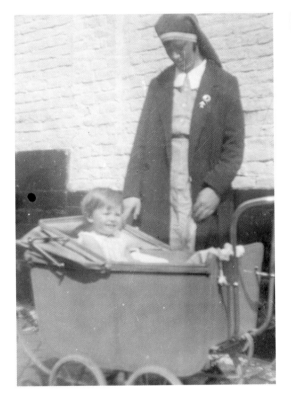

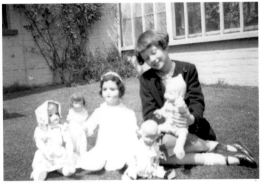

above Audrey in pram with nurse Greta, 1930.

top 1930s: Little Audrey in all her splendor.

middle Audrey at five, with her father, September 30, 1934. She probably would never have imagined on that beautiful late-summer day that by the time she was ten, he would have disappeared from her life, not to reappear for twenty-four years.

bottom Audrey with dolls, May 8, 1938.

Family photos.

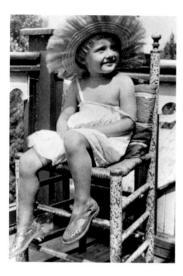 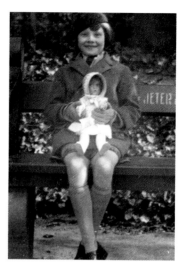

top left Audrey in Brussels, August 1932. We still have a set of these wonderful eighteenth-century Dutch hand-painted chairs.

top center Late 1930s. Audrey with her Aunt Miesje.

top right Since the writing on the bench is French, I would venture to say that this picture was taken in Brussels, Belgium, the city of Audrey's birth.

opposite Audrey in 1937. Whenever I see these childhood photographs, I pray that she had a carefree, sunny day, filled with memories of pleasant beach sounds and warm sand between her toes. Those memories truly become the foundation of our lives.

Family photos.

'the Beach'
'37

17

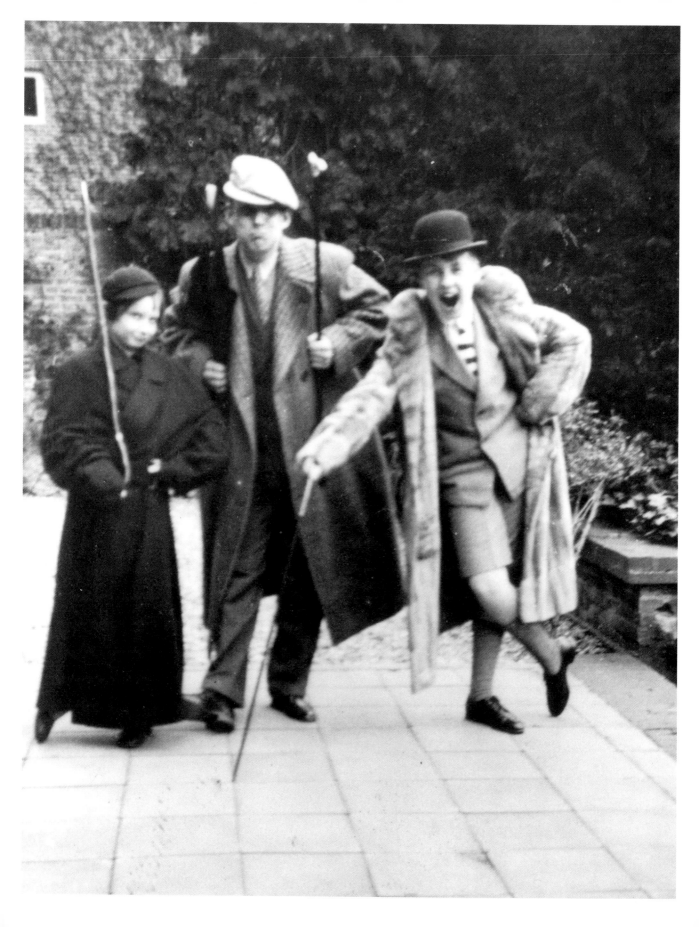

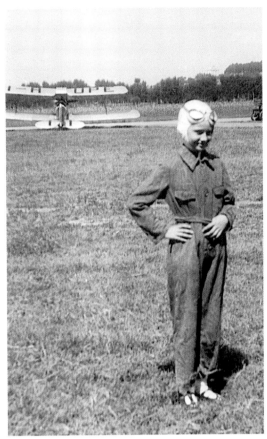

opposite Audrey playing charades with her brothers, April 24, 1938. Are these the first signs of things to come?

top left Audrey at a family reunion, 1939.

bottom left July 1938, Fregene, near Rome. Fregene is a lovely area of pine woods right near the sea. Audrey probably didn't return to Italy until years after the war ended. I remember going there for lunches on Sunday with Andrea Dotti and her when we lived in Rome.

top right 1937, airfield near Rome. This reminds me of her telling me about my grandfather, who had many talents, few of which were work-related. He was an accomplished equestrian, spoke thirteen languages, and flew gliders. Audrey often spoke of the few memories she had of her father, and she remembered vividly going gliding with him, the sound of the wind, the real sense of flying.

Family photos.

ARTWORK BY AUDREY

this page Childhood
artwork by Audrey, 1940s.

opposite A drawing signed "a.h.," 1944. Audrey's father had
already changed his name by then. One year before the end
of the war, dreaming of simple children's moments she
probably hadn't known for at least five years.

Oe H 1944

23

ARTWORK BY AUDREY

opposite Audrey's pencil drawing of her mother, 1944.

above and next page Artwork from Audrey's childhood in the 1940s.

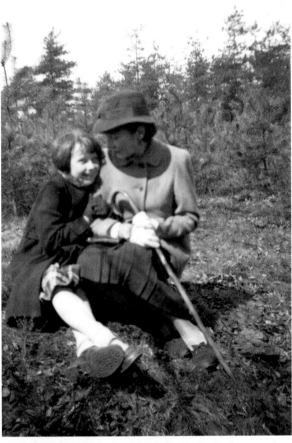

with my
mother —
the war
1942

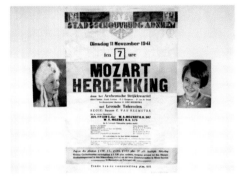

top left Audrey and her mother in 1942. This picture is the clear proof of the resiliency of the human spirit: People try to continue living no matter how grim the circumstances. Family photo.

top right Musical benefit concert *Tableau Vivant* in Arnhem, Holland, January 29, 1940. Audrey participated in several benefit performances whose "moral uplifting value" to the Dutch occupied population concealed fund-raising efforts on behalf of the Dutch resistance. Photograph by Manon van Suchtelen. Audrey Hepburn Estate Collection.

middle right January 29, 1940, *Tableau Vivant*, Arnhem, Holland. Audrey, second from left. Ella, my grandmother, is also in the play (second from right). Family photo.

bottom right November 11, 1941, concert announcement.

top left and right Audrey in the 1940s, probably taken right after the war, once they moved back to England.

bottom left Audrey circa 1947.

bottom right Audrey in her early teens.

opposite One of the first pictures taken of Audrey after the war, in 1946.

Family photos.

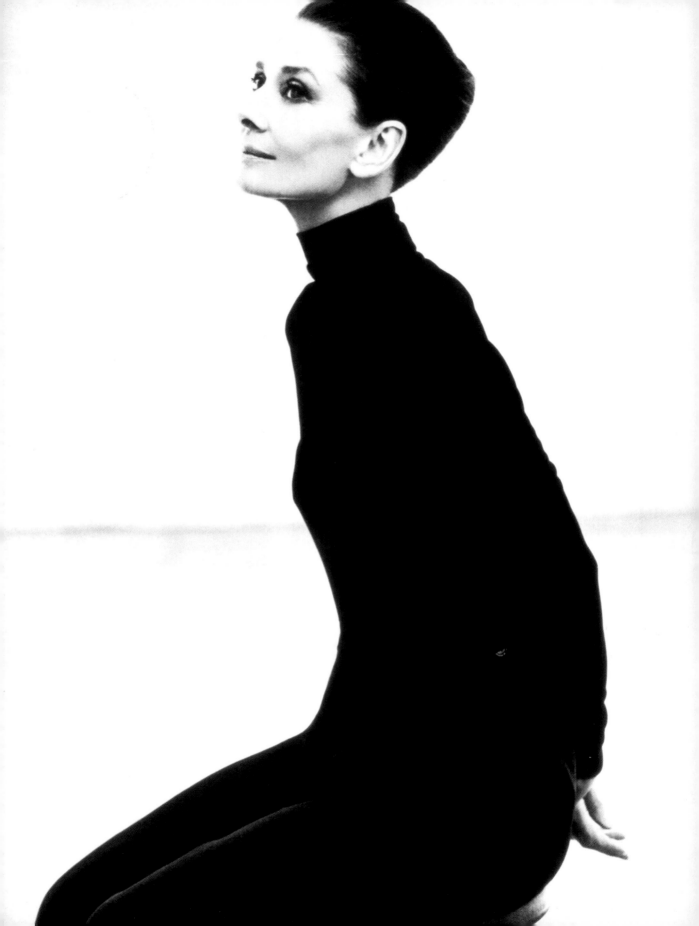

CHAPTER 2 "I CAN RECALL . . ."

"I can recall ..." So many biographies are built upon these words, yet seldom do we let ourselves recall what lies just beneath the surface. Yet if I close my eyes, as far back as I can go ...

I remember that unmistakable soft smell that sometimes still envelops me when I open an old box of my mother's clothes. I remember her soft hands and those powerful embraces that told how much and how deeply she loved.

I remember her long hair, her bare feet, which as a little boy I often caressed while she put her makeup on. Whenever she had to go to a dinner or a cocktail party, she would always say, "Oh, if only I could stay home and eat in the kitchen with you."

I remember the beautiful evening dresses: Givenchy always, and Valentino in Rome ... pea-coats in the winter, collars turned up ... square-toed boots in the 1970s, cotton pants and La-costes in the summer, ballet slippers and a long robe around the house in the morning.

I remember school days, cramming for exams for which she probably fretted more than I did. She would test me before bed and again in the morning, waking up with the sort of sleepy head only adults enjoy.

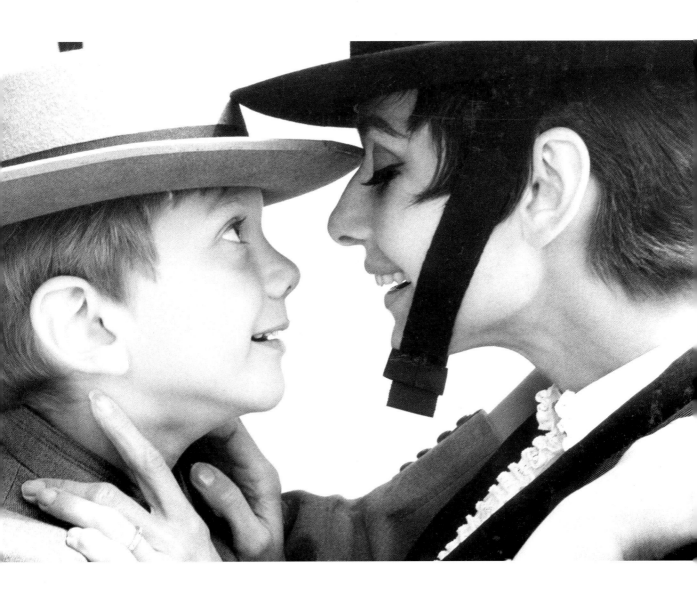

I remember her elation at good grades, her support and positiveness for the "not so good ones."

I remember sleepovers on weekends, when we would chat with the lights out, during those precious few moments before one falls asleep. We would talk about feelings and plans and people and things, but in that way that is specific to that darkness, like two souls suspended.

I remember all that, and the feelings and emotions. That was my mother's world: feelings and emotions. Yet her feelings and emotions were never quite peaceful. Someone once wrote that feelings cause us to act, whereas emotions cause us to react. Feelings are deeper; they have a healthier root system. Well, she had feelings for all of us, yet she was never able to let go of her emotions or find peace within herself. She was truly scared on some level. The abandonment of her father was a wound that never truly healed. She never really trusted that love would stay.

I can see her in the kitchen, preparing something wonderful. She really tried so hard, on every level, to please, be happy, be loved.

I am often asked: Was she really that thin? How did she do it? What was her secret? Well, there was a secret: She starved during the war, yet continued to study ballet all the while. Her eating habits were simple, and she ate a normal amount. She loved pasta at least once a day, but she didn't combine it with protein. In those days we didn't know about food combinations, so she did it naturally. She would have pasta and a salad, and she would only help herself once.

As the years passed, she ate less and less meat, but she wasn't a vegetarian. She didn't eat veal for humane reasons, but she did eat a limited amount of beef, chicken, and fish. She was a very good cook and also believed that the color combinations of the foods on your plate were important: "It isn't very interesting to eat a plate full of white, therefore it can't be very good for you either." That was the way she designed a healthy diet: with a little style and color coordination, we ended up with a portion from all the food groups.

She also walked every day. In Rome there isn't anywhere to park, and the traffic is awful, so she walked everywhere. And in Switzerland, after dinner, she would take the dogs for a run in the vineyards behind our home.

It is fair to say that a plate of spaghetti *al pomodoro* was my mother's favorite dish. She would have pasta once a day, and spaghetti *al pomodoro* at least once a week. Here is the official *pomodoro* sauce my mother preferred. We cannot call it her recipe, since it is a classic "one way of many." It takes a little longer than the "fry the onion or garlic and then the herbs with extra-virgin olive oil in a nonstick pan, add the tomato sauce, and you're ready by the time the water is boiling" recipe. But this one is healthier and in the end easier. Once the prep is done, the cooking doesn't require any supervision.

Peel and dice a small onion, 2 cloves of garlic, 2 carrots, 2 stalks of celery; chop and put in the pot. Add 2 large tins of Italian pelati, or prepeeled Roma tomatoes, and half a bunch of fresh basil, washed, leaves whole. Add a long drizzle of virgin olive oil and simmer on low for 45 minutes. Turn off and let rest at least 15 minutes. Serve over 1 box of pasta cooked barely al dente (still a tiny bit of a snap at the core) with lots of fresh Parmesan (must be Reggiano) and the other half of the basil, well washed and cut with scissors in a cup or glass to prevent bruising or blackening.

It may seem like a lot of sauce, but that's the way my mother liked it—pasta absolutely swimming in sauce. Leftovers can be gently sautéed the next day in a frying pan for those unwise enough not to be there the first time.

The secret to Italian cuisine is its ingredients, my mother taught us. Everything is prepared in the moment, unlike French cuisine, which was designed for large royal entourages and therefore used rich sauces to hide the lack of freshness. Peasants created Italian cuisine. Unfairly perceived as a few tomato-covered dishes with melted cheese on top, it is actually one of the richest and most varied cuisines in the world. In some areas, unique regional dishes cannot be found again twenty miles north or south.

Since the above recipe is traditional, here is an "Audrey adaptation" of a classic Italian pesto, which is usually prepared with basil in a mortar with lots of olive oil and garlic, pine nuts, and Parmesan. My mother designed this way of preparing it and made it lighter and less dry over the pasta by making more of a sauce out of it.

For each box of pasta (1 pound/450grams), start with 1 large bunch of Italian parsley and 1 large bunch of basil (leaves only; discard the stalks). Wash these well and put them in a large blender, in batches if they won't all fit at once, with 1 garlic clove (or more, to your taste). Then add 1 cup of milk (low-fat is okay), a long drizzle of the best extra-virgin olive oil you can get, and a chunk of Parmesan the size of an avocado pit. Hold the top down and blend until creamy. Add more milk to keep the sauce sufficiently liquid so that it blends well.

To round this off, as my mother always did, have a nice salad afterward. Her favorite dressing, which she perfected with her dear friend Connie, is:

90 percent seasoned rice wine vinegar, 10 percent extra-virgin olive oil, a long splash of low-sodium soy sauce, and fresh pepper to taste.

My mother didn't snack, but when she had a dessert, it had to be sweet. She loved a scoop of vanilla ice cream with maple syrup dribbled over it. After her afternoon nap, which she had learned to take because of the early calls and long hours of film production, she would often have a piece of chocolate—one piece! She said that chocolate chased away the blues.

Here is another secret: My mother really wasn't so thin. She used to refer to herself as "fake thin." Her upper body, especially her thoracic cage, was thinner than average, thus her thin waist. The early whooping-cough incident, combined with malnutrition during the war, led to asthma in her youth, and she had somewhat weak lungs throughout her life. She smoked—like most dancers and just about everybody else at the time—and was told throughout her life that she might be in the early stages of emphysema. Her ballet training also played an important role in the development of her physique. Although her upper body was slight, her arms and her legs were athletic and she was well proportioned overall.

So if you want to be in good shape, it's really pretty simple: Grow up during a war, suffer famine in your early life, exercise every day, and later in life eat reasonable amounts of everything and feel good about it. What this really means is that if we don't feed too many fats or sugars to our children, they will have an easier time of it later in life. This is also why my

top In "our home away from home,"
with Connie Wald in Beverly Hills,
circa 1980. Family photo.

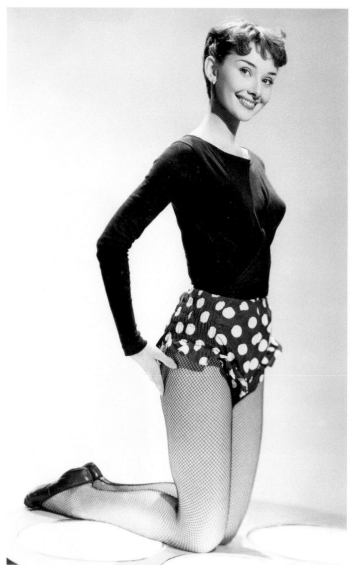

36

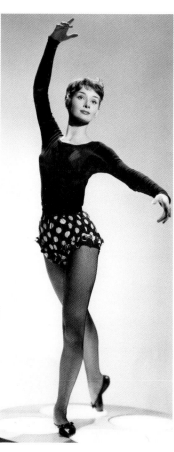

mother was very outspoken, during her years with UNICEF, on the benefits of breast-feeding.

My mother's dream was always to be a prima ballerina. She studied ballet from a tender age, continuing even during the war. When the war ended, she moved back to London, and continued to study with Marie Rambert, who was at the time one of the most distinguished ballet teachers, having worked with Nijinsky. One day she sat Marie down and asked her if, should she continue to train and perfect her skills, she would have a chance one day to become a prima ballerina. Marie very graciously answered that she was one of her best students and that she would probably have a much better career as a second ballerina: the work would be steadier, and she could always teach at her academy and make a good living.

"But what about my dream?" uttered the crushed young Audrey. No matter how hard she had trained, her most important and formative years had passed and could not be recaptured. The war had been tough on her, and poor nutrition had impaired some of her muscular growth and development. Besides, she was too tall for any male dancer of the era. Male dancers in that time were much smaller, and they wouldn't have had the strength to pick her up.

My mother simply couldn't compete with the other dancers who had received proper training as well as proper sustenance during the war years. The war had stolen her dream. She remembered going back to her room that day and "just wanting to die." The dream that had kept her hope alive all those years had just vanished.

She didn't ask for a second opinion. Once she decided whom to trust, she followed their advice. She listened and learned. She loved Mme. Rambert, and they remained friends for the rest of their lives, but the dream was gone, and she had to go on and make a living. If it wasn't going to be ballet, if she couldn't be the best dancer, she would be the best at something else. But she had to settle for what she could get right away, so she took a few modeling jobs and then a few acting jobs. The rest is history.

37

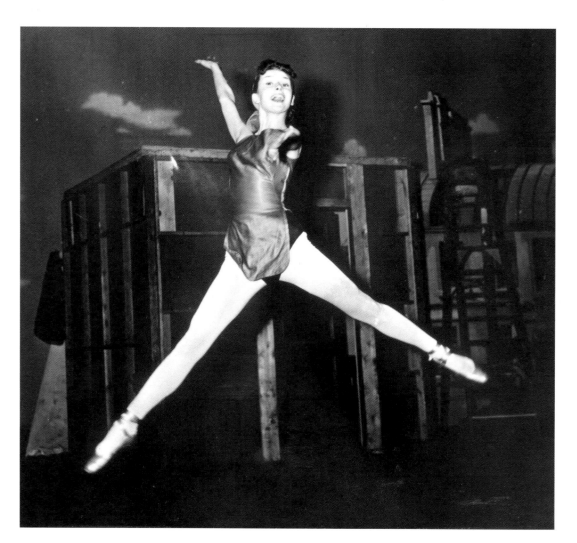

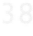

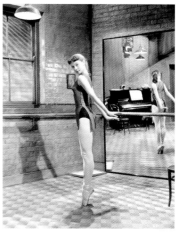

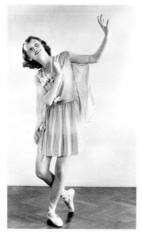

above and far left Audrey landed an early
part in the film *The Secret People*
(released in 1952), starring Serge
Reggiani and Valentina Cortese.

left Dance shot during the war, 1942.
Photograph by Manon van Suchtelen.

opposite Photograph by Antony
Beauchamp, circa 1949.

Audrey Hepburn Estate Collection.

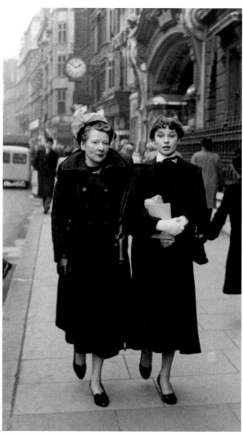

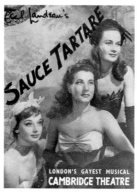

top and bottom left Audrey's cabaret days, London, with Marcel Le Bon, circa 1949. No longer a dancer—not yet an actress; stuck in cabaret purgatory. Only four years after the liberation and three years before *Roman Holiday*, Audrey is twenty years old. Bottom left photograph by Noel Mayne.

middle bottom 1949, Playbill for *Sauce Tartare*. After she was told that she wouldn't make it as a prima ballerina, Audrey went to work immediately in a series of musical revues. *Sauce Tartare*, which was quite successful, gave birth to a sequel called *Sauce Piquante*, a series of Feydeau-style comedies set to music.

top right Audrey and her mother in London, circa 1949, probably taken right after the war, once they had moved back to England. While my mother starred in these musical revues, my grandmother did odd jobs to complement the small stipend that my mother was receiving. She was the concierge of the building where they lived, washing the stairs once a week and doing the regular maintenance. Photographer unknown.

opposite Photograph by Antony Beauchamp, circa 1949.

Audrey Hepburn Estate Collection.

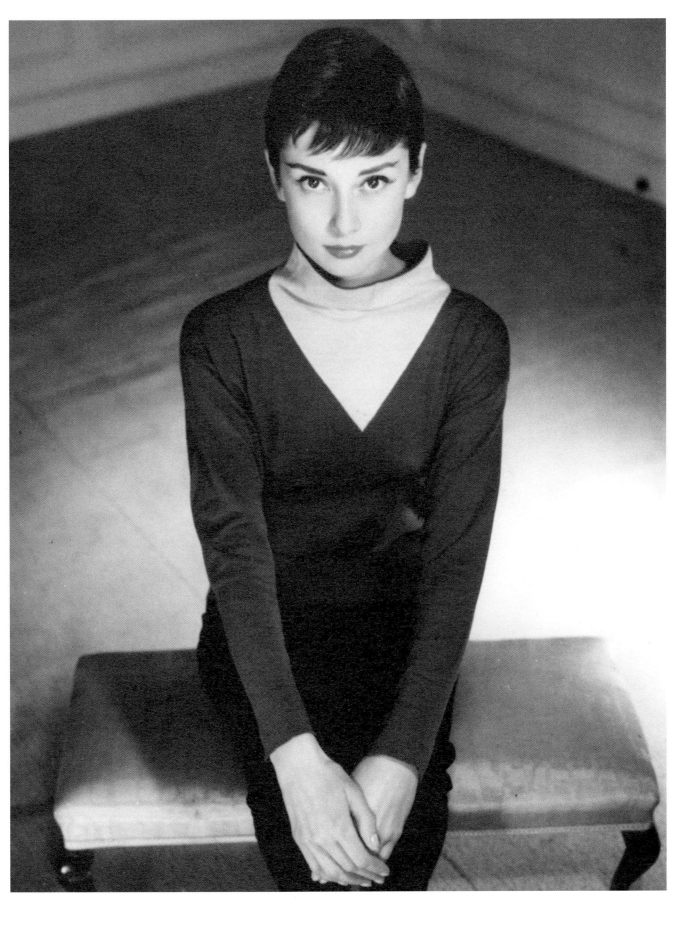

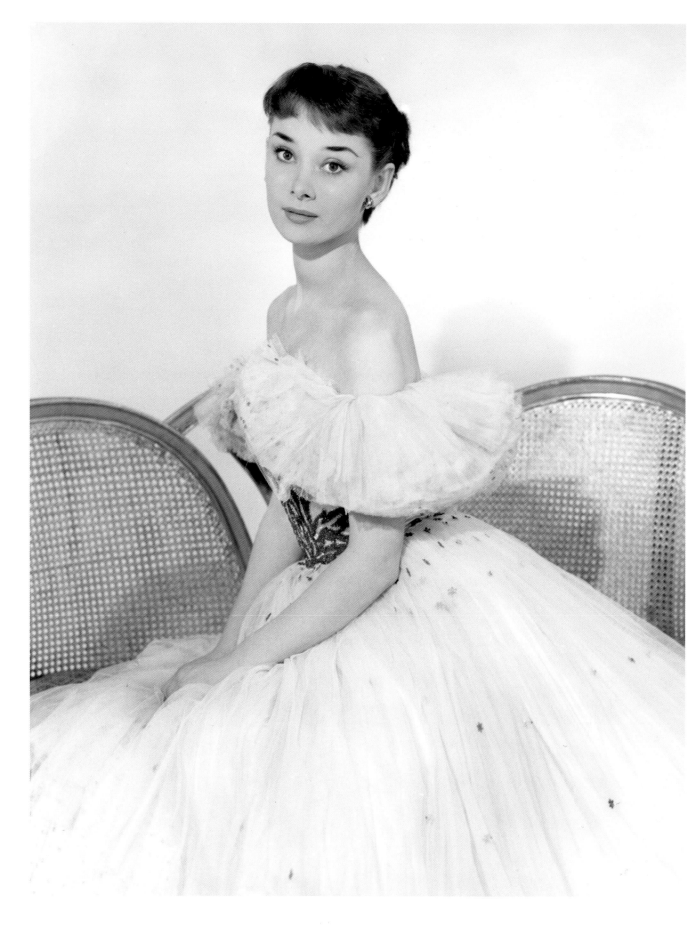

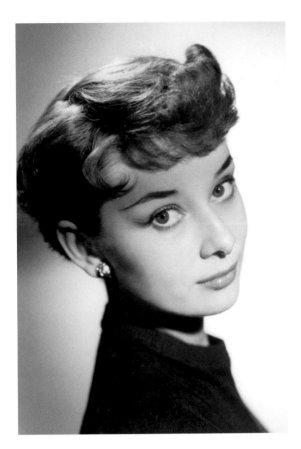

opposite and top left London, circa 1948.
Photographs by Noel Mayne.

top right My mother in London right after the war.
She is probably still hoping she will become a
dancer. Photographer unknown.

Audrey Hepburn Estate Collection.

She attributed her discovery to Colette, the famed French writer. What all actors—or all artists, for that matter—mean by "discovery" is the moment when someone, taking a chance on you, hands you the opportunity to display your talent. Up until that time she had played only bit parts in a few British films like *The Lavender Hill Mob* and *The Secret People*. Then came *Nous Irons à Monte Carlo (Monte Carlo Baby),* a fluffy musical-comedy follow-up to *Nous Irons à Paris*. While shooting in the south of France, Colette, who was staying at the same hotel on the beach where they were shooting, noticed this waifish girl struggling with her budding acting career. Colette, who had been preparing for the production of her play *Gigi,* upon seeing my mother, exclaimed: "I have found Gigi!"

44

opposite *Gigi:* photograph by Richard Avedon. My mother first came to the United States to star in *Gigi* on Broadway in 1951. She often told the story that "the first thing I saw when I came to America was the Statue of Liberty. The second . . . Richard Avedon." Copyright © Richard Avedon.

bottom Colette and my mother, circa 1950. Photographer unknown. Audrey Hepburn Estate Collection.

Hepburn

... and

Hepburn

Audrey Hepburn is a virtual Miss United Nations, half-Dutch, half-Irish, Belgian-born, a new star in England and America.

46

Few pleasures are greater than that of gazing at the stars — both those in the night sky and in our own man-made heavens of the theatre and the cinema.

I have devoted many hours to this dreamy pursuit, some of the most delightful recently to the inspection of a new but very brilliant star that bears a classic name—Hepburn.

I am speaking of Audrey Hepburn, whom I discovered in Monte Carlo and who now, only a year later, is lighting up the American sky in two glittering roles—one in a Broadway play, "Gigi," and the other in a moving picture, "Monte Carlo Baby."

It is unheard of in astronomical circles to have two stars of the same name, for astronomers, despite their constant mooning, are orderly folk. When they call something something, then nothing else may be called the same. In the theatre it is different, particularly where the Irish are concerned. And the Irish were very much concerned in the case of Audrey Hepburn. Her father was one of that charming, unpredictable race.

He did not know that he was be-

getting a star, poor man. And I am sure that when the knowledge finally began to dawn on him his last thought was to change the name he had given her simply because there already happened to be a fixed star, also named Hepburn.

I personally never have encountered the other Hepburn, Katharine The Great, but she flew over my country, France, about the same time I was discovering her namesake. She was on her way south to make a picture called, "The African Queen." I hear that it is a fine picture and that in it she proves herself a great actress by dispensing with make-up and other aids to luminosity, which lesser lights find necessary.

So now American stargazers will behold two shining Hepburns—Audrey and Katie—who are unrelated and never even have met, but whose names are being emblazoned simultaneously on theatre marquees.

I did not need a telescope to discover my Hepburn. It happened one day in Monte Carlo. She was there with a group of cinema people, led by Ray Ventura, the European or-

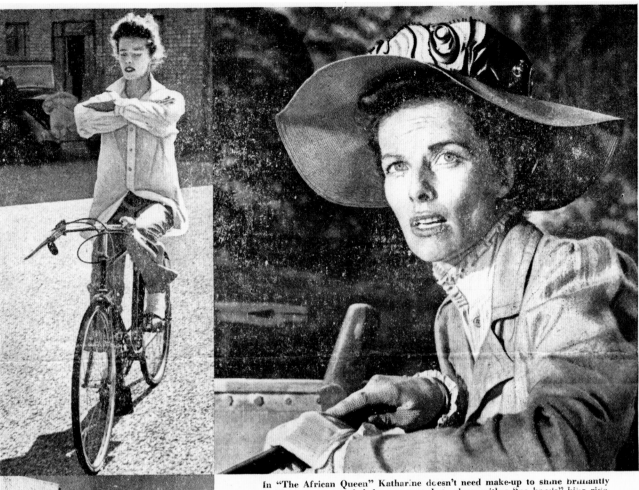

In "The African Queen" Katharine doesn't need make-up to shine brilliantly and between scenes she's human enough to clown with a "no hands" bike ride.

By Colette

TRANSLATED FROM AN ARTICLE WRITTEN EXCLUSIVELY FOR THE AMERICAN WEEKLY BY THE WORLD-FAMOUS FRENCH AUTHOR

chestra leader and producer. They were making two versions of one film, the first in French, called "We'll Go to Monte Carlo," and the other in English, "Monte Carlo Baby" (the latter is being shown in the United States now).

Audrey was the only member of the cast to play in both, and the moment I saw her I could not take my eyes away. "There," I said to myself incredulously, "is Gigi!"

A novel of mine, which had just been turned into a play by Anita Loos, "Gigi," tells the story of a French gamine, and all of us, Anita, Gilbert Miller, the producer, and I were searching for someone to play the leading role.

What author ever expects to see one of his brain-children appear suddenly in the flesh? Not I, and yet, here it was! This unknown young woman, English, I guessed, was my own thoroughly French Gigi come alive! That afternoon I offered her the part in the Broadway play.

What it takes to make a celestial star I do not know, but no first-rate human star of my acquaintance has been formed without suffering. Although 21 when I met her, Audrey already had this qualification. She had acquired it as a child.

Born in Brussels of a Dutch mother and Irish father, she was living in England when World War II broke out. But England seemed unsafe, so her mother took her home, to Holland, which, of course, turned out to be even less safe. She

was 10 then, an impressionable age, just right for obtaining the maximum effect from bursting bombs and scenes of cruelty.

It was a hard, hunted life. One of her two brothers was seized and carried off to a Nazi labor camp. She distributed food for the Underground and carried parcels to hidden allied pilots. Once, when the Germans were rounding up women to run their military kitchens, she was picked off the street with a dozen others, but escaped.

After the liberation she and her mother were assigned to a rest home for soldiers, where they began to eat regularly again. On her first day of freedom a Dutch officer gave her five chocolate bars which she gorged and which made her violently ill.

Following two years of ballet study in Amsterdam, she returned to England and soon pirouetted her way into musical shows. Then came bit parts on the stage and in pictures, ending in Monte Carlo.

Now, as Gigi, and with her movie out at the same time, she is, as the astronomers say, "in the ascendant." When she finds her final place in the firmament, there will be two great fixed stars named Hepburn, to the confusion of astronomers but to the delight of ordinary theatre-goers. Then, perhaps, secure in the heavens, Audrey too, like Katharine, may dare some day to lay aside her make-up.

When Colette saw Audrey acting in the movie "Monte Carlo Baby" (above) she found "Gigi."

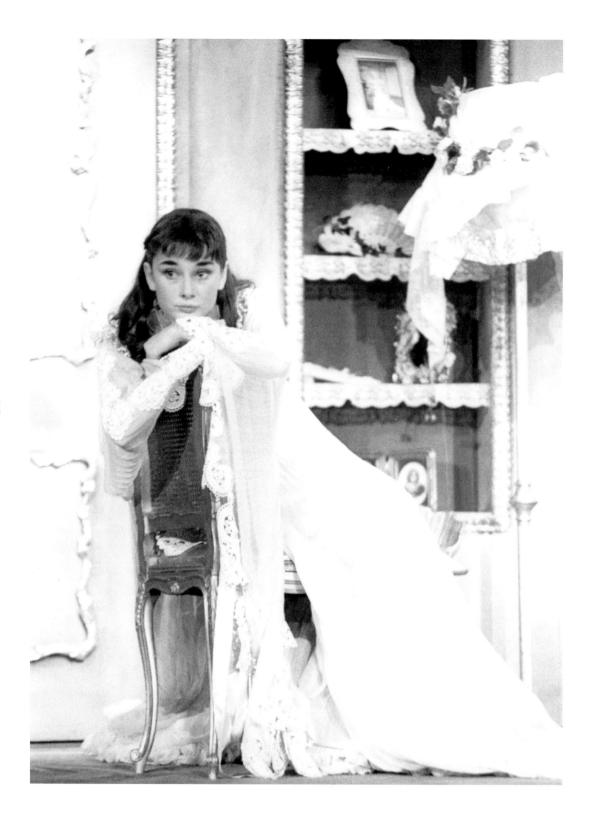

49

Colette was a genius. Not only is her writing brilliant and modern, but her vision of things to come in my mother's life was uncanny: from "Miss United Nations" to "lay aside her make-up."

I have often been asked which of my mother's films I love best. Every time I watch *Funny Face,* in which my mother starred with Fred Astaire, it fills me with joy to see her soar and dance away after all those years. In it, she performs a modern dance solo in an "existentialistic" club in Paris, and her craft is supreme. She gets to spread her wings and fly away on a dancing whirlwind that had been bottled up for years.

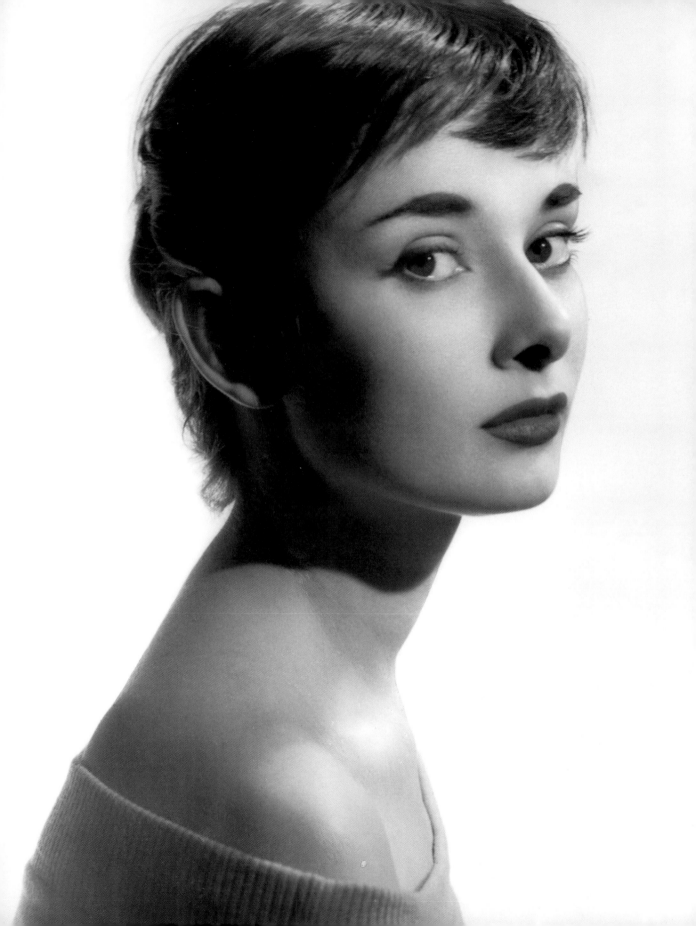

opposite Gene Moore was introduced to my mother by Richard Avedon when she first came to America to star in *Gigi*. Gene was looking for models to base his mannequin designs on, and this portrait is a result of that photo session. Later, Gene Moore went on to design the windows of Tiffany's for over thirty-five years. Audrey Hepburn Estate Collection.

Excerpt from *My Time at Tiffany's*, by Gene Moore
In 1951, somewhere along the French Riviera, Colette met an actress named Audrey Hepburn and immediately insisted that Hepburn be given the lead in the forthcoming Broadway adaptation of her *Gigi*. Thus Audrey Hepburn came to New York, Richard Avedon photographed her for *Harper's Bazaar,* and I saw the photograph. I called Avedon, found out where Hepburn was staying, asked her if she'd agree to become a mannequin, and eventually photographed her at Alexander's studio. She was so very beautiful, radiant and feminine, an ideal Colette heroine. And tall, taller than I am. We became friends, and she later used the photographs I'd taken as her first publicity pictures with Paramount for her first movie, *Roman Holiday*.

below *Funny Face*. Photographs by Bill Avery. © 1978 Bill Avery/mptv.net.

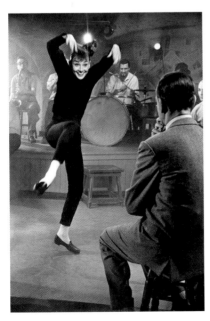

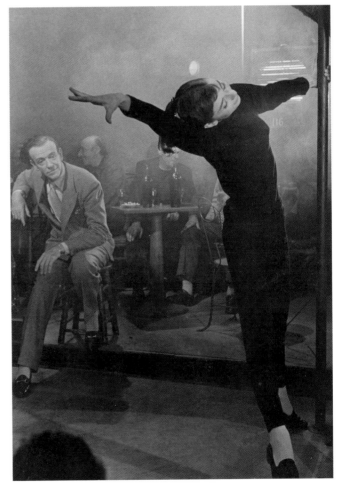

below and opposite *Funny Face*. I have often been asked, in the many interviews I have given since my mother's death, which is my favorite of her films. I've never really answered that question, since it would be absurd to think that I would have sufficient objectivity to choose a favorite. Nevertheless, I have always tried to answer it by naming the movies I knew she had a personal affection for. *Funny Face* is one of these. It was a dream come true to dance with Fred; what a joy it must have been, after all those years, for her to be able to reconnect with her first love—dancing! "She took off on a dance whirlwind that had been bottled up for years."—Fred Astaire. Photographs by Bill Avery. © 1978 Bill Avery/mptv.net.

52

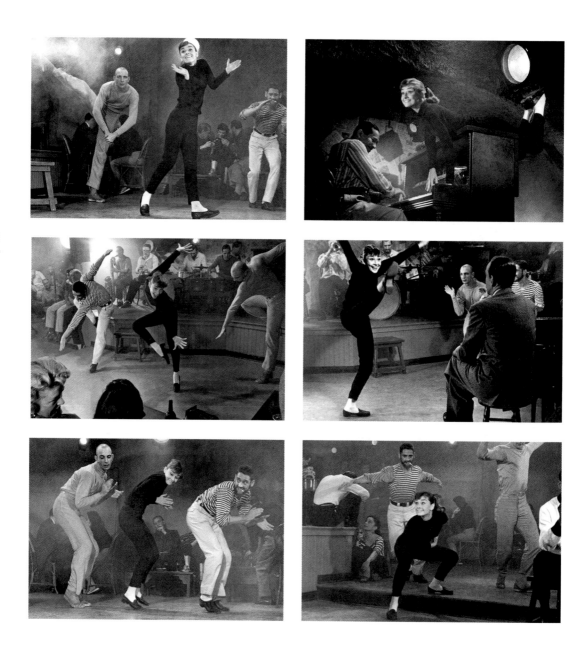

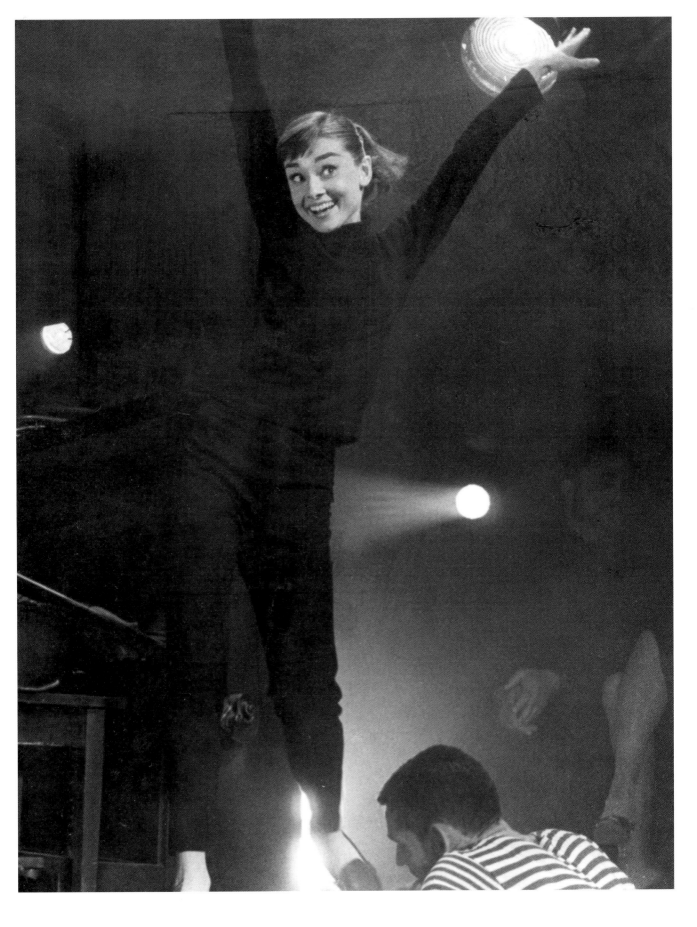

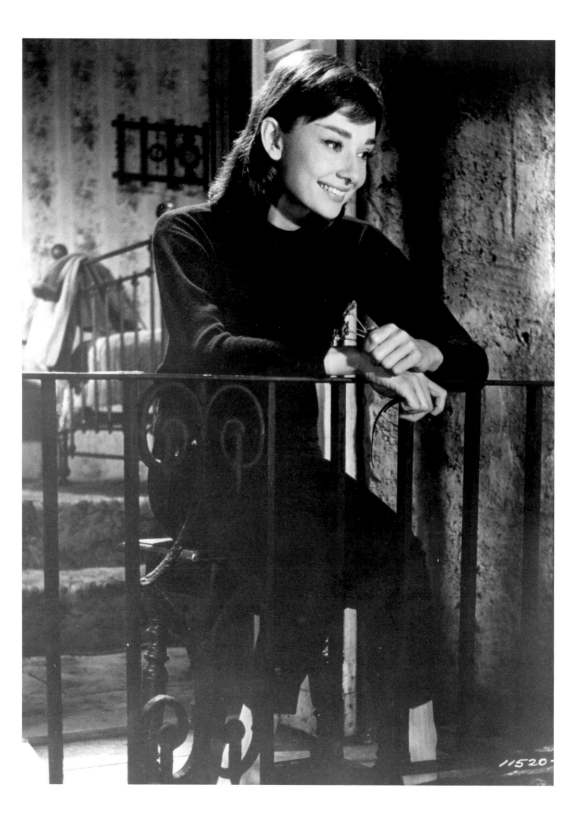

11520

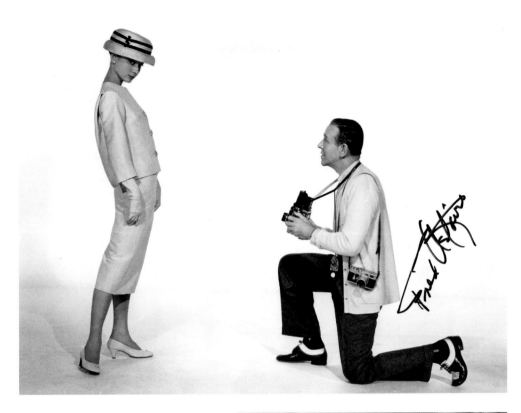

opposite and top *Funny Face* publicity stills. © Paramount Pictures. All rights reserved.

right Fred Astaire's inscription reads: "Two *'tired'* dancers!! Get it?" Family photo.

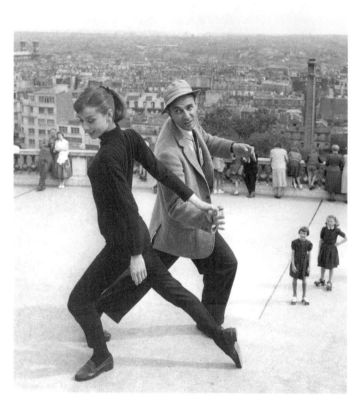

These are some of Fred's thoughts on working with my mother on *Funny Face,* excerpted from *The Reminiscences of Fred Astaire* (July 1971), pages 30–33, in the Oral History Collection of Columbia University.

I liked it very much, and I loved Audrey. She was just about one of the most lovely people that you could ever meet or work with, my goodness. So I enjoyed all those things that came my way, and there were a lot of them. She had in the past been a dancer, as she told me, but she sort of hadn't danced for quite a while by the time we worked together. She particularly asked for me for that picture. Otherwise, I never would have made it. I wouldn't have been—they didn't—you know, it wasn't a thing they were making for me. They had her, and she said, well, I'll do it if you get Fred Astaire. And that was the biggest compliment you can get, you know. At that point, I didn't really—I think I was thinking about not doing too many things, and when I heard that she wanted me, I

said, Gee whiz, I certainly hope that that can be arranged. And then there was a question about whether it was going to be done at Metro or where. See, Roger was the promoter of that, and he was at Metro. And then Metro couldn't do it on account of her rights at somewhere else and I don't know what all. It all ended up by us doing it at Paramount. I just went along.

I said, You find out where to do it, baby, I'm certainly doing it. I'm doing it with that one. And so we did have a good time. We shot some of it in Paris. Those are very happy memories that I have about that one.

We were way out—the famous line that she said.

We waited and waited to do this dance, which was "He Loves and She Loves." I think that's what the song was. The dance out in the beautiful meadow in the outskirts of Paris. And it rained and rained and rained while we were there. We couldn't shoot at all for about two weeks. And we shot around that number and the field got muddier and muckier and finally we went out and we just had to shoot, and the sun was shining and the rains were over, we hoped.

And they were. But the field was muddy. So we had this—it was difficult to work in.

And little Audrey, she said, "Here I have waited twenty years to dance with Fred Astaire, and what do I get? Mud!" My favorite remark of all times. She's just a great—gosh, she's cute.

Well, we found some dry spots and put some lamps, some heat lamps, on it, and where we worked we finally got it into order so we could shoot, because we were running out of time. We'd been over there for so long waiting to do the things that had to be done. One of the things in that was a fashion show, that was supposed to have been in the—in some location. Anyway, we were outdoors in the middle of this Jardin Tuileries or whatever it is and this rain started to come down. So Stanley Donen says, shoot it, shoot it. So I had the raincoat. I put the raincoat on but Audrey was a model in that thing and she just got out there and got this dress soaking wet, and we used it in the picture which was a good effect really.

She was good.

I thought it was very good. I loved a lot of the picture. I thought it was fine.

My mother's acting career was a second choice, a default choice. But the rules were the same as in ballet: hard work, discipline and professionalism.

The first time I got a clear picture of what acting was all about was when I had to do a school play. I think I was about twelve years old and I was going to play *Le Malade Imaginaire* by Moliere. The character has no real afflictions, but years of studied hypochondria combined with the fear of disease have made him almost as well versed on a variety of conditions as the doctors he consults. The result is one of the longest and most arduous monologues about disease ever written. It is also brilliantly funny.

My mother gave me the following advice: "Just read it. Don't try to learn it. But first you must know what these illnesses are and where they hurt." Fortunately, my brother Luca's father, Andrea Dotti, is a psychiatrist. So I grilled him and got all the answers as well as the theories behind hypochondria.

But the performance was nearing and I still felt I had not memorized the text. "This is what I do," my mother said. "I read my lines right before I turn the lights off at night and then again when I open my eyes in the morning." "That's it?" I asked. "That 's it!" she said.

So I did, every day for four or five days before the performance. On the day of the outdoor performance, as she saw me off to the bus, she said: "When you get up there, you will have the feeling that you have forgotten everything. That's normal, it happens to all of us. Just go with it, it's in there, don't worry." And, of course, she was right. I panicked for a second and then it came out, all of it, and it was fun. As the performance came to an end and all our chums were cheering us, I looked up and saw her, watching from afar, in the shade of a tree. She later told me she had snuck up on the performance but didn't want to throw me. So she stood to the side and watched.

58

opposite Audrey, circa 1949. Antony Beauchamp was one of the very first to photograph Audrey in a style and a look that were going to be hers for most of her career. Antony who, at the time, was married to Sarah Churchill, the daughter of Winston Churchill, saw my mother in a chorus line in a London theater and wanted to photograph her for his series of "New Faces." She immediately told him that she couldn't afford his fees. He told her not to worry—he'd photograph her for nothing. Years later, apparently, when she was able to choose her still photographer for a film shooting in Italy, she asked for Antony. Audrey Hepburn Estate Collection.

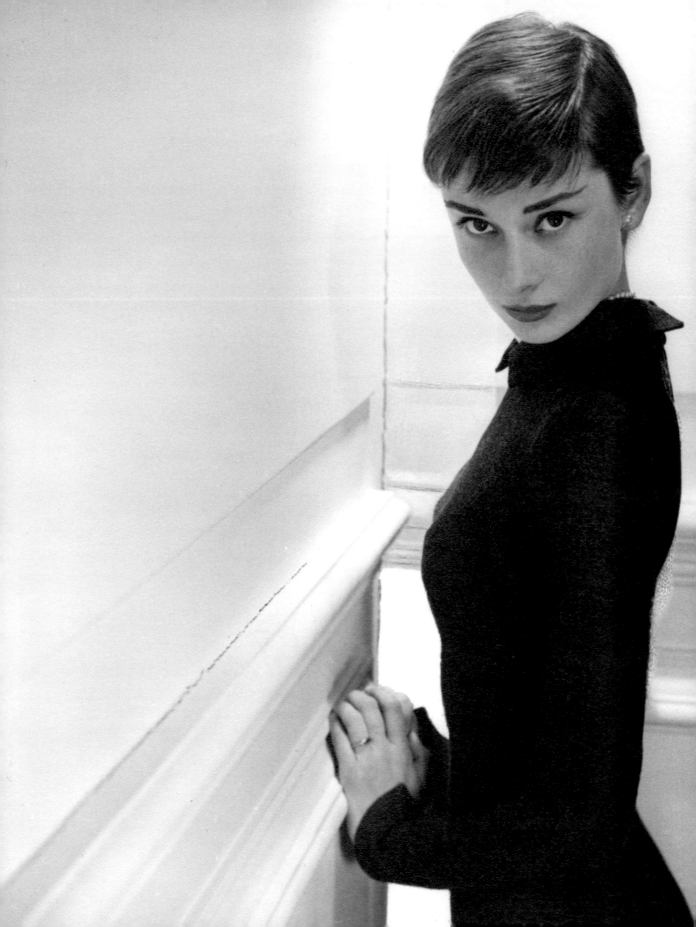

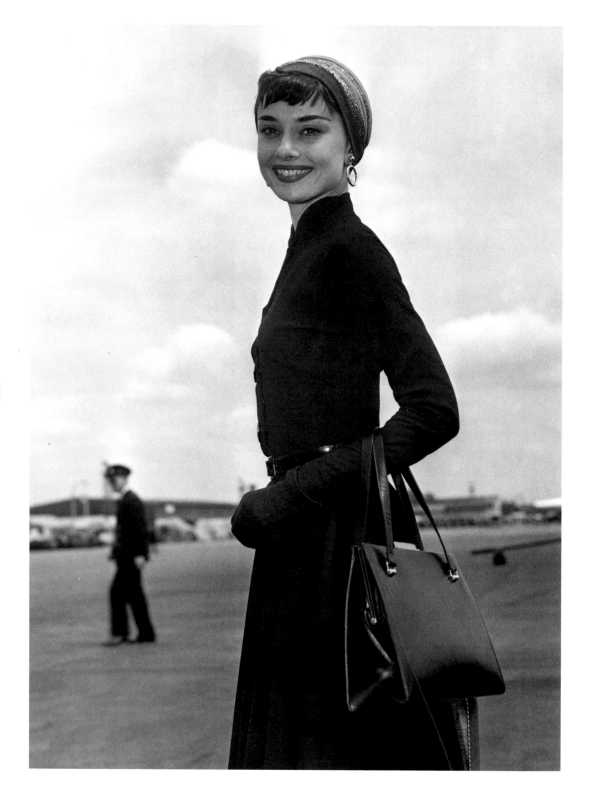

60

Roman Holiday production stills, 1952. Audrey Hepburn Estate Collection.

opposite Circa 1953, photographer unknown. Audrey Hepburn Estate Collection.

top right Director William Wyler touches up Audrey's makeup.

bottom left Audrey with Gregory Peck, playing cards on the set.

bottom right With director William Wyler on a Vespa motor scooter in the streets of Rome.

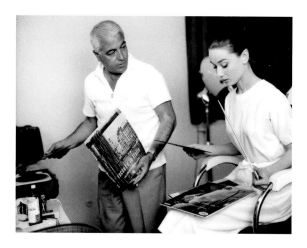

top Audrey on the set of *The Nun's Story* with her makeup artist, Alberto de Rossi. There was very little glamour makeup on *The Nun's Story,* for obvious reasons, but he aged her throughout the film. Photograph by Pierluigi. Pierluigi/Reporters Associati.

bottom My parents with Alberto de Rossi and his wife, Grazia, at the premiere of *War and Peace,* 1956. Alberto was my mother's makeup man throughout her career, and Grazia was her hair stylist. Alberto is really the one who created the legendary "Audrey Hepburn eyes," in a slow process of applying mascara and then separating each eyelash with a safety pin. I remember her saying when he died, crying as though she had lost a brother, that she would rather not work again. I have sweet memories of going to the soccer games with him. Grazia still lives in a beautiful area outside Rome, and I consider her a member of my family. Photographer unknown. Audrey Hepburn Estate Collection.

opposite Photograph by John Engstead, circa 1953. © 1978 John Engstead/mptv.net.

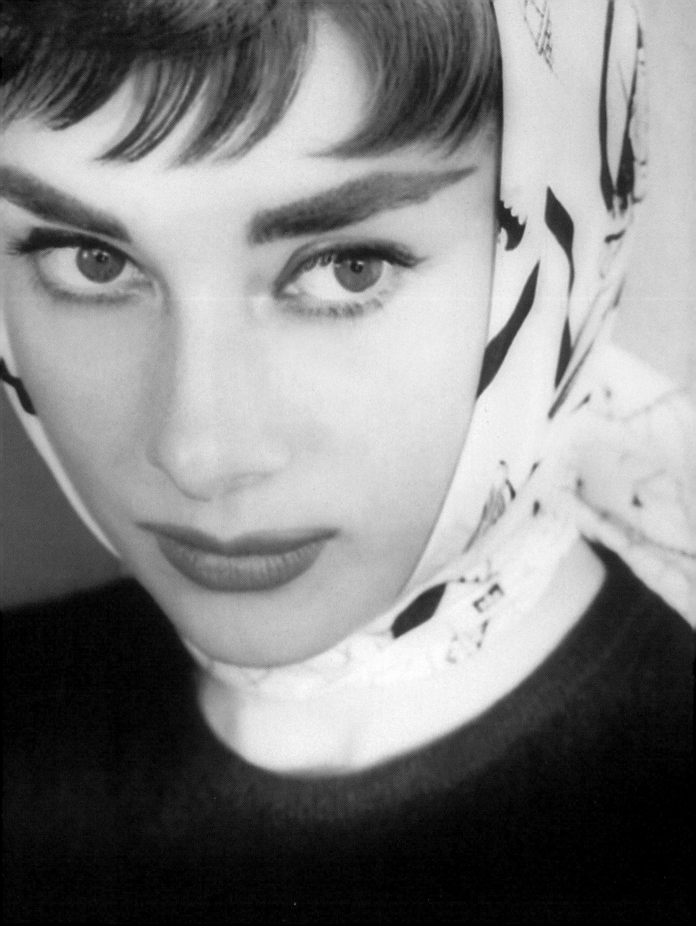

ACADEMY OF MOTION PICTURE ARTS AND SCIENCES

May 25, 1954

RECEIPT FOR ACADEMY AWARD STATUETTE

Excerpt from Academy By-Laws, Article VIII, Section 1, Paragraph (g):

"Every Award shall be conditioned upon the execution and delivery to the Academy by the recipient thereof of a Receipt and Agreement..."

Gentlemen:

I hereby acknowledge receipt from you of replica No. 718 of your copyrighted statuette, commonly known as "the Oscar", as an Award for **Best Actress - "ROMAN HOLIDAY"**.

I acknowledge that my receipt of said replica does not entitle me to any right whatever in your copyright of said statuette and that only the physical replica itself shall belong to me. In consideration of your delivering said replica to me, I agree to comply with your rules and regulations respecting its use and not to sell or otherwise dispose of it, nor permit it to be sold or disposed of by operation of law, without first offering to sell it to you for the sum of $10.00. You shall have thirty days after any such offer is made to you within which to accept it. This agreement shall be binding not only on me, but also on my heirs, legatees, executors, administrators, Estate, successors and assigns. My legatees and heirs shall have the right to acquire said replica, if it becomes part of my Estate, subject to this agreement.

Audrey Hepburn
Audrey Hepburn

Any member of the Academy who has heretofore received any Academy trophy shall be bound by the foregoing Receipt and Agreement with the same force and effect as though he had executed and delivered the same in consideration of receiving such trophy.

64

The **PLAYBILL** ®
for the Forty-Sixth Street Theatre

ONDINE

left A receipt for her 1954 Oscar for *Roman Holiday* from the Academy of Motion Picture Arts and Sciences (AMPAS).

right Broadway Playbill for *Ondine*. It was my father's idea that Audrey continue doing theater although her film career had already started. Gregory Peck, upon his return from Rome, where *Roman Holiday* had been shot, had told my father with whom he had created the La Jolla Playhouse, "You have to meet this girl." This was their first play together; she won the Tony Award for it, in the same year she got the Oscar for *Roman Holiday*. Playbill® is a registered trademark of Playbill, Inc. All rights reserved. Used by permission.

opposite Mid-1950s: Notice the magazine on the floor of the window display. There she is, looking into the window of the department store, unsuspecting that the window designers are already using her as a fashion inspiration. Photographer unknown. Audrey Hepburn Estate Collection.

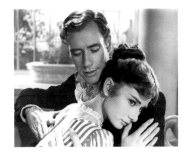

opposite *Sabrina*, with Billy Wilder and Humphrey Bogart, 1953. I once asked Audrey about "Bogie." She said they got along okay, yet she felt, and heard rumors to the effect, that he really didn't think much of her as an actress. I told her I thought that wasn't fair. She looked straight at me and said he probably had reason to. Here they chat with Billy Wilder while shooting the memorable dance in the tennis court. Audrey Hepburn Estate Collection.

bottom left *Love in the Afternoon*, on set with director Billy Wilder. © 1957 Allied Artists Pictures Corporation. All rights reserved.

top *War and Peace:* three production stills. This is a meaningful film for me, since my mother and father starred in it together, as Prince Andrei and Natasha. © Paramount Pictures. All rights reserved.

bottom right *Love in the Afternoon*, on set with Gary Cooper, Billy Wilder, and my father. Photograph by Al St. Hilaire. © 1978 Al St. Hilaire/mptv.net.

top Production still with Gary Cooper, 1957, *Love in the Afternoon* (aka *Ariane*). My mother spoke often of Cooper with much affection and respect. He truly was the "gentle man" of the silver screen. They became quite close, and when he passed away in 1961, Mr. Cooper's wife sent my mother his twenty-four-carat gold Zippo lighter. She always cherished it, and it remains one of our family's heirlooms. © 1957 Allied Artists Pictures Corporation. All rights reserved.

bottom left New York City. During the rehearsals of *Mayerling*, February 5, 1957. One of the first live broadcasts of a play on national television (NBC Producers Showcase). Clowning around with my father in a boxing ring—unrelated to the production. Photographer unknown. Audrey Hepburn Estate Collection.

bottom right With Maurice Chevalier, 1956. The photo is inscribed, "To Audrey's mother from Ariane's father—Maurice Chevalier." They are having tea on the set. Maurice plays my mother's father in the movie, and this photo was a gift to my grandmother. Photographer unknown. Audrey Hepburn Estate Collection.

opposite *Sabrina*, with Billy Wilder (left) and William Wyler (right). Wilder and Wyler were probably the most important and influential directors of my mother's career, along with Stanley Donen. She did three movies with Wyler (*Roman Holiday*, *The Children's Hour*, and *How to Steal a Million*) and two with Wilder (*Sabrina* and *Love in the Afternoon*). Photographer unknown. Audrey Hepburn Estate Collection.

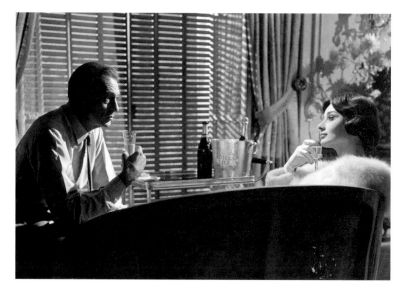

top left *With costar Anthony Perkins and fawn Pippin.*

bottom left *My parents, as director and star, on the set.*

opposite *Two for the Road production still; directed by Stanley Donen, 1967. © 1967 Twentieth Century Fox. All rights reserved.*

top right *At home with Pippin (aka Ip) who has grown up quite a bit. Photograph by Bob Willoughby. © Bob Willoughby 1960.*

top and bottom left *Green Mansions, 1959, directed by my father, was based on the classic novel by William Henry Hudson. Green Mansions. © Turner Entertainment Co. A Warner Bros. Entertainment Company. All rights reserved.*

bottom right *With James Garner, goofing around on the set of The Children's Hour—a much needed respite from an extremely intense script. Photograph by Bob Willoughby. © Bob Willoughby 1960.*

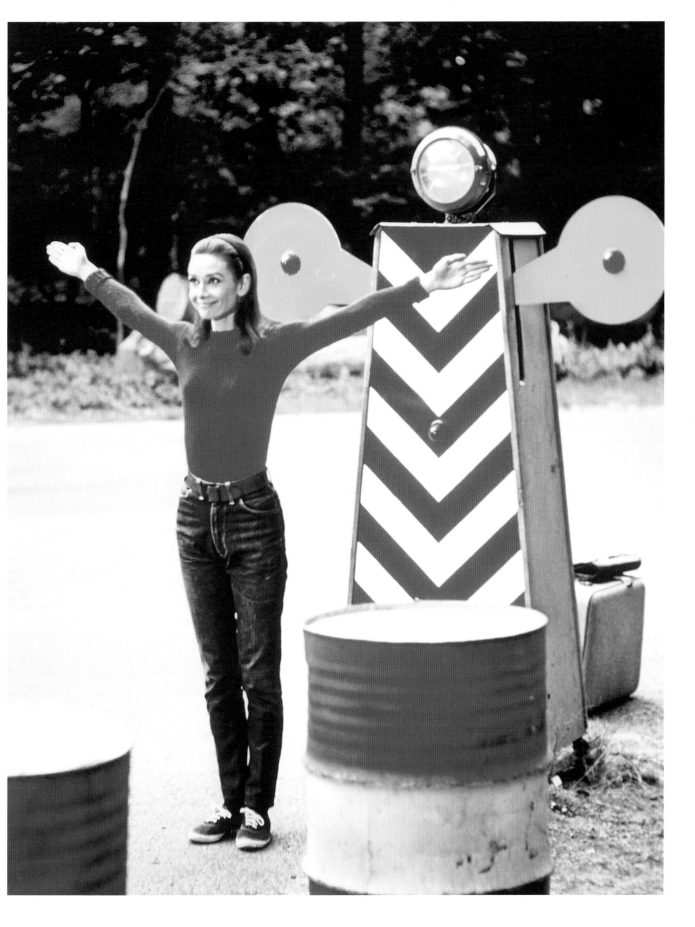

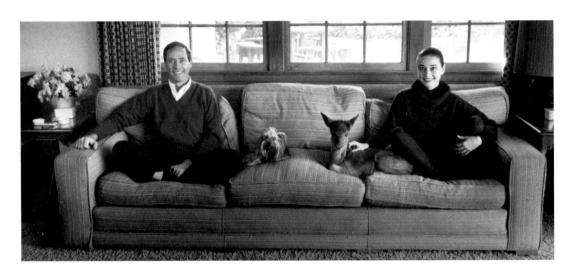

top Ip the deer was kept at home throughout preproduction of *Green Mansions* so that my mother and she could become close to each other. My parents used this photo as their Christmas card in 1958. Photograph by Bob Willoughby. © Bob Willoughby 1960.

bottom With Mel on location of his movie, *The Sun Also Rises,* 1957. The photographer, John Swope, was close not only to my parents, but also to Ernest Hemingway, the author of *The Sun Also Rises.* John was probably there visiting, but not as a photographer. © John Swope Trust/mptv.net.

opposite 1955 photographs by Philippe Halsman, "La Vigna," outside of Rome. Taken during the early days of production of *War and Peace,* which was shot mostly at Cinecittà Studios in Rome and on location in Italy. My parents rented a home in Rome during the production, which took several months. This was also the location where the cover of this book was photographed. © Halsman Estate.

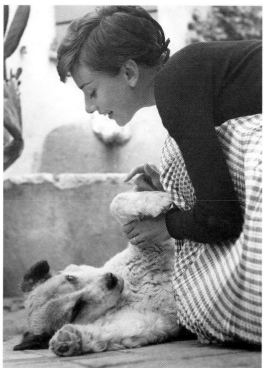
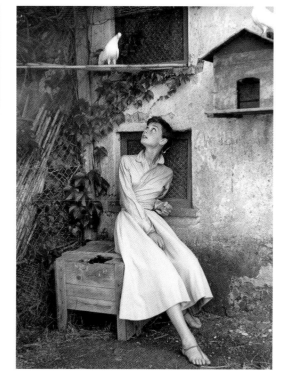

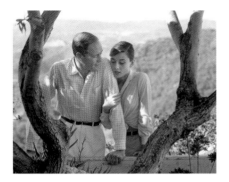

74

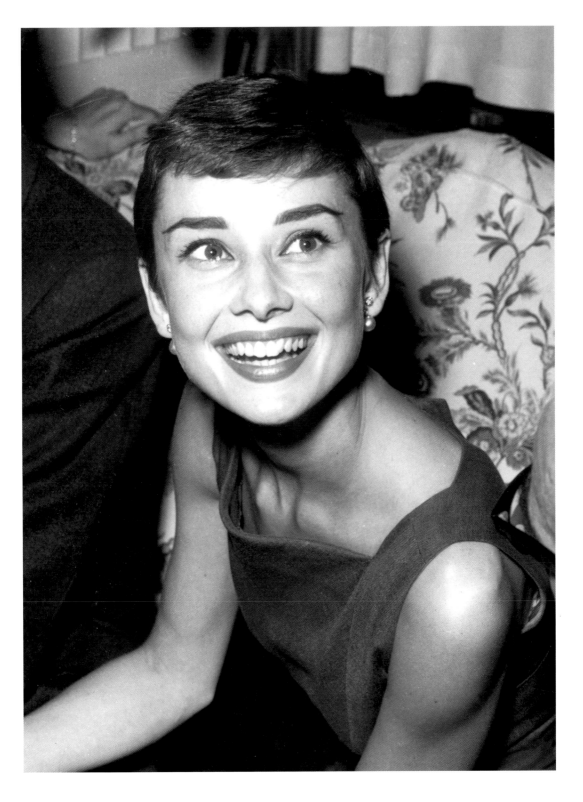

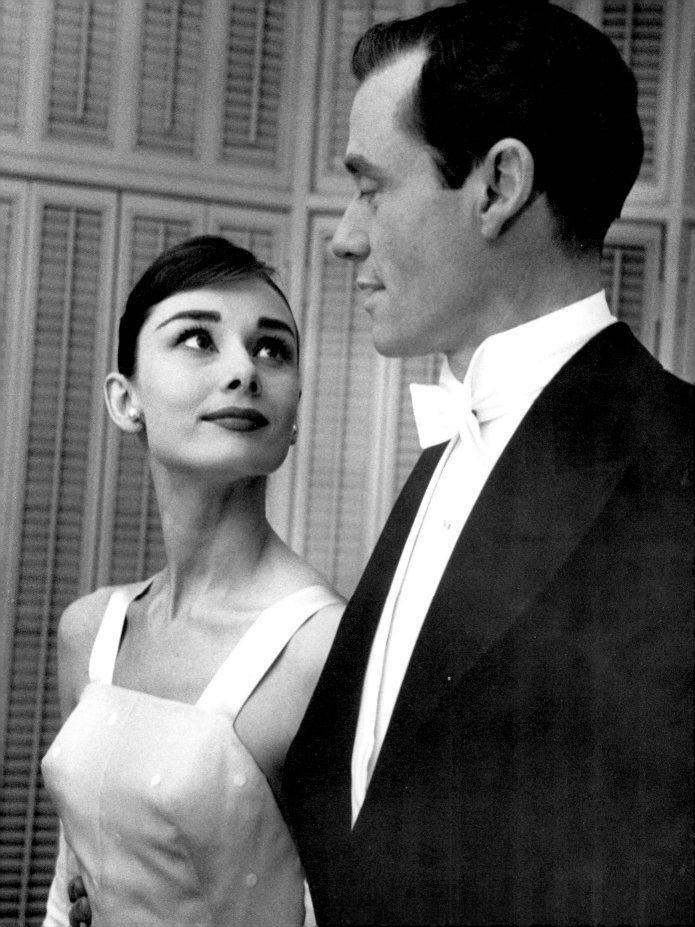

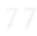

opposite 1956 Academy Awards: Mom and Dad, all spiffed up going to the show. Photograph by Bill Avery. © 1978 Bill Avery/mptv.net.

top left Photograph by Augusto Di Giovanni. Di Giovanni, circa 1954.

middle September 24, 1954: The day of my parents' wedding in Bürgenstock, Switzerland. Family photo.

right The premiere for *El Greco*, in which my father starred, circa 1966. Photographer unknown. Audrey Hepburn Estate Collection.

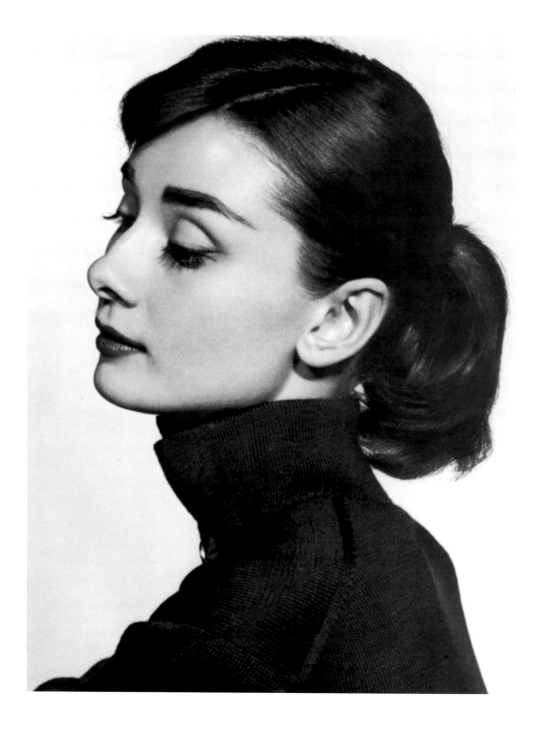

78

above Photograph by Yousuf Karsh, 1956. © Yousuf
Karsh/Camera Press.

opposite One of my absolute favorites, circa 1956.
Photographer unknown. Audrey Hepburn Estate
Collection.

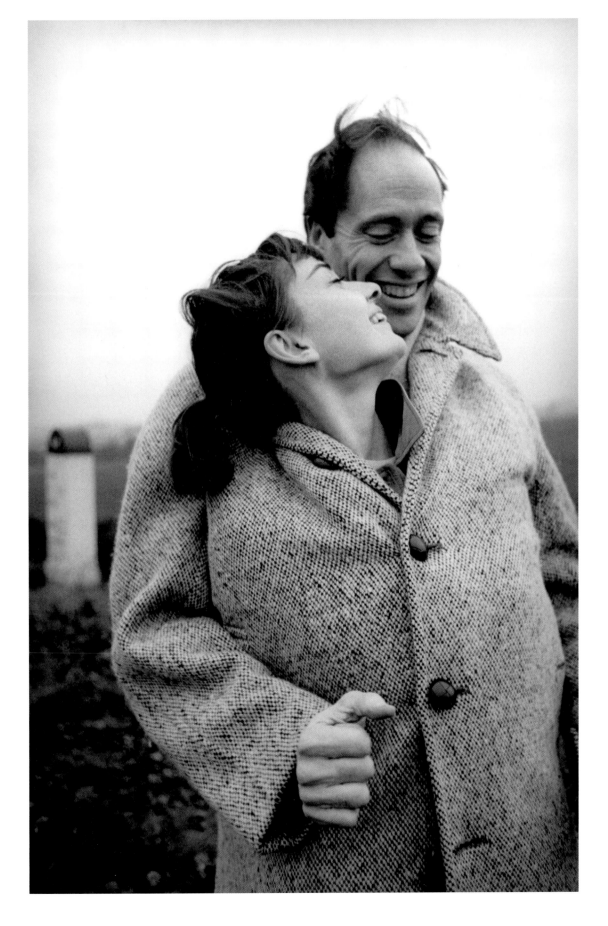

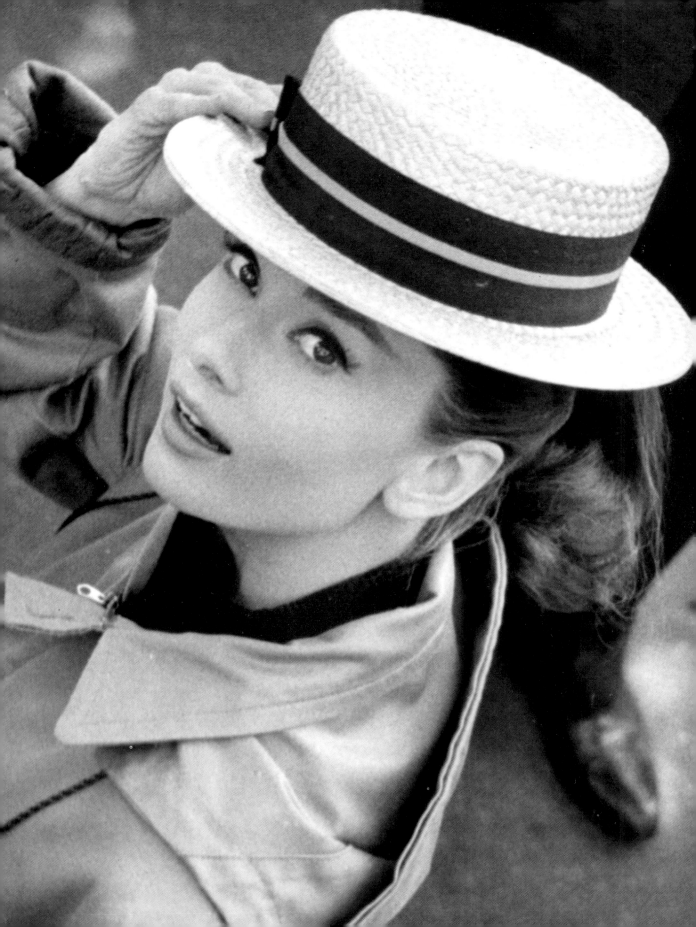

CHAPTER 3 UNFORGETTABLE

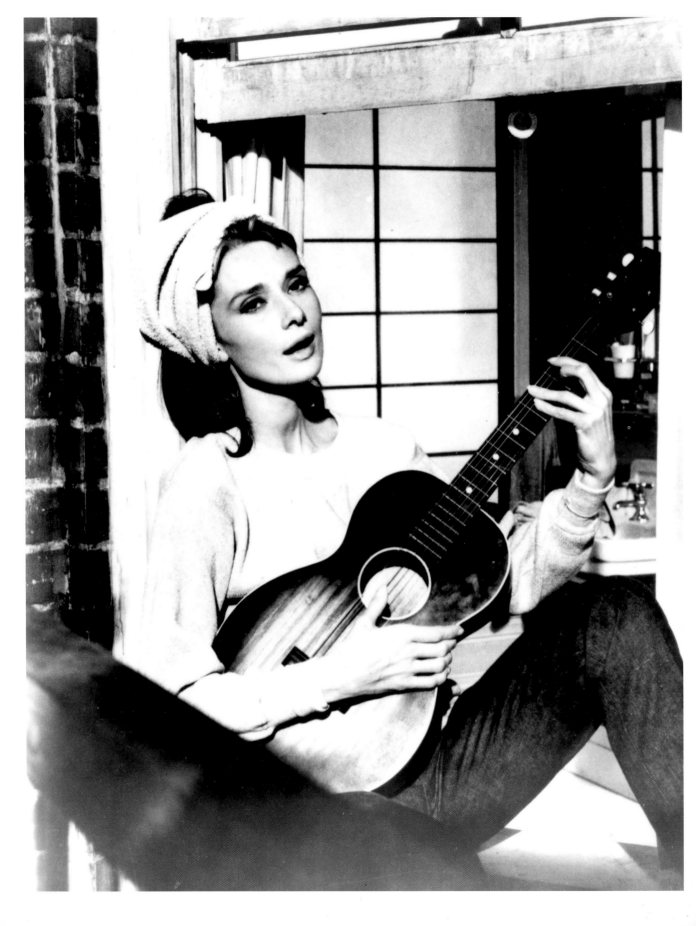

"It's not just the words, but also the tune that makes a great song," my mother taught us early in life. "It is not only what you say, but *how* you say it."

83

A perfect example of this is her performance of "Moon River" in *Breakfast at Tiffany's*. She wasn't a professional singer, nor was she graced with an operatic voice, which is why her singing in *My Fair Lady* was dubbed by Marnie Nixon. Yet her performance of "Moon River" is so sincere and so right for that moment on the fire escape that it works beautifully. Henry Mancini, her friend and the magical composer of many of her films' sound tracks, talked about how she inspired him in a newspaper article in the late 1970s:

> It's unique for a composer to really be inspired by a person, a face or a personality, but Audrey Hepburn certainly inspires me. She not only inspired me to write "Moon River," but also "Charade" and "Two for the Road." If you listen to those songs you can almost tell who inspired them because they all have Audrey's quality of wistfulness—a kind of slight sadness. Normally, I have to see a completed film before I'll compose the music. But in this case I knew what to write for Audrey just by reading the script. Then, when I met Audrey the first time, I knew the song would be something very, very special. I knew the exact quality of her voice and that she could sing "Moon River" beautifully. To this day, no one has done it with more feeling or understanding.

He went on to describe her performance in another film they did together:

> There was a scene in Charade *they ran off for me where Audrey returned to her apartment alone and discovered the old man had absconded with all her worldly goods. She sat forlornly on a suitcase, and at that moment, the first few notes of "Charade" came to me. I don't know how or why. I wish she'd come back and do more films, because I'm truly inspired by her screen presence.*
>
> *"Moon River" was written for her. No one else has ever understood it so completely. There have been more than a thousand versions of "Moon River," but hers is unquestionably the greatest. When we previewed the film, the head of Paramount was there, and he said, "One thing's for sure. That f———g song's gotta go." Audrey shot right up out of her chair! Mel Ferrer had to put his hand on her arm to restrain her. That's the closest I have ever seen her come to losing control.*

So much of who she was, of what made her unforgettable, cannot be put into words. So how did she affect people so profoundly? What chord did she touch?

Cecil Beaton, the brilliant photographer, visual consultant, and the power behind the entire look of *My Fair Lady,* wrote another famous appreciation of my mother in *Vogue,* November 1, 1954, in which he placed her in the context of Europe after the war.

> *It is always a dramatic moment when the Phoenix rises anew from its ashes. For if "queens have died young and fair," they are also reborn, appearing in new guises which often create their own terms of appreciation. Even while the pessimists were predicting that no new feminine ideal could emerge from the aftermath of war, an authentic existential Galatea was being forged in the person of Miss Audrey Hepburn. No one can doubt that Audrey Hepburn's appearance succeeds because it embodies the spirit of*

opposite Photograph by Cecil Beaton, circa 1953. Courtesy of Sotheby's London.

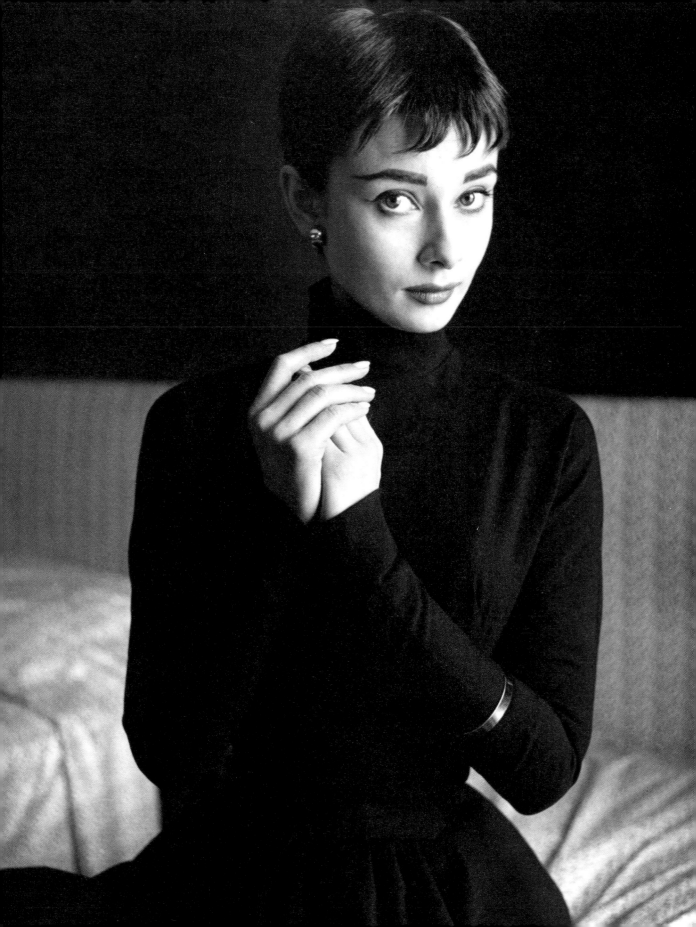

today. She had, if you like, her prototypes in France—Damia, Edith Piaf, or Juliet Greco. But it took the rubble of Belgium, an English accent, and an American success to launch the striking personality that best exemplifies our new Zeitgeist. Nobody ever looked like her before World War II; it is doubtful if anybody ever did, unless it be those wild children of the French Revolution who stride in the foreground of romantic canvases. Yet we recognize the rightness of this appearance in relation to our historical needs. And the proof is that thousands of imitations have appeared. The woods are full of emaciated young ladies with rat-nibbled hair and moon-pale faces. What does their paragon really look like? Audrey Hepburn has enormous heron's eyes and dark eyebrows slanted towards the Far East. Her facial features show character rather than prettiness: the bridge of the nose seems almost too narrow to carry its length, which flares into a globular tip with nostrils startlingly like a duck's bill. Her mouth is wide, with a cleft under the lower lip too deep for classical beauty, and the delicate chin appears even smaller by contrast with the exaggerated width of her jaw bones. Seen at the full, the outline of her face is perhaps too square; yet she intuitively tilts her head with a restless and perky asymmetry. She is like a portrait by Modigliani where the various distortions are not only interesting in themselves but make a completely satisfying composite.

Beneath this child-like head (as compact as a coconut with its cropped hair and wispy monkey-fur fringe) is a long, incredibly slender and straight neck. A rod-like back continues the vertical line of the nape, and she would appear exaggeratedly tall were it not for her natural grace. Audrey Hepburn's stance is a combination of an ultra fashion plate and a ballet dancer. Indeed, she owes a large debt to the ballet for her bearing and abandon in movement, which yet suggest a personal quality, an angular kinship with cranes and storks. She can assume almost acrobatic poses, always maintaining an innate elegance in her incredibly lithe torso, long, flat waist, tapering fingers and endless legs. With arms akimbo or behind her back, she habitually plants her feet wide apart-one heel dug deep with the toe pointing skywards. And it is more natural for her to squat cross-legged on the floor than to sit in a chair.

Audrey Hepburn is the gamine, the urchin, the lost Barnardo boy. Sometimes she

appears to be dangerously fatigued; already, at her lettuce age, there are apt to be shadows under the eyes, while her cheeks seem taut and pallid. She is a wistful child of a war-chided era, and the shadow thrown across her youth underlines even more its precious evanescence. But if she can reflect sorrow, she seems also to enjoy the happiness life provides for her with such bounty.

It is a rare phenomenon to find a very young girl with such inherent "star quality." As a result of her enormous success, Audrey Hepburn has already acquired the extra incandescent glow which comes as a result of being acclaimed, admired, and loved. Yet while developing her radiance, she has too much innate candor to take on that gloss of artificiality Hollywood is apt to demand of its queens. Her voice is peculiarly personal. With its unaccustomed rhythm and sing-song cadence on a flat drawl, it has a quality of heartbreak. Though such a voice might easily become mannered, she spends much time in improving its musical range.

In fact, with the passing of every month, Audrey Hepburn increases in dramatic stature. Intelligent and alert, wistful but enthusiastic, frank yet tactful, assured without conceit and tender without sentimentality, she is the most promising theatrical talent to appear since the war. Add to this the remarkable distinction she emanates, and it is not rash to say she also gives every indication of being the most interesting public embodiment of our new feminine ideal.

——"Audrey Hepburn by Cecil Beaton." *Vogue*, November 1, 1954

Cecil Beaton/*Vogue* © Condé Nast Publications

So it wasn't just the brilliant packaging or the simple yet moving themes of her films. It wasn't just the talented screenwriters and directors. It was also what the French wisely call a certain *je ne sais quoi* ("I don't know what") that came across in between the lines of good dialogue. It was the speech of her heart and the inflection of pure intentions.

She lived her life believing in the power of simplicity. Whether it had to do with fashion,

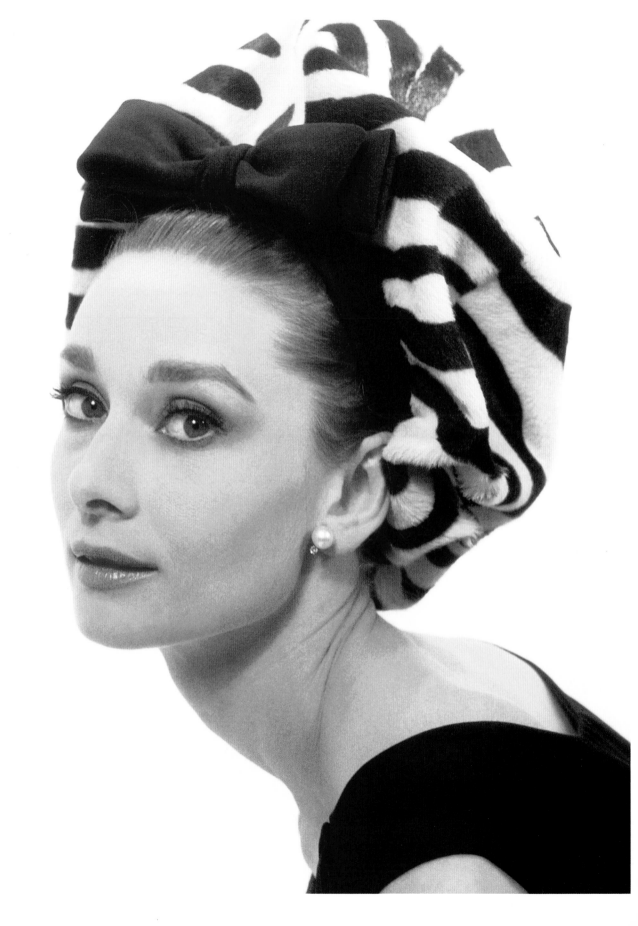

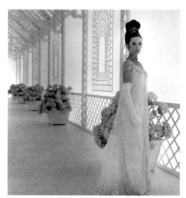

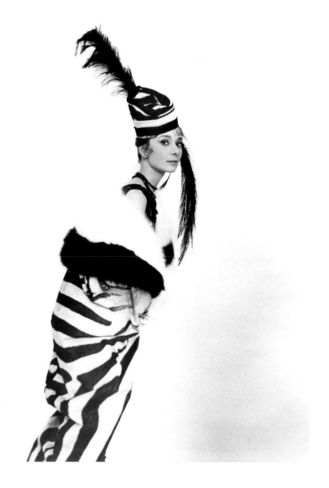

opposite Photograph by Cecil Beaton, 1964.
Cecil Beaton/© Condé Nast Archives/Corbis.

above *My Fair Lady*. Photographs by Cecil Beaton.
Courtesy of Sotheby's London.

below and opposite *My Fair Lady*, 1963, photographs by Cecil Beaton (wardrobe tests). Getting the role of Eliza Doolittle in *My Fair Lady* was a huge milestone in Audrey's career. Apart from the fact that it was a hugely successful musical, it meant so much to her to play this role that went from Cockney street urchin all the way to Mayfair grande dame. Being English, she knew those two characters so well and all of the nuances that came in between. It has often been suggested that Audrey's getting the role instead of Julie Andrews, who played it onstage, caused a rift between them that lasted a lifetime. Nothing could be further from the truth, since she enjoyed a lifelong friendship of mutual respect with both Julie and her husband, Blake Edwards, who directed her in *Breakfast at Tiffany's*. Julie Andrews hadn't been in any film up to that point, which is why the role was probably given to my mother. Nevertheless, Julie Andrews went on to star in *Mary Poppins* the same year and received the Best Actress Oscar for her role. Photographs courtesy of Sotheby's London.

90

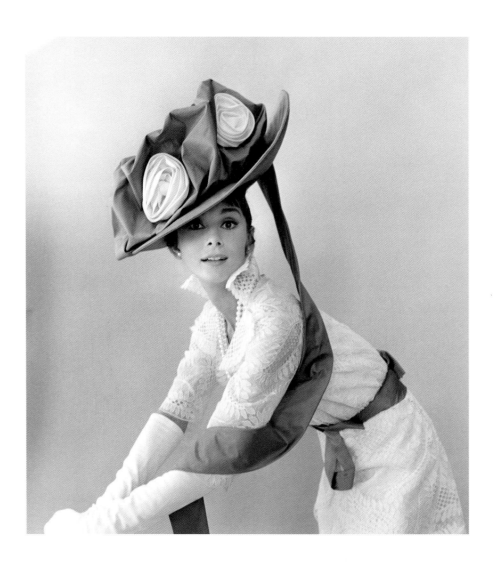

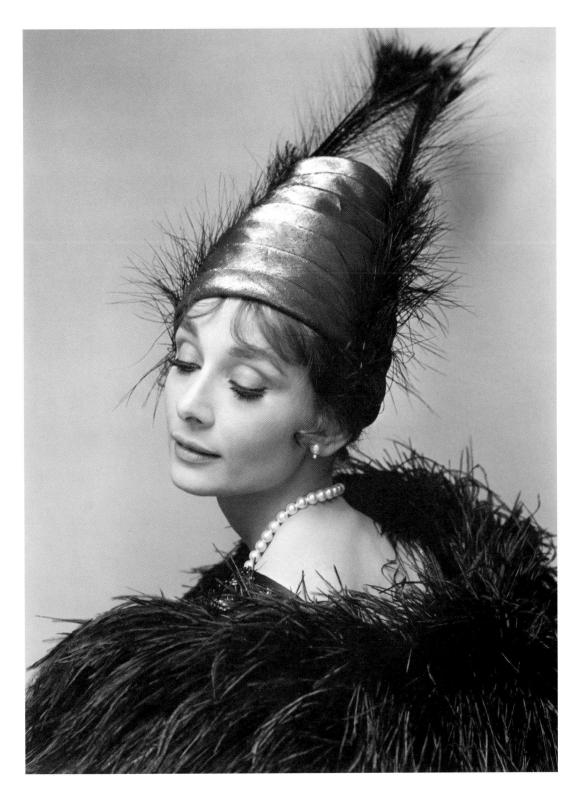

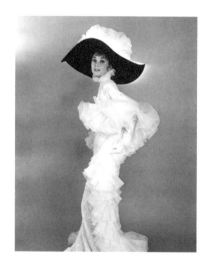 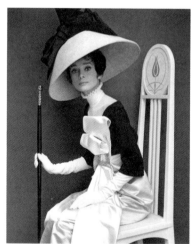

above *My Fair Lady*. Photographs by Cecil Beaton. Courtesy of Sotheby's London.

opposite Wardrobe portrait shoot, signed by Cecil Beaton. Cecil Beaton truly was a Renaissance man: In *My Fair Lady*, he created the "look," the sets, designed the costumes, photographed Audrey, later painted her, and then wrote about her—all of it beautifully! He also served as the art director and costume designer for the Broadway show. Courtesy of Sotheby's London.

To the best model any designer could ever have
& the most adorable human being. . .
Love from
her
devoted
Cecil.

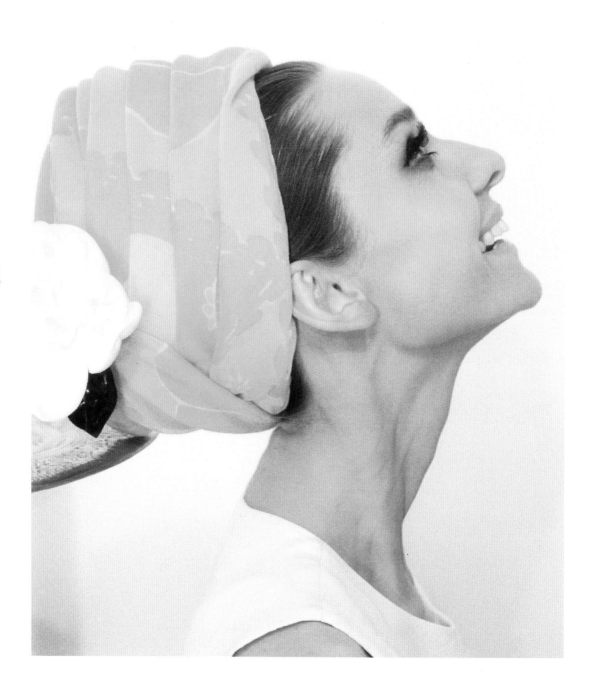

work, or relationships, she used to say, "Boil it all down to what counts the most: What is the essence of what you are trying to do, what is the most important thing? Things only get complicated when you are trying to address too many issues."

She even walked as if it were the most important thing in her life, so briskly that we had to learn to keep up. One day I asked her why she walked so fast. She answered, "I just want to get there." Later she said it was a reaction to her mother, who had always been a slow walker.

I remember telling her about a girl I was in love with. Unfortunately, the girl liked somebody else more, or maybe she liked both of us—a situation teenagers have gone through for centuries. She listened, thought about it, and then said plainly, "You better take care of your studies, because if they fail as well, you'll be twice as unhappy."

Her inner themes were always simple, and they brought everything back to basics: care. Be kind. Love. Yet it was also the way her soul gently whispered those emotions that brought it home.

It put us in touch with all we so carefully hide as we adjust to society, to life.

Of course, brilliant writing had to come first. In *Love in the Afternoon,* Gary Cooper, who plays a wealthy playboy, is leaving for his next conquest. They both have feelings for each other as they are saying good-bye at the train station. She puts forth a very convincing front to reassure him that she's equally as strong and independent as he is. As the train shudders forward and her eyes are now starting to well up with tears, she continues to describe in great detail all the other men who are pursuing her, and how they will be swooning at her feet, although we know perfectly well there are none. As the train picks up speed, she is now running on the platform, tears streaming down her face, the train so loud she's almost screaming as she keeps trying to convince him she'll be fine. By now, we all know she won't be.

Finally Cooper picks her up off the quay, and they embrace. The screenplay meant to do just that. But it was her readings of those precious lines of dialogue, her ability to envelop them with

95

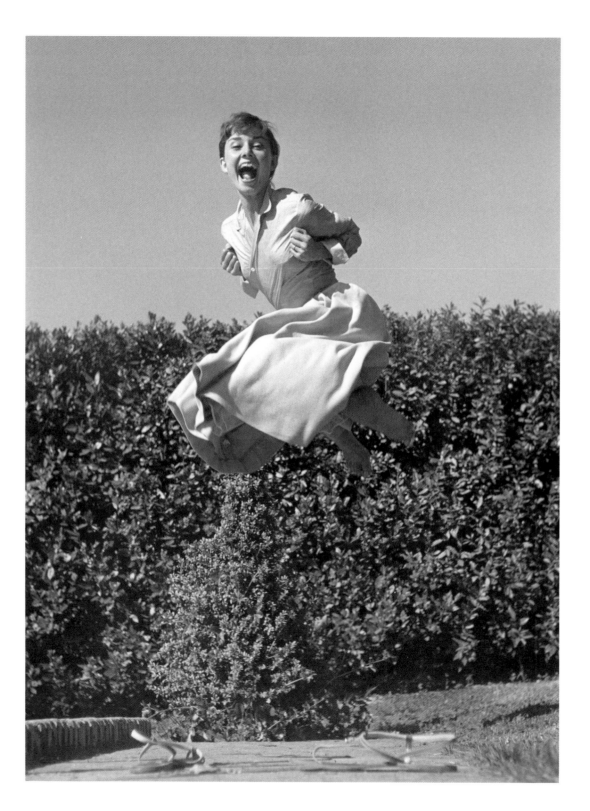

a shroud of vulnerability, that made the performance unique. It's all about how deep you are willing to dig, how much you are willing or able to expose.

She really wants him to go on and continue to be himself. She knows how the cookie really crumbles, yet she wishes for the world to be otherwise. It is the honesty of her good-bye intertwined with her struggle to hide her true desperate emotions that makes the scene work and the moment unforgettable. She finds a way to connect the imaginary story to a true and existing pain inside her. For that, you need a great script, a great director, and the muscle that knows how to connect to the real pain she knew, which lay right below her surface.

So it's that easy. If you live fully, it's all there, like the kind of view that brings tears to your eyes, the real symphony of life: hills and valleys, as far as the eye can see.

Although she was never an ardent follower of any formal religion, my mother's own faith endured throughout her life: her faith in love, her faith in the miracle of nature, and her faith in the goodness of life. She honored this second chance at life at every opportunity that presented itself and most of all at the end of her life, through her work for UNICEF.

Sometimes a near-death experience can free us of the shackles that life slowly trains us to wear. We come to realize what's worth the sweat and what isn't. Although she had no memory of her childhood near-death experience, the knowledge of it, coupled with the fertile ground of an already self-effacing nature, were the roots of the humility that graced her entire life.

I never heard her say, "I did this," or "I've done that." Toward the end of her life, throughout the UNICEF years, I would hear her say regularly, as the world listened to her, "I can do very little." I never heard her say that she liked any of her performances. When people complimented her, she would always shy away and ultimately explain how those who surrounded her were the reason for her success.

Bessie Anderson Stanley wrote, "To laugh often and much, to win the respect of intelligent people and affection of children, to earn the appreciation of honest critics and endure the betrayal of false friends, to appreciate beauty, to find the best in others, to leave the world a bit

better whether by a healthy child, a garden patch or a redeemed social condition, to know even one life has breathed easier because you have lived, this is to have succeeded." By Ms. Stanley's standards, my mother's life was a success: She was graced with good choices. The first choice she made was her career. Then she chose her family. And when we, her children, were grown and had started our lives, she chose the less fortunate children of the world. She chose to give back. In that important choice lay the key to healing and understanding something that had affected her thoughout her entire life: the sadness that had always been there.

Her choices healed the sadness of a little girl who didn't know her father for most of her life and yet who yearned and longed for that warm embrace, that reassurance that you are loved and that you matter. When I look back, that is just what she gave to Luca and me: the reassurance that we were loved and that we mattered. This was the most valuable essence, the roots that live and grow forever inside you. She truly was a wonderful mother and friend.

THROUGH MY FATHER'S VIEWFINDER

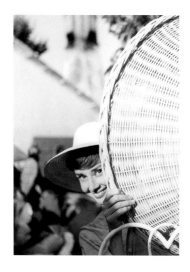

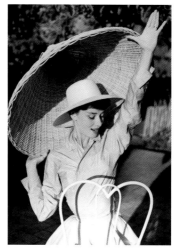

bottom left, center, and opposite "La Vigna" circa 1955. Switzerland. Photographs by Mel Ferrer.

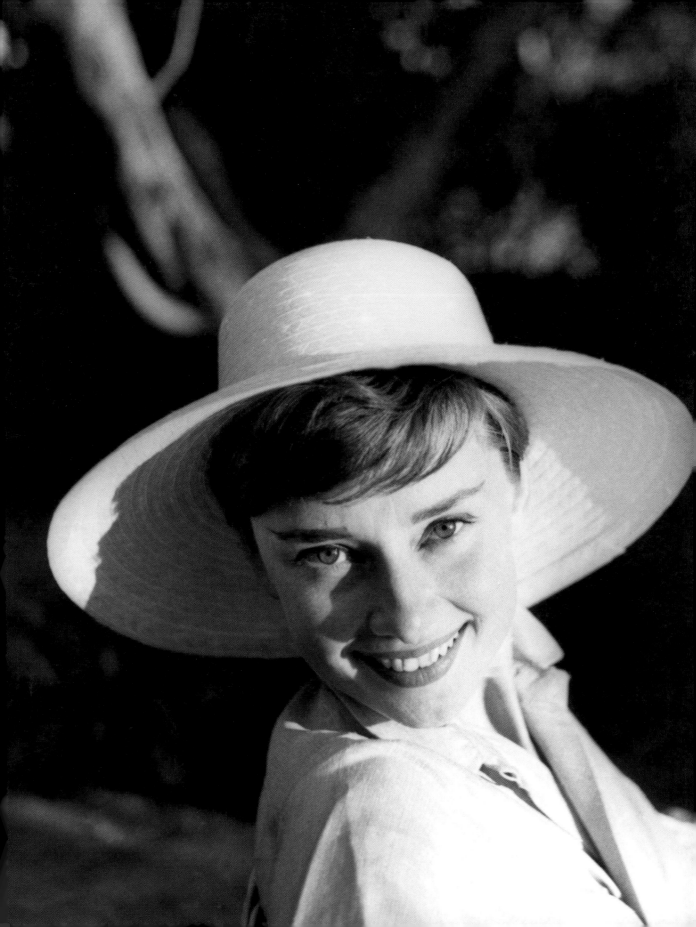

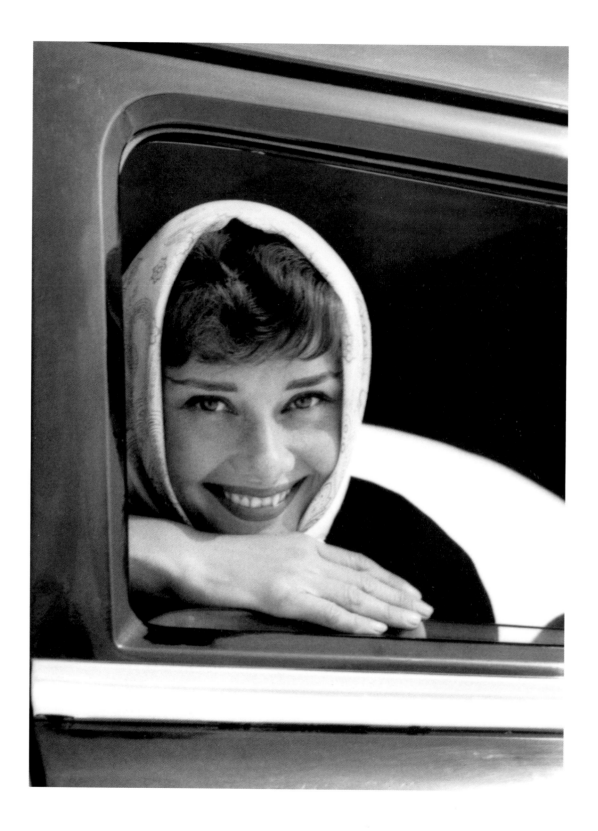

opposite 1954: St. Moritz, Switzerland: My mother was exhausted by years of nonstop work and a worsening asthmatic condition, so my father whisked her away to the mountains. They ended up moving to Lucerne, Switzerland, where I was born. Photograph by Mel Ferrer.

below Circa 1957, with Otto Frank and his second wife, Bürgenstock, Switzerland. Photograph by Mel Ferrer.

My mother had been offered the role of Anne Frank, and after careful consideration she declined, feeling that going back to that place would be too hard. She felt akin to Anne Frank, whose life was "very much parallel" to her own.

"Anne Frank and I were born in the same year, lived in the same country, experienced the same war, except she was locked up and I was on the outside. [Reading her diary] was like reading my own experiences from her point of view. I was quite destroyed by it. An adolescent girl locked up in two rooms, with no way of expressing herself other than to her diary. The only way she could tell the change in season was by a glimpse of a tree through the attic window.

"It was in a different corner of Holland, but all the events I experienced were so incredibly accurately described by her—not just what was going on on the outside, but what was going on on the inside of a young girl starting to be a woman . . . all in a cage. She expresses the claustrophobia, but transcends it through her love of nature, her awareness of humanity and her love—real love—of life."

In March 1990, Audrey narrated portions of The Diary of Anne Frank as part of UNICEF's "Concert for Life: An American Tour for the World's Children," composed and conducted by Michael Tilson Thomas.

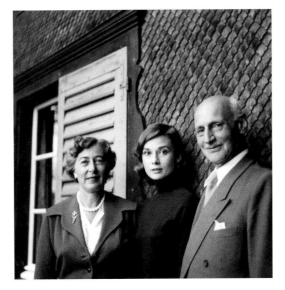

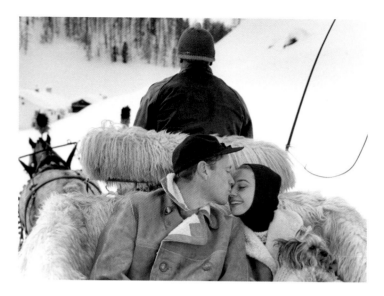

Christmas 1958
St. Moritz

top 1950s, Switzerland: My parents and Famous, her Yorkshire terrier, taking a ride on a horse-drawn carriage in the snow, near St. Moritz. Photograph by Sanford Roth. © 1978 Sanford Roth/MPTV.net.

left 1958: Famous. Photograph by Mel Ferrer.

middle 1958: St. Moritz. Audrey with her brother Ian; his wife, Yvonne; and their daughter. Photograph by Mel Ferrer.

right Christmas 1958: My parents, having fallen in love with Switzerland, spent another holiday in St. Moritz and began looking for a home. Photograph by Mel Ferrer.

opposite Photograph by Norman Parkinson, circa 1955. This was also shot at "La Vigna" during the production of *War and Peace*. © Norman Parkinson Ltd./Fiona Cowan.

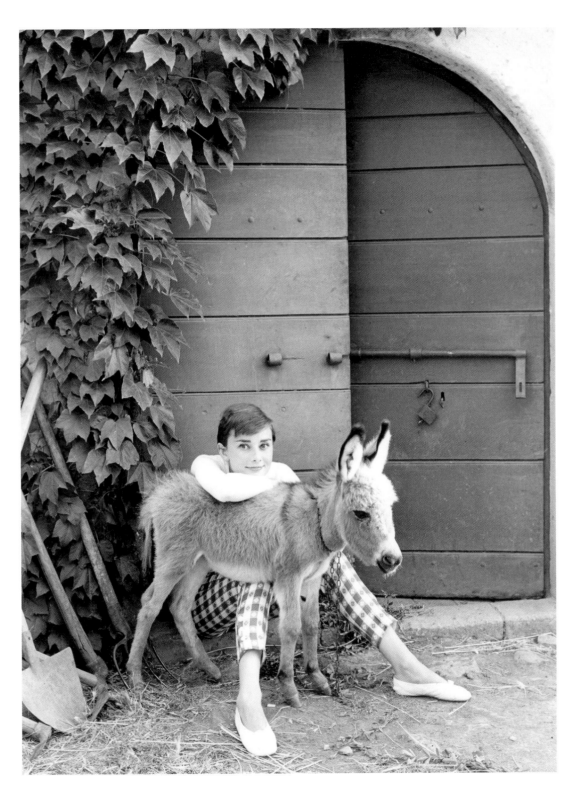

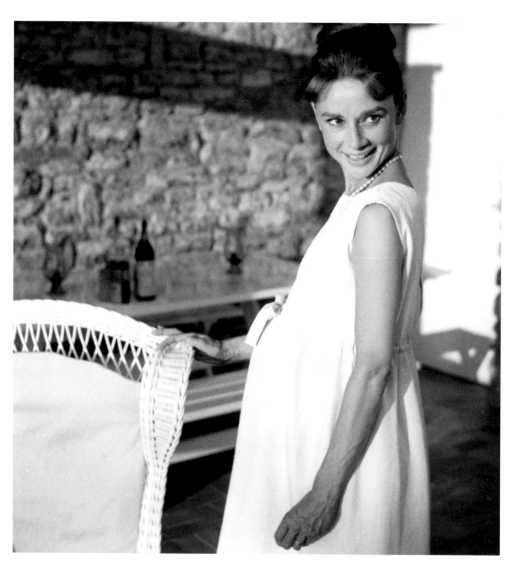

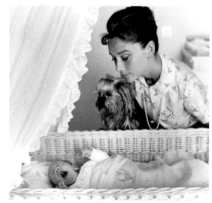

above Audrey, pregnant with Sean, 1960. There I am—in her tummy. Photograph by Mel Ferrer.

right and opposite 1960: my one and only Richard Avedon shoot. Photographs by Richard Avedon. © Richard Avedon.

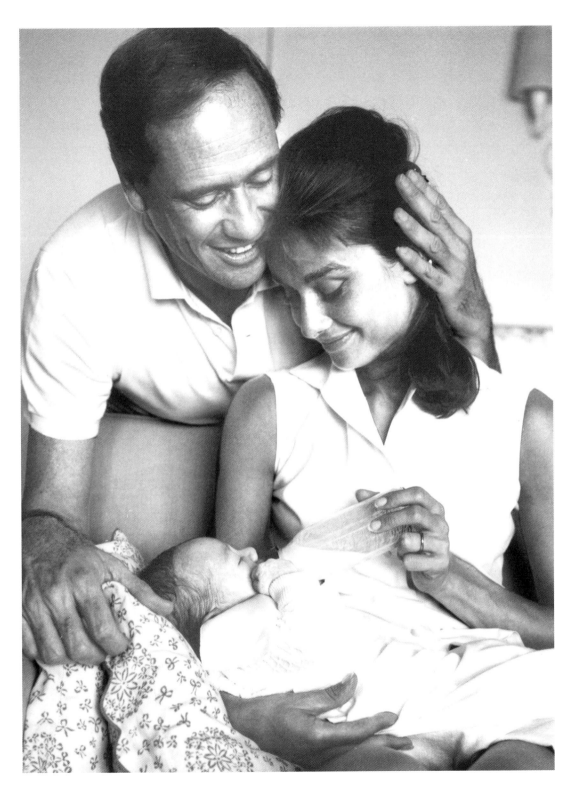

below left, right, and opposite bottom left With my mother at home in Bürgenstock, Lucerne, Switzerland, 1962. This was the home my parents lived in when I was born and where I grew up for the first three years of my life. The house was perched atop a peak overlooking the city of Lucerne and its lake. My room as well as Gina's, my nanny, were on the third floor. There was also a guest room where members of the family stayed when they visited. My parents' room was on the second floor right below mine. My father had rented the house for the fresh mountain air, to help my mother's asthma. Photographs by Pierluigi. Pierluigi/Reporters Associati.

opposite top At the circus with my parents, 1961. Photograph by Pierluigi. Pierluigi/Reporters Associati.

opposite bottom right Bürgenstock, Switzerland, 1962. Here I am, two and a half years old. I can remember those wonderful wooden sleigh rides down the snow-covered driveway that connected our home to the intersection with the main road, about a mile away. Photograph by Mel Ferrer.

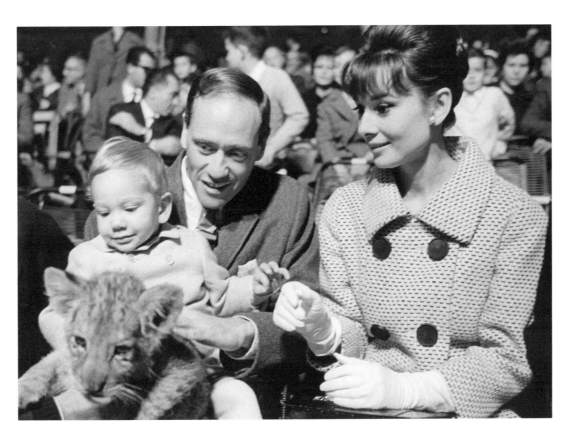

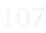

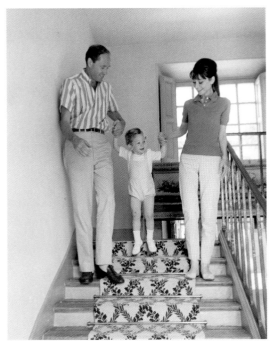

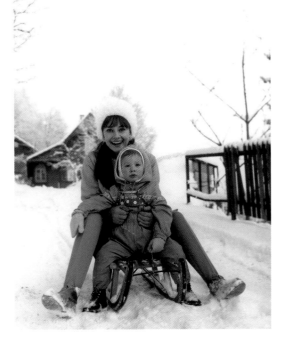

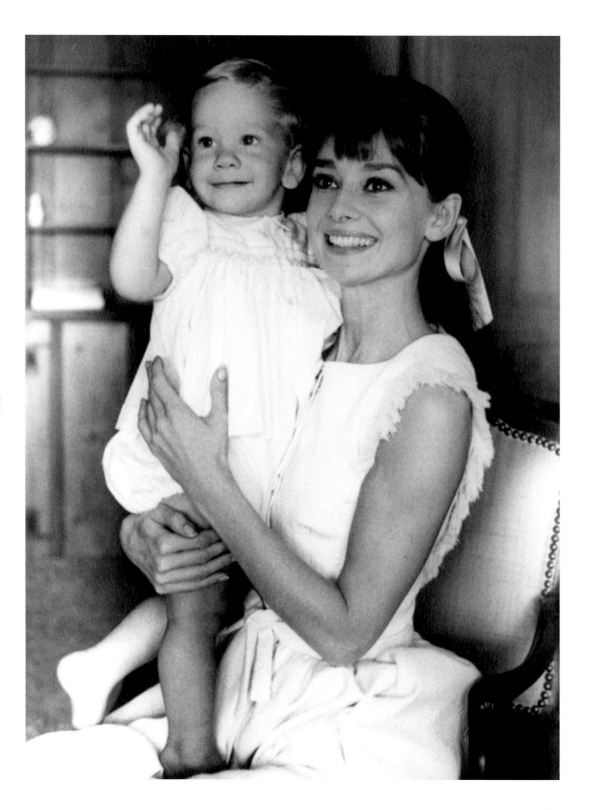

109

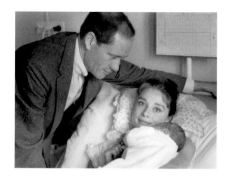

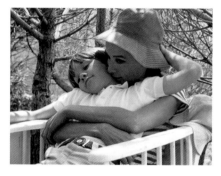

top Just born at Lucerne Hospital (my first pictures), July 1960. Photograph by Pierluigi. Pierluigi/Reporters Associati.

middle and bottom *Two for the Road*, 1965, location shoot in the south of France. These are my first memories of being on a set. I remember the beach. I remember my parents. I remember my first impression of being on a movie set, sitting on the camera dolly, spending time with the prop man in his truck as he showed me his amazing collection of props, which I perceived as a truck full of toys. I also have memories of Pierluigi, whom my mother called "Pierleone." They were good friends, and he was the only photographer allowed to take pictures in the hospital right after I was born. He truly was the family photographer. Photographs by Pierluigi. Pierluigi/Reporters Associati.

opposite 1961: Photograph by John Swope (with my dad). John was a dear friend of the family and probably one of the great and most underrated photographers of the last century. My parents were very close to him and Dorothy McGuire, his wife. John would appear in my parents' life and in my life in all the same places we vacationed and lived—in Switzerland, where they had a home, in Spain, where I spent time with my father, and in Rome, where I lived with my mother. © John Swope Trust/mptv.net.

above left Christmas shopping in Paris, 1962. Family photo.

above right Paparazzi would photograph us on the streets, then send prints to my mother. Photographer unknown. Audrey Hepburn Estate Collection.

opposite top With Dad at the circus in Rome, 1960s. Photograph by Roberto Bonifazi. Audrey Hepburn Estate Collection.

opposite bottom left My parents and me arriving at the Rome airport, September 5, 1964. Photograph by Domenico Esposto. Audrey Hepburn Estate Collection.

opposite bottom right At the circus, 1966. Photograph by Henry Pessar. Audrey Hepburn Estate Collection.

top 1963: Age three and a half, in Bürgenstock. Our last Christmas at Villa Bethania. Photograph by Mel Ferrer.

middle Marbella, Spain, 1964, at a *burrada*. A *burrada* is a picnic you take along on a burro ride. Photograph by Mel Ferrer.

bottom Spain: My mother and me with a baby goat. Photograph by Mel Ferrer.

opposite La Paisible, 1965: With Assam, her second Yorkshire terrier. Family photo.

top and opposite top 1960s. This is where I talk about Jessica Diamond, my friend and the photo curator for the Audrey Hepburn Estate Collection. She insisted this embarrassing series of pictures be included in this book: "These pictures say more about what kind of a mother she was . . ." I guess we just like to get dressed up in this family. Family photos.

opposite bottom April 1964: almost four years old. Family photo.

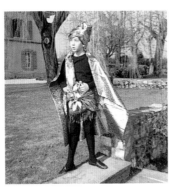

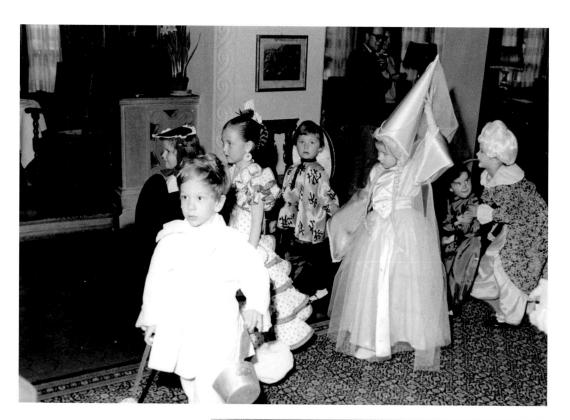

opposite top Dress-up kids' party, St. Moritz, Switzerland, 1964.

opposite bottom My first birthday party at La Paisible, 1965.

above "Santa Catalina," our home in Marbella, Spain, 1966. This was the last birthday party with both my parents there. My father named the house "Santa Catalina" after my mother's middle name, Kathleen.

Family photos.

121

opposite top and middle The island of Giglio,
Tuscany, circa 1969. Family photos.

above My mother at the 1968 Olympics in Grenoble,
France, with the ski team. Family photo.

opposite bottom Switzerland, circa 1970. Family
photo.

below With Connie Wald in Gstaad during her visit to Switzerland, 1967. Family photo.

opposite top With Connie Wald in the gardens of La Paisible, Audrey's home in Switzerland, 1967. Family photo.

opposite bottom left Picking flowers at La Paisible, 1965. Photograph by Mel Ferrer.

opposite bottom right Audrey in Rome. I especially like this series of photographs. It's very 1970s, yet it captures her the way I knew her for most of my youth. Photographer unknown. Audrey Hepburn Estate Collection.

top My mother and Andrea Dotti's wedding. Family photo.

bottom Audrey with Andrea Dotti. Photograph by Henry Clarke, 1971. Henry Clarke/*Vogue* © Condé Nast Publications.

opposite Audrey's wedding to Andrea Dotti in Morges, Switzerland, January 18, 1969. This photo was taken right after the wedding; I'm standing only a few feet away to the right. The newlyweds are standing in the doorway of city hall in the small town of Morges, only five minutes away from La Paisible in Tolochenaz. Photograph by Marcel Imsand.

124

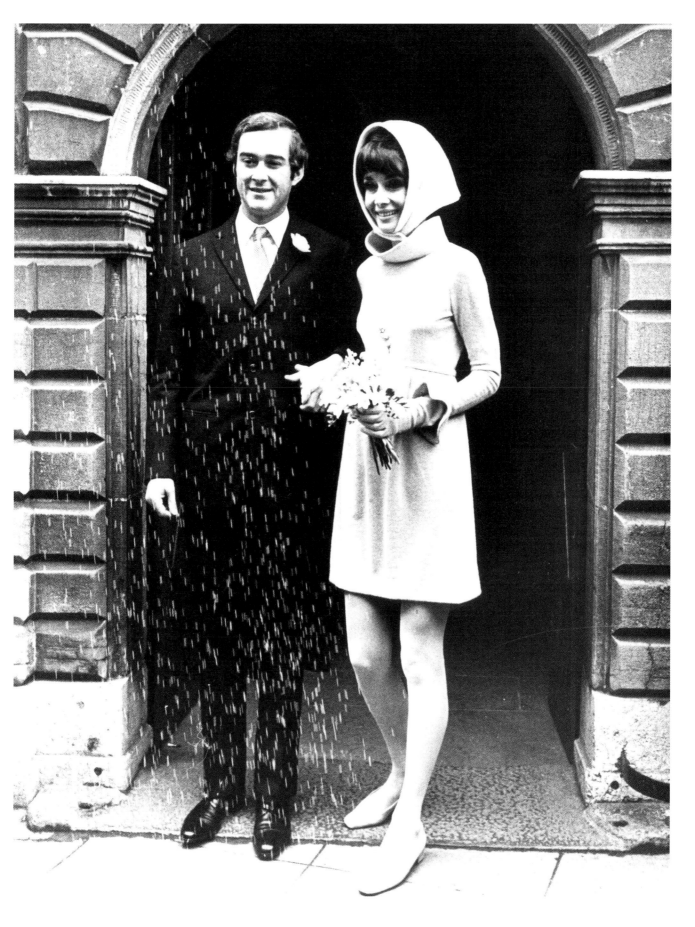

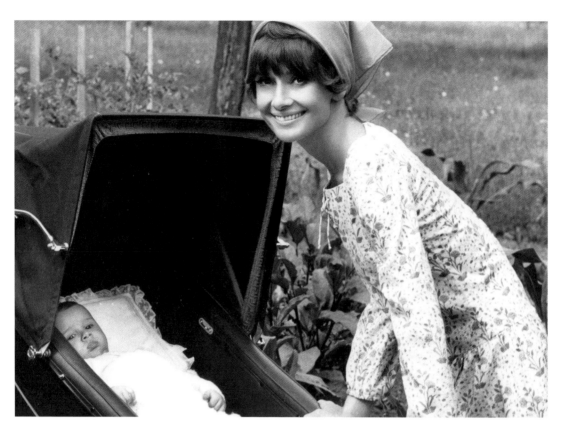

opposite top With my little brother, Luca, in his pram in the yard of La Paisible, Switzerland. Photograph by Henry Clarke, 1971. Henry Clarke/*Vogue* © Condé Nast Publications.

opposite bottom Rome, April 1971: Luca has just turned one year old. The picture on the left was taken right before we went to a costume ball at the French Embassy. Family photos.

below With Luca at three and a half months old, April 1970. Family photo.

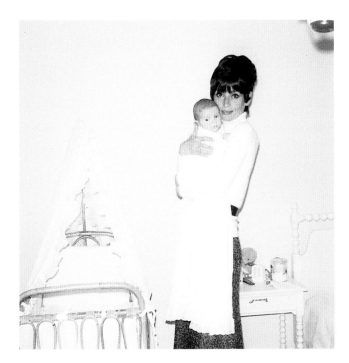

top Andrea Dotti and me playing Battleship on the floor of our first apartment in Rome, November 1969. Family photo.

middle Playing with Luca, age three and a half, at our apartment in Rome, November 1973. Family photo.

bottom With my mother and Andrea in Rome on a Sunday at the flea market. Photographer unknown. Audrey Hepburn Estate Collection.

opposite top Audrey kept this 1979 picture of myself and Luca on the wall of her bedroom. Family photo.

opposite bottom With my mother and Luca on holiday in Florida, where most of Robby's family lives, May 1987. Photograph by Marina Spadafora. Family photo.

128

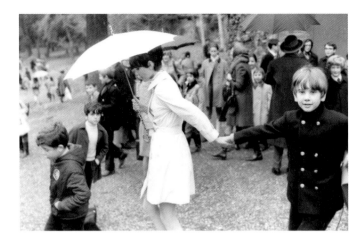

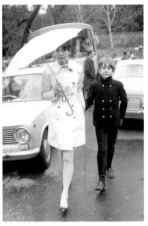

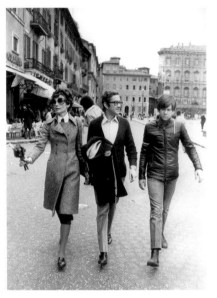

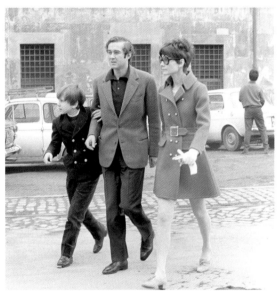

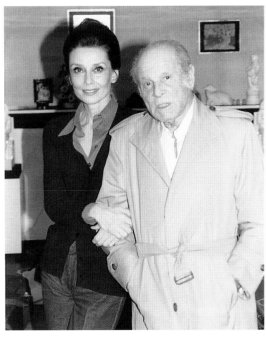

131

I am often asked what it was like to have a famous mother. I always answer that I really don't know. I knew her first as my mother and then as my best friend. Only after that did I understand that she was an actress and, with time, that she was truly an exceptional actress. Only after she passed away did I realize to what an extent she had truly touched our world. The outpouring of affection and the constant remembrances that she inspires indicate that the work she dedicated herself to confirmed for everyone that the twig they had fallen in love with years before had grown into a beautiful tree. She was indeed worthy of all their affections.

We grew up as normal kids; we didn't grow up in "Hollywood," not the place, not the state of mind. Our mother never watched her own films. Once they were done, that was it. So we weren't a "show biz" family at all. I didn't grow up surrounded by filmmakers, and I didn't play and go to school with their kids.

top With Connie Wald at her home in Beverly Hills, 1980s. Family photo.

bottom Audrey with her best friend Connie Wald at Connie's house, my mother's "home away from home." Family photo.

opposite Backstage at an awards ceremony, early 1980s. I am keeping her company prior to her going onstage. Photographer unknown. Audrey Hepburn Estate Collection.

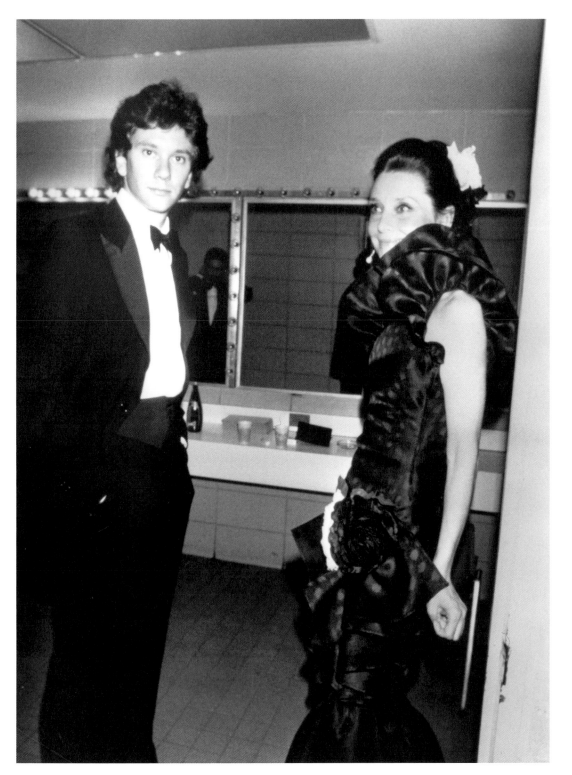

opposite April 1971: This shoot was done in the garden of La Paisible, with my cocker spaniel, Cokey, named because he was black as coal, or "coke." Photograph by Henry Clarke. Henry Clarke/*Vogue* © Condé Nast Publications.

top With Robby Wolders, 1989. Family photo.

bottom My mother, Robby, and I at Connie's, 1984. Family photo.

below On holiday with Robby in Mauna Kea, Hawaii, 1988. Family photos.

opposite top Greta Hanley, my mother's nanny, holding two-year-old Audrey in 1931. Over fifty years later she was able to track my mother down in 1988 because of her work with UNICEF. She had heard that my mother was coming to Dublin and showed up at the hotel. Upon hearing Greta was there, my mother rushed through the crowd and into her arms. They were both elated. Dublin, Ireland, 1988. Family photos.

opposite bottom The picture of my mother I keep next to my bed. Family photo.

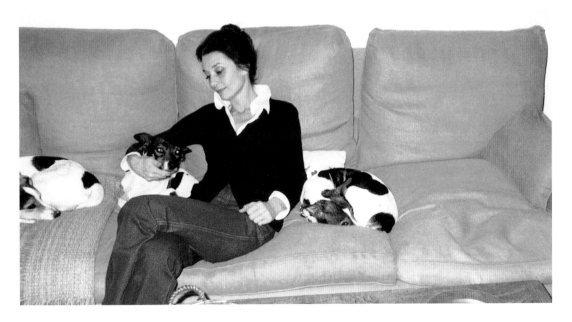

I spent the first years of my life in Switzerland, going to our little village school. My friends were the sons and daughters of farmers and schoolteachers. There was an orphanage down the road, and those children were my friends too. I remember being awakened in the middle of the night by one of my school chums. One of his father's cows was giving birth. I can still feel the cold air whipping my face as we ran, in the middle of the night, under the train tracks to catch this most wonderful event. Another friend, my best friend, lived in the house whose garden touched ours. We carved a passage through the hedge and spent hours in his attic playing with an old train set that had been built by his father and then perfected by his older brother.

When we moved to Rome, I attended the French Lycée Chateaubriand. My friends there were the children of normal people. My mother would pick me up from school every day. There were photographers sometimes, but they had always been there. At first the other kids called me the "actorette," but when they figured that, being the tallest in my class, I made a pretty good soccer goalie, all that changed. I guess it never bothered me, and I never really stopped to think why the paparazzi were always present. Like all children, I thought my mother was beautiful too and that it was okay for them to take her picture. And beautiful she was, inside and out and through and through.

She stopped accepting films when I had to go to school and I couldn't travel to the set to visit her. She did the same after I left home to go to boarding school, when my brother Luca started school.

"I had to make a choice at one point in my life," she said in March 1988, "of missing films or missing my children. It was a very easy decision to make because I missed my children so very much. When my elder son started going to school, I could not take him with me anymore, and that was tough for me, so I stopped accepting pictures. I withdrew to stay home with my children. I was very happy. It is not as if I was sitting at home, frustrated, biting my nails. Like all mothers, I am crazy about my two boys."

How I loved it when she would take me to buy schoolbooks or to shop for socks. I took it for granted then. I don't now.

She truly was my best friend.

And the wonder of it all is that she let me know that I was hers as well.

above In 1977, we were living in our second apartment in Rome in the Parioli area. This would have been shot in the morning, since Audrey is still wearing her *liseuse* over her nightgown. In the background are the curtains to her bedroom. Photograph by Elisabetta Catalano. © Elisabetta Catalano.

Up until the time she visited some of the most war-ravaged countries in Africa for UNICEF, my mother's saddest memories were of the loss of her father and three pregnancies.

She told us how she felt pangs of emptiness at the sight of other children in their fathers' arms, how she wished he were there so she could be like the others. Yet she always hoped he was alive, out there, somewhere. As a child, she couldn't let go of that profound and natural desire. This is also why, after her divorces to both my father and my brother Luca's father, she did all she could to ensure that we continued to enjoy a complete relationship with both.

She also spoke soberly of her miscarriages and of the pain they brought. It was a pain she had never felt before: "That was the closest I came to feeling like I was going to lose my mind."

From the time she was a little girl she had always loved children: "What I always had," she said, "and maybe I was born with it, is an enormous love of people, of children. I loved them when I was little, and I used to embarrass my mother by trying to pick up babies out of prams at the market. . . . The one thing I dreamed of in my life was to have children of my own. It always boils down to the same thing. Not only receiving love, but wanting desperately to give it . . . almost needing to give it."

Having children was for her one of the great joys of her life, an opportunity to heal her own childhood. So it made perfect sense that later in life, when "donor fatigue" had become common humanitarian jargon, she spoke out on behalf of the less fortunate children of the world: "Donor fatigue and compassion fatigue just cannot apply to the monumental suffering in the developing world today—the only true fatigue is that of a mother seeing yet another one of her babies die." There is no doubt in my mind that, were she given one more day, among us, after spending the first few seconds hugging us, she would again talk about those children.

It was Robert Wolders, the man she spent the last twelve years of her life with, who first introduced the subject of UNICEF.

They went to Macao in October 1987 for a concert to benefit UNICEF at the request of Leopold Quarles Van Ufford, my mother's cousin and the former Dutch ambassador to Portugal. She wrote and delivered a beautiful speech. Immediately recognizing her natural connection to the children, James Grant, the executive director of UNICEF at the time, approached her and offered her the ambassadorship and $1.00. She left for her first trip in April 1988.

UNITED NATIONS NATIONS UNIES

New York

LETTER OF APPOINTMENT

To: ___Ms. Audrey HEPBURN___

You are hereby offered a FIXED–TERM APPOINTMENT in the Secretariat of the United Nations, (United Nations Children's Fund), in accordance with the terms and conditions specified below as amended by or as otherwise provided in the relevant Staff Regulations and Staff Rules, together with such amendments as may from time to time be made to such Staff Regulations and such Staff Rules. This appointment is offered on the basis, inter alia, of your certification of the accuracy of the information provided by you on the personal history form. A copy of the Staff Regulations and Staff Rules is transmitted herewith.

1. Initial Assignment

Title: UNICEF Goodwill Ambassador

Category: Professional Level: Assistant
 Secretary-General
Division: Office of the Executive Section:
 Director
Official Duty Station: New York

Assessable Salary: ___ --- ___ , which after United Nations assessment gives an

approximate net salary of ___$1.00___ per annum.

Effective Date of Appointment: 9 March 1988

2. Allowances

The salary shown above does not include any allowances to which you may be entitled.

3. Tenure of Appointment

This temporary appointment is for a fixed term of two years/23 days from the effective date of appointment shown above. It therefore expires without prior notice on the ___31st___ day of ___March___ , ___1990___ .

A Fixed–Term Appointment may be terminated by the Executive Director of UNICEF prior to its expiration date in accordance with the relevant provisions of the Staff Regulations and Staff Rules, upon 30 days written notice.

FIXED-TERM APPOINTMENT
UNICEF 98/A (8–80) – E.

Should your appointment be thus terminated, the Executive Director will pay such indemnity as may be provided for under the Staff Regulations and the Staff Rules. (The normal expiration of the appointment at its term does not require the payment of any indemnity). There is no entitlement to either a period of notice or an indemnity payment in the event of summary dismissal for serious misconduct. The Fixed–Term Appointment does not carry any expectancy of renewal or of conversion to any other type of appointment in the Secretariat of the United Nations.

4. Information Note

Your particular attention is drawn to the Staff Rules relating to the Staff Assessment Plan and to the Regulations and Rules relating to the United Nations Joint Staff Pension Fund.

5. Conditions of Service

Your particular attention is drawn to Staff Rule 109.1 providing that if the necessities of the service require abolition of a post or reduction of the staff, staff members specifically recruited for the United Nations Children's Fund have no entitlement under this rule for consideration for posts outside that agency.

___29 March 1988___ _James P. Grant_
 DATE THE EXECUTIVE DIRECTOR

To: Director, Personnel and Administration, United Nations Children's Fund

I hereby accept the appointment described in this letter, subject to the conditions therein specified and to those laid down in the Staff Regulations and the Staff Rules. I have been made acquainted with these Regulations and Rules, a copy of which has been transmitted to me with this letter of appointment.

___15 April 1988___ _Audrey K. Hepburn_
 DATE STAFF MEMBER

above Audrey's contract with UNICEF, dated April 15, 1988.

"I came from Ethiopia feeling exhilarated and optimistic," she said after her first trip. "I went with so many people telling me how harrowing and dreadful it would be to see the extent of the suffering, the death, and the despair. Certainly, I saw children in an advanced state of malnutrition, although they are not dying in masses as happened before. But I also witnessed how much is being done to help and how just a small amount of aid can assist in treating the sick, irrigating the land, and planting new crops. I came to realize that Ethiopia's problems are not insolvable if only the world will give a little more."

"If people are still interested in me," she said in 1988, "if my name makes them listen to what I want to say, then that is wonderful. But I am not interested in promoting Audrey Hepburn these days. I am interested in telling the world about how they can help in Ethiopia, and why I came away feeling optimistic."

She did. And it lasted for a while. She could see the light at the end of the tunnel. But then came Somalia. Nothing could prepare her for that. Nothing.

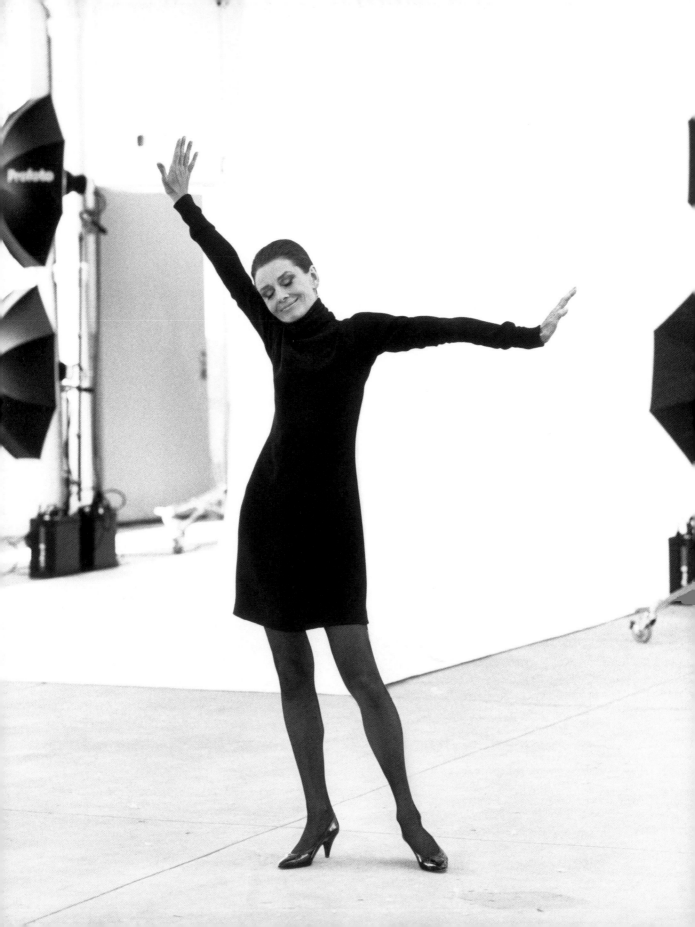

CHAPTER 4 ONE OF THEM

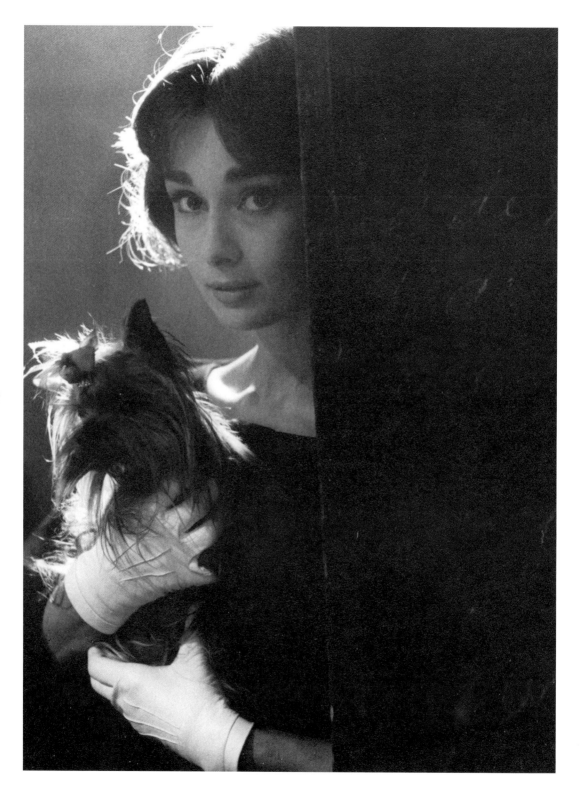

Audrey had been complaining of stomach pains since her return from Somalia.

Her Victorian upbringing prevented her from telling my brother Luca and me, but Robby was aware of it, and they went to see a few specialists in Switzerland. The results were inconclusive, and so she decided, since she was coming to Los Angeles in October 1992, that she would look into it further at that time.

She looked tired and tense as I watched her walking up the ramp of the international terminal at the LAX airport. This was a woman who didn't believe in traveling first class. Once in a while Robby and she would buy each other business-class airfares as a special gift, to go on holidays or for that additional UNICEF trip. But throughout our youth she had traveled economy all over Europe. She felt that in a day and age when so many people were going hungry, it was inappropriate to fly first class. In the same way, she felt that a car shouldn't be anything more than safe and reliable transportation, and so we owned a series of Volvos and Audis.

My mother didn't drive. Although not all mothers drove in the 1970s in Rome, I had to ask why. It seems that my father had given her a brand-new Thunderbird in the 1950s soon after she got her license. One day, as she was driving herself back from the studio, a woman rear-ended her. Although fully aware that she was in the wrong, the woman became very aggressive.

My mother got home and told my father, and he became incensed. When the woman found out who my mother was, she sued, hoping to embarrass her into a settlement or at least into

not pursuing her rights. The combination of everything—the fear, the disappointment, and the anger this had spurred in everyone—made her decide to sell the car and never drive again. She felt that driving was something that required a certain aggressive trait she didn't possess, and that she therefore would never be very good at it. That was certainly true of driving in Rome or Paris.

By 1992 my mother's work for UNICEF, which was now going on to its fifth year, had become very strenuous. The schedules were grueling. In some cases, since the airfares were donated, my mother and Robby would have to make numerous stops on the way to a destination in a developing country. This would make the journey longer, although Robby looked at it as a way to break up the trip and lessen jet lag. Subsequently they would travel to developed countries, where she would give interviews, talking about everything she had seen and learned, make appearances, and join in UNICEF's fund-raising efforts. They did this all several times a year, with a few weeks' break to recover from jet lag, and then back on the road.

How often we heard the horror stories, looked in her eyes, and saw the disappointment at the way our society was treating its future generations! Someone once asked her why she worked so tirelessly on behalf of the less fortunate children of the world when so much of the pain and sorrow was being created by the political war machines of emerging governments or rebel factions. Her answer was always the same: "It's as if you are sitting in your living room and you hear that terrible sound of screeching tires followed by a thump. Your heart is pounding as you run out to the street and find that a child has been hit by a car. At that moment you don't stop and wonder whose fault it is—was the driver going too fast, or did the child run after his ball? You just pick him up and run all the way to the hospital." She kept it that simple.

We had talked on the phone, as we did at least once a week, upon her return from Somalia, and I felt for the first time in my life a chilling and dark cloud enveloping her voice. She said, "I have been to hell and back." I wanted to know more, but she said we would talk about it when she arrived in Los Angeles.

What my mother saw in the faces of those millions of Somali children was what the selfish needs of a few were doing to their future. The toughest thing about Somalia was that there was

no infrastructure. In countries like Vietnam, she had been able to dream of the day when the hospitals, the schools, and their roads would be rebuilt. But Somalia, once you left Mogadishu, its capital, had no schools, no hospitals, and no roads.

She spoke once of peace as something that we should study. "We have ways to study war. We even teach it in universities. Wouldn't it be wonderful if there was a place where we could learn how to create and preserve peace? A university of peace."

Every Christmas, when the family reunited, she would tell us about her trips and the children, the interviews and how nervous she had been when she had to address the U.S. Congress: "They were charming," she said of the congressmen, "and it was not easy to field some very difficult, unexpected questions about Ethiopia, dealing with the political situation, over coffee and grapefruit—but I was very gratified to hear that after this meeting the United States had augmented funds for Ethiopia."

Of course she would never take any credit for it, so it was Robby who would fill in the blanks: "That simple appearance in front of the United States House of Representatives," he said, "added sixty million dollars to this year's budget." And we would listen with pride. When it was over, we realized that she had yet again put a whole year of her life into this extraordinary cause. But we also saw how tired she was, and asked gently, "When are you going to take a break?" We knew we couldn't ask her to stop, but we hoped that she would take some time to enjoy the fruit of her hard work.

It wasn't to be.

The doctors in Los Angeles put her through another battery of tests and, finally, yet again coming up with the same inconclusive results, they advised that an investigative laparoscopy was in order. We checked her into Cedars Sinai, and the surgery was performed on November 1, 1992. After two hours, the surgeon came out to the waiting room and told us that they had found abdominal (or "abominable," as she would later say, making light of it) cancer that had spread from the appendix.

No one had been able to detect it because the appendix cannot be reached endoscopically; its angle is too sharp, and you cannot see what is just around the corner. This useless little appendage we still know so little about was killing her. Is the appendix where our perfect body

stores all of the tiny things that cannot be digested, or is it a place for the soul to collect all the hurts that it cannot digest?

The cancer had grown slowly, maybe for as long as five years. It had no mass, yet it had metastasized as a thin veil, encasing her intestines. We were told that treatment was appropriate and in some cases could lead to remission.

The pain she felt was caused by a strangulation of the ileum, the small intestine, which was causing it to spasm as the passage of nutrients became more and more difficult. They removed about a foot of intestine and sewed her back up.

Nothing made sense. But we pulled it together and went into the recovery room. As we told her the news, she paused and then quietly said that she knew all along it had to be something more serious than a bug she might have caught in Somalia, for which she had endured a treatment of Flageol, one of the most powerful and destructive antibiotics available. She made me promise never to let anyone ever talk me into taking it.

After having helped to feed millions of children, there she was: unable to eat, herself. To allow time for her to heal, they had to put her on TPN (total parenteral nutrition), a yellowish liquid that provides basic sustenance and is fed to you intravenously so that your digestive system can heal.

She had described to us the basic corn and rice flour meal that UNICEF provides the millions starving in those camps. We had also seen photos of the children in Africa who, on the verge of death, are put on an IV drip because of severe dehydration.

She was now one of them.

We had to wait for the scar to heal before she could receive her first treatment of chemo. We, the family, would take turns during the day: I would usually visit her in the morning and then go to my office under the pretext of work that needed catching up. There I would spend hours reading, researching, and calling every cancer center for the latest treatment or information available. Unfortunately, I was soon faced with the intolerable reality that the only treatment was a particular chemotherapy—5FU Lucovoril—which had been used since the 1960s. Suddenly the 1960s felt like the middle ages.

After a week we brought her "home"—the home of her best friend Connie Wald, where she would stay whenever she came to Los Angeles.

Connie and my mother met when Audrey first came to Los Angeles after shooting *Roman Holiday*. Connie was then married to Jerry Wald, one of the most prolific and creative film producers and executives of all times. They had been friends forever. We would regularly gather there for wonderful family dinners, after which they would usually wrestle over who would do the dishes. Connie called my mother "Ruby," as though she was this insufferable despotic old maid from the *Upstairs, Downstairs* television series who had been with the family for too long. Mother would plead that a good houseguest should at least have the right to do the dishes. They cooked together, laughed a lot, and loved each other to death. This truly was her home away from home. But this time, coming home had a very different meaning. What a blessing it was to have a haven in this grave moment, a friend who made her chicken soup from scratch!

The day came for the first treatment, and it all went well: no side effects. She was to have her next one in a week, but it wasn't to be. A few days later she had another occlusion. It caused a pain so severe that the postsurgical pain medication she was receiving had become insufficient. We'd had but a few days of hope, careful walks by the pool and nights of watching television, all of us sitting on the floor around her bed, watching comedies, like the British series *Fawlty Towers* and nature shows on the Discovery Channel. She spoke of how much she enjoyed them. They reassured her that the miracle of nature was still well and alive and that life, with its beautiful simplicity, would continue no matter what.

The doctors wanted her back in surgery ASAP.

December 1, 1992, was the hardest day of my life. We were preparing to take her back to the hospital, and as everyone rushed around, carrying out their respective duties, we had a moment alone in her bedroom. I was helping her to get dressed when it all rushed to the surface and flooded her. She turned around and, with tears in her eyes, hugged me desperately and sobbed once or twice. As I held her tight, she whispered, "Oh, Seanie, I'm so scared." I stood there, holding her with all my might, as I felt huge chunks of me falling inside.

I reassured her that it was going to be all right, promised that we were going to see this through together, that I would tell her if I thought that things got desperate . . . to take courage,

because we weren't there yet. This is the only time my mother ever let me see how truly scared she was. As a young boy I had spent hours with her discussing the nature of relationships, of love and life. We were truly friends. We both knew when something was wrong with the other. We were blessed with a spiritual umbilical cord. They say that at some point in our lives we become the parent to our own parents. I had always envisioned it as parents becoming too old and senile to take care of themselves. This was not the case.

We both knew that the future was not bright, but the resiliency of our spirits kept us looking forward, hoping, trusting, like children who are told they will feel better in the morning. We drove to Cedars in my 1973 white Buick Centurion convertible. The paparazzi had been stalking the house for days.

Paparazzi had been a part of our life for as long as I can remember. Whether we went out for dinner or on a weekend, if she picked us up from school or went shopping, especially in Rome, they were there. I still remember driving to Sunday lunches in the back seat of my stepfather's car, looking out the rear window as he tried to lose them through the maze of Roman streets. I'll never forget the time that she took me to the Spoleto Festival, a classical ballet and theater festival in a charming medieval town on the border of Tuscany and Umbria. I had just returned from my first job on a film. During the production, which had kept me employed for almost a year, I had grown a beard. I guess I didn't want everyone to know that I was only eighteen. So the paparazzi caught up with us in Spoleto and got a few snaps of us hurrying in to an evening performance. The next day the picture was printed in the papers with the following headline: AUDREY CON IL NUOVO AMORE DELLA SUA VITA ("Audrey with the new love of her life"). When we saw it, we both laughed, realizing that they had no idea who I was. She said, "Well, apart from the 'NEW,' for once they got something right." She cut it out and framed it.

Apart from this incident, Audrey cringed at the constant intrusions of the paparazzi into her personal life. She knew how to deal with them, but she felt as though it was her fault that they were there and therefore her fault if they invaded our lives. Nevertheless, she always remained gracious, polite, and respectful to them.

The tabloids had been full of those desperate headlines announcing gloom and doom before we even knew how serious the cancer really was. Fortunately, we were successful in keep-

ing the press away from her. How could they know what only a few people in the operating room suspected? How did they know details even the family hadn't been told? On that morning we drove in my car because we figured that they would never believe that Audrey Hepburn would travel in such an old—albeit charming—gas-guzzling fossil. And we were right. She lay down in the back so that all they could see was my wife and me when we pulled out of the driveway. It worked; they didn't follow us.

And so we again waited on that afternoon of December 1, 1992. This time the surgeon called us in to the prep room adjacent to surgery. It hadn't even been an hour. He said the disease had developed exponentially. There was nothing he could do. He had to sew her back up. It was going to go rather quickly now. The words were melting in his mouth, the walls went soft, everything slowed down. Robby uttered, "Such a valuable human being."

I could taste a dry loneliness slowly creeping up my throat. She was probably waking up by now. I took a deep breath and went into the recovery room. She looked peaceful. It was over. She was never afraid to die; she just didn't want to be in pain unnecessarily. We had made a pact early on. I would always make sure that the pain would be controlled. I sat on the bed. She looked up and smiled and told me that some crazy lady had come and woken her up to know if she wanted to vote. Bill Clinton was winning. I remembered that only a few hours ago—or was it a few days?—I had worried about whether he was going to make it or not. She told the lady that she wasn't an American and therefore couldn't vote. A teaching doctor and his class had dropped by as well, and she had woken up again to a room full of youngsters ogling at her incision.

Hospitals have truly become a place of mayhem and confusion. I felt the blood pumping in my throat. But this wasn't the time for anger.

So I told her: I told her what the doctor had told us, that it was all too irritated to operate. She looked away and calmly said, "How disappointing." That was it. I held her hand, and felt as powerless as I've ever felt in my life.

In a way, that was the day my mother died. And we both sat calmly in that room, holding hands and considered it in silence.

Maybe this is the best thing that modern medicine has to offer: early diagnosis. It gives us a

chance to live out fully our borrowed time, instead of having to deal with the shock and grief of a loved one's disappearance, all the while regretting not having connected, not having had a chance to say "Thank you" or "You were everything to me."

That was the lowest point for all of us. The two months that followed were hard yet beautiful. We weren't waiting anymore. We were free of doubt, of anguish, of that crushing sense of powerlessness. All we did was love each other, truly live as if tomorrow was going to be the last.

Our family country doctor in Switzerland, who still makes house calls, said, "If you live well, you also die well." My mother was blessed with both in the end.

We went home to Connie's and a few weeks later, through a generous gift from her lifelong friend Hubert de Givenchy, we flew home to Switzerland in another close friend's private jet. My mother had never splurged during her life. Such a grandiose gesture never occurred to us, and she certainly, although she could afford it, would never have suggested it. Therefore, no matter how bittersweet, it felt right to fly home in such a grand way. We had been looking into ways of getting her home for the holidays, how to deal with airlines and a sick passenger. When I told her of Hubert's gesture, her eyes filled with tears of joy and gratitude. She urged me to get him on the line. We did. She could hardly speak. She was so overcome with emotion. All she could utter was "Oh, Hubert . . . *je suis si touchée*" ("I'm so moved").

When she hung up, she looked up like a child, unbelieving at what he had just told her. "He said that I have been everything to him in his life." It is safe to say that the feeling was mutual.

Hubert de Givenchy became not only the provider of the exterior envelope but also the archetype of what a man should be. "To be a gentleman means, as the word says, that you must first be a gentle man," she taught us. And that he was. Together they created her look, the externalization of her style. She saw the clothes he created as the beautiful vase that would enhance a simple field flower, whereas he viewed them as the vase that is kept simple so that nothing will detract from the natural beauty of the flower itself. As a result of their collabora-

152

opposite Audrey with Hubert de Givenchy, walking on the banks of the Seine in Paris, 1982. Almost thirty years have passed since they first met; the work is now done. All that remains are wonderful memories and a lifelong friendship. Photograph by Jacques Scandelari. Audrey Hepburn Estate Collection.

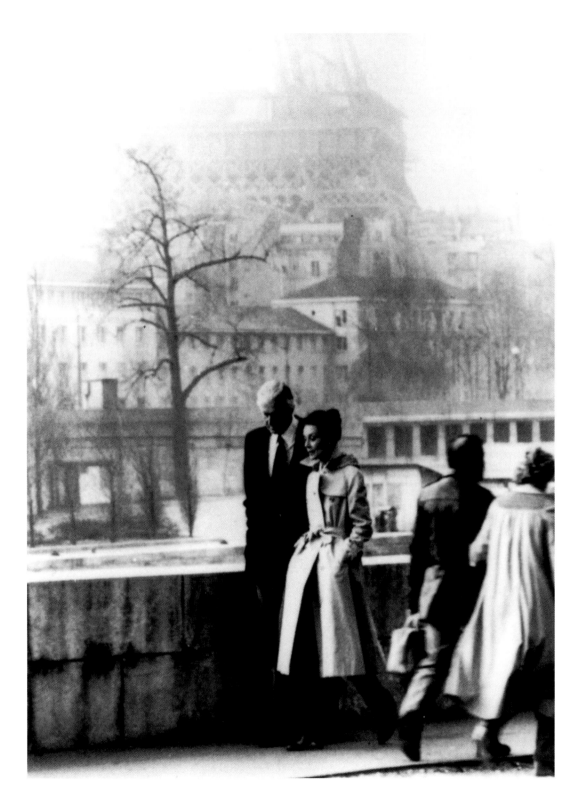

tion, she has often been referred to as the most elegant, the most stylish, woman in the world. But that elegance had its roots in both their inner values. It came from the right place. It wasn't a way to be noticed but a way to be humble.

Hubert often joked that our mother would be elegant in a potato sack. But what is that "little black dress" after all? Isn't it a magnifying glass to the soul? Isn't it the understated wrapping to a gift that comes from the heart and not from the wallet? It's the image in all of us of that daughter, that sister, or that mother who feels good about who she is when she goes out into the world. It represents the good values that come from pure intentions and not from deficit.

My mother believed that a woman should find a look that works for her and use fashion and its seasonal changes to accessorize it, rather than to be a slave to fashion, re-creating one's look over and over again. She always told us to underdress: "It is better to be the only one in a blazer at a black-tie affair than to be the only one in a black tie at an informal event."

In a way, her fashion philosophy was more in keeping with that of an old-fashioned gentleman. It is usually more acceptable for a man to find a look that suits him and stay with it over time than for a woman to do so. From this basic approach stemmed the principle of being appropriately dressed for the occasion. In much the same way that she studied the characters in a screenplay, she would be concerned about the appropriateness of what she wore for an occasion, rather than just how a piece of clothing stood on its own.

With Hubert she certainly never needed to worry about that. Clothes had to be of the best quality. A Cuban mother once said, *"Lo que es barato sale caro y lo que es caro sale barato"* ("What is cheap ends up being expensive, and what is expensive ends up being cheap"). Cheap, not only reasonably priced, may not last as long as something more expensive and therefore of better quality, although expensive doesn't always mean good quality.

Shoes were also very important to my mother. They were at the very foundation of that ethic of quality. If you have good shoes, always a half size bigger rather than smaller so that they do not get deformed over time or hurt your feet and their development, you can afford to wear simple clothes. Salvatore Ferragamo, the shoemaker of dreams and one of my mother's good friends, wrote in the preface to his biography how anguished he felt when he saw feet that were hurt and tortured in the name of style or vanity. This is probably why he is the greatest shoe-

maker of all time. His intentions were pure, and he cared. Certain Eastern philosophies hold feet to be the containers of our spirits, of our souls. What a nice business it must be to dress peoples' spirit, if that's the case!

"Less is more" was at the core of my mother's basic "look" philosophy. Hubert remembers first receiving a call at his atelier, to tell him Miss Hepburn was in Paris and would like to meet with him to discuss a possible collaboration for her next film. The appointment was set, and he fretted at the thought of meeting and possibly working with Miss Katharine Hepburn.

He laughs as he recollects his surprise when instead of Miss Katharine Hepburn, this extraordinary gamine wearing a Venetian gondolier's outfit showed up on his doorstep. He also clearly remembers that the chemistry was instant and that from that point on, he always designed with Mother in his mind's eye.

Style is a word we use often, for a multitude of purposes. In the case of my mother it was the extension of an inner beauty reinforced by a life of discipline, respect for the other, and hope in humanity. If the lines were pure and elegant, it was because she believed in the power of simplicity. If there was timelessness, it was because she believed in quality, and if she is still an icon of style today, it is because once she found her look, she stayed with it throughout her life. She didn't go with the trends, didn't reinvent herself every season. She loved fashion but kept it as a tool to compliment her look.

"Take good care of your clothes," she would say, "because they are the first impression of you." So when she appeared, her clothes didn't scream out, "Look at me!" but, "This is me . . . no better than you." And she truly believed in that. She didn't see herself as anything special or unusual, which is why she worked so hard and was always pleasant and professional. Her style was only an extension of who she was, the person we all admired, because down deep we knew that what we saw was not just clever packaging but an honest and 100 percent genuine human being.

below 1960: My mother and Hubert de Givenchy had now been friends for seven years. He visited her for my christening and brought with him a christening gown that we still have. Photograph by Mel Ferrer.

opposite On the set of *Sabrina* with Hubert de Givenchy, November 3, 1953. This was the first of many collaborations. Production still. Audrey Hepburn Estate Collection.

156

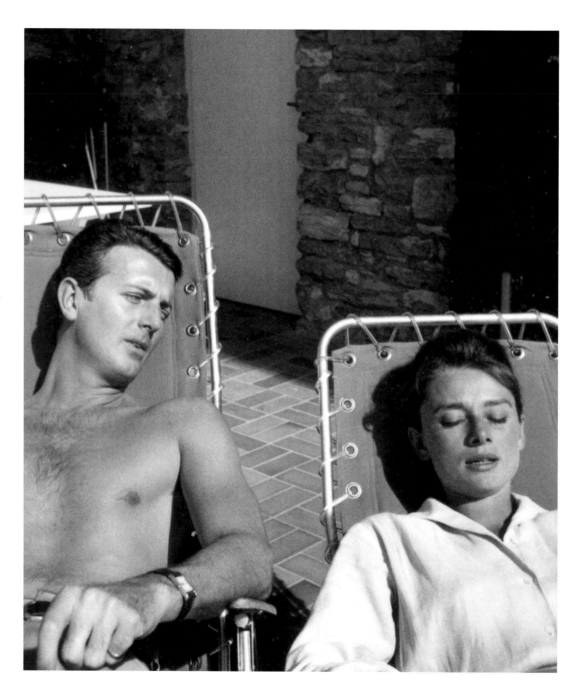

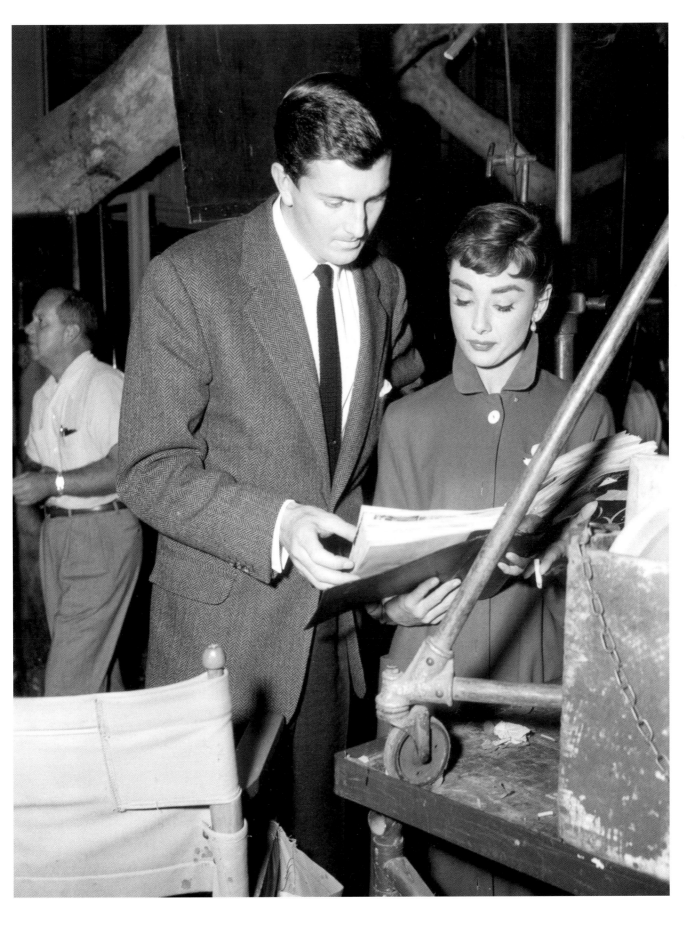

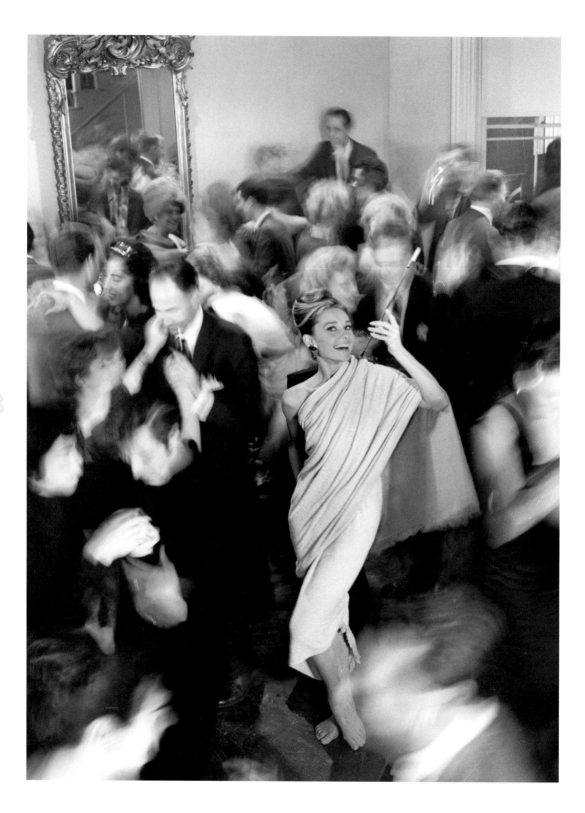

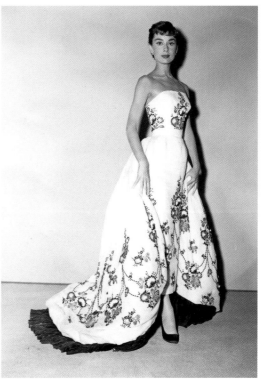

opposite *Breakfast at Tiffany's:* This shot absolutely captures the party scene in *Breakfast at Tiffany's* by using time-lapse photography with Audrey standing absolutely still at the center of the image. Many have said that my mother would have been elegant in a brown paper bag. I rather prefer the curtain in this shot. © Paramount Pictures. All rights reserved.

above *Sabrina* wardrobe test shots, September 22, 1953. © Paramount Pictures. All rights reserved.

160

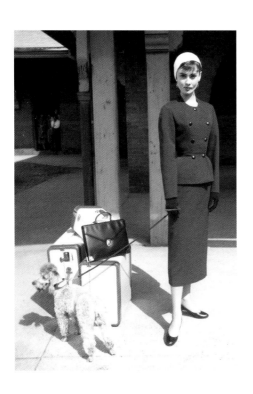

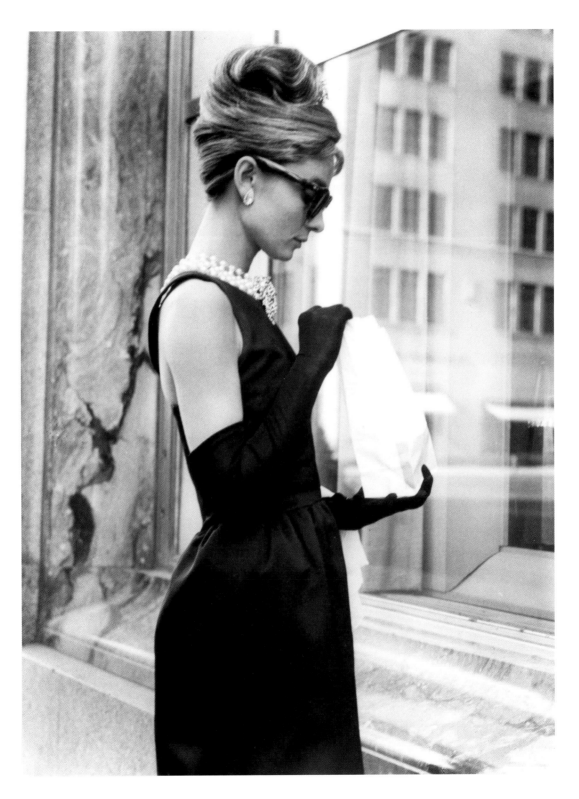

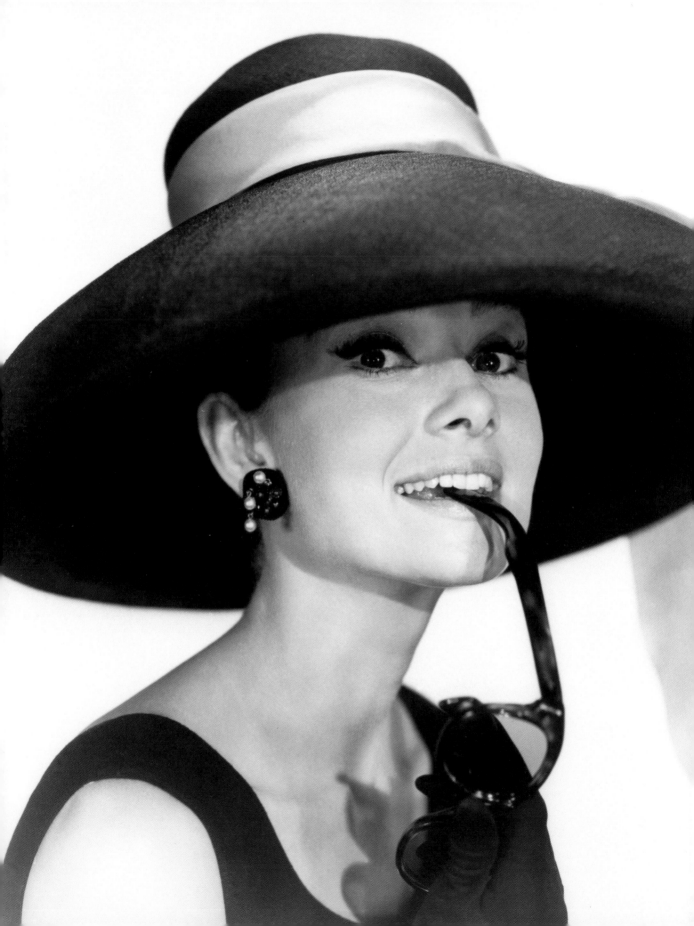

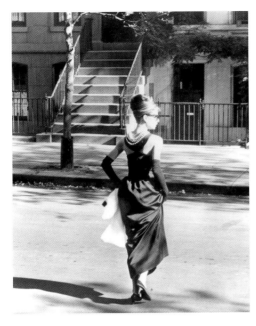

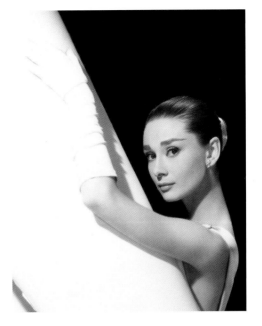

163

opposite and top left *Breakfast at Tiffany's*
production stills, 1961. © Paramount Pictures.
All rights reserved.

bottom left *Paris When It Sizzles*. This was the only
film my mother ever described as "not as good" as
the rest of her work. It was, nevertheless, a joy to
make, which is why she often told me not to

correlate the experience of making the movie with
its outcome. Photograph by Vincent Rossell.

top right *Funny Face* publicity still. © Paramount
Pictures. All rights reserved.

bottom right *Paris When It Sizzles* publicity still.
© Paramount Pictures. All rights reserved.

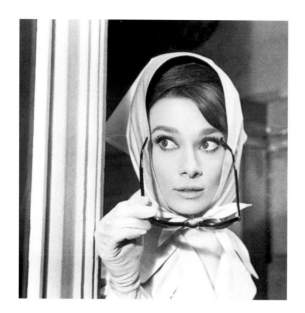

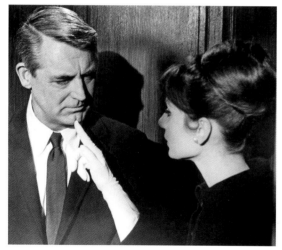

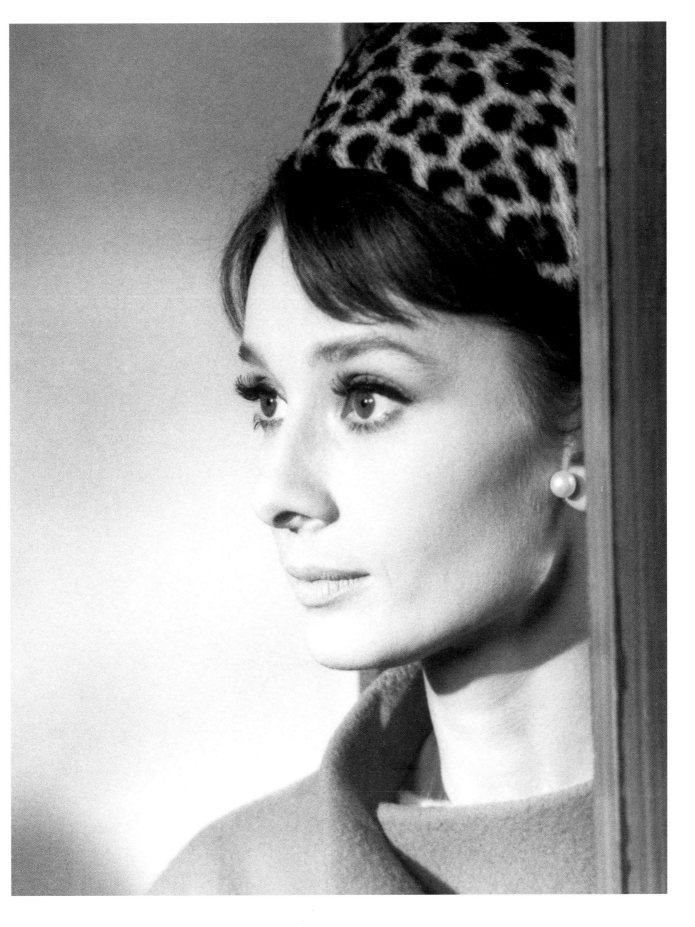

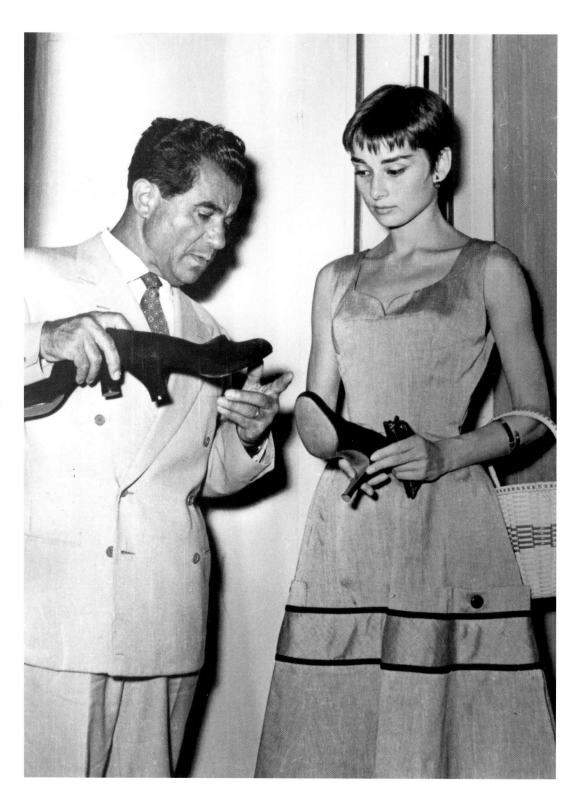

166

opposite In the workshop of Salvatore Ferragamo, Florence, Italy, 1954. The wonderful friendship that began in 1954 was crowned on what would have been Audrey's seventieth birthday by the announcement that Salvatore Ferragamo, now a $500-million-plus per annum fashion giant, and the Audrey Hepburn Children's Fund had entered into a new venture to raise funds for the construction of the new Audrey Hepburn Children's House at Hackensack University Medical Center in New Jersey. Costing more than $6 million, the facility opened its doors in 2002 and will treat over a thousand cases of child abuse per year. The money was raised through the federal and state governments and the proceeds of *Audrey Hepburn: A Woman, the Style,* the exhibit Ferragamo created for the fund, which traveled from Europe to the Far East for over two years. Photograph by Foto Locchi S.R.L. Firenze.

below left *How to Steal a Million,* 1966. Photographs by Pierluigi. Pierluigi/Reporters Associati.

bottom On the set of *How to Steal a Million.* left With Peter O' Toole and director William Wyler. right With opera legend Maria Callas, 1966. Photographs by Pierluigi. Pierluigi/Reporters Associati.

167

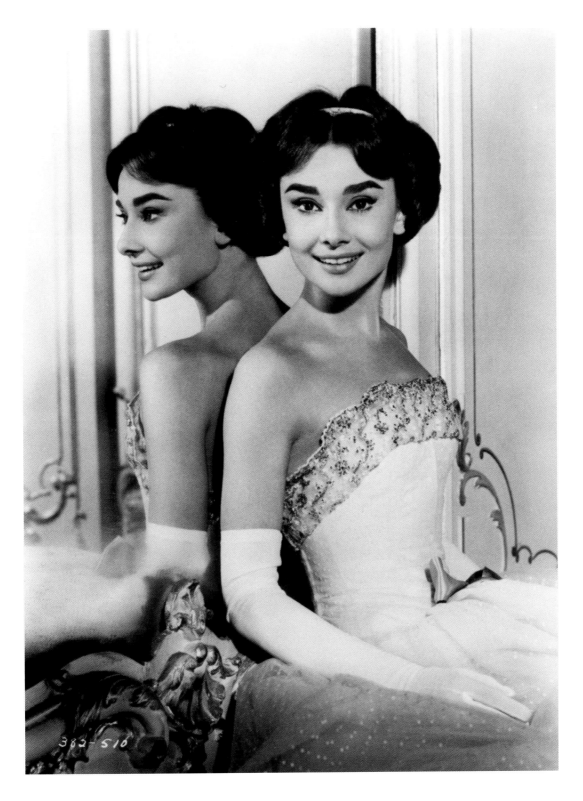

169

382-510

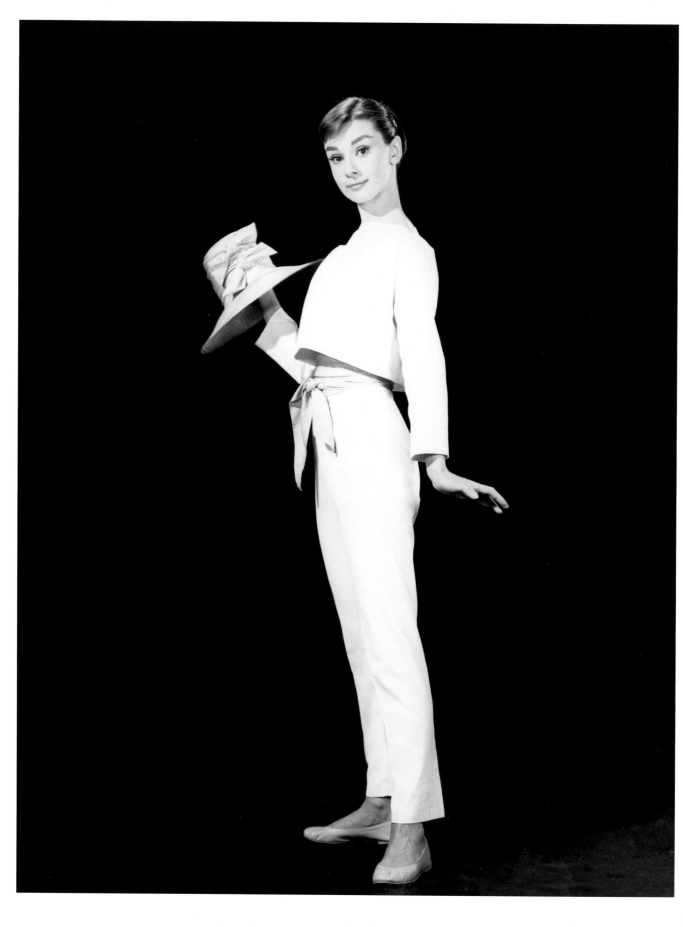

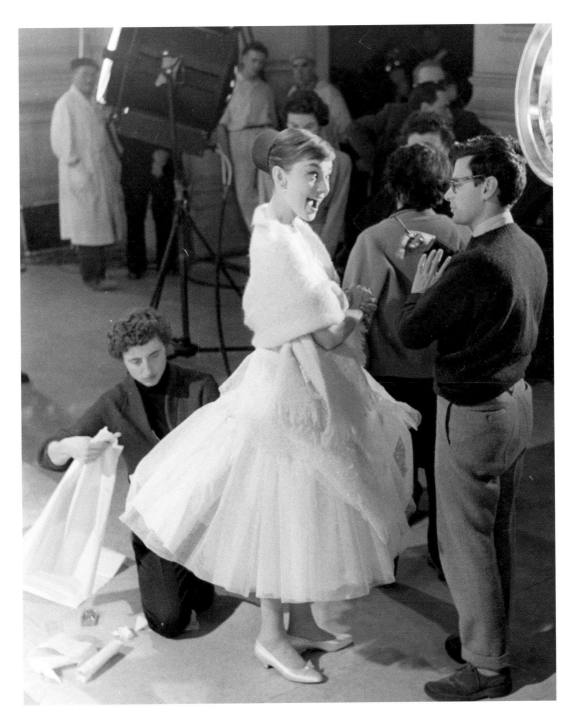

opposite *Funny Face* publicity still. Photograph by
Bud Fraker. © Paramount Pictures. All rights
reserved.

above *Funny Face*, on set with Richard Avedon.
Photographer unknown. Audrey Hepburn Estate
Collection.

 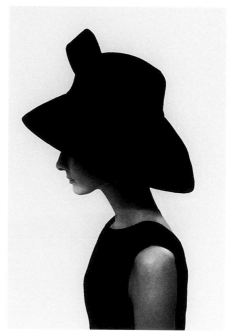

above left and middle Photographs by Bert Stern, 1963. Bert Stern/*Vogue* © Condé Nast Publications.

above right Photograph by Cecil Beaton, 1964. Cecil Beaton/*Vogue* © Condé Nast Publications.

opposite Photograph by Bert Stern, 1963. Bert Stern/*Vogue* © Condé Nast Publications.

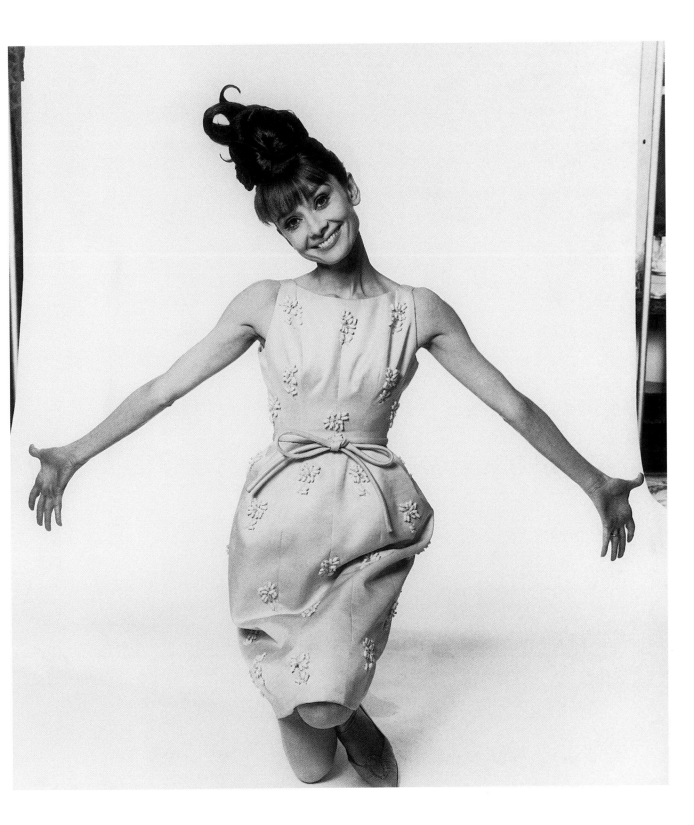

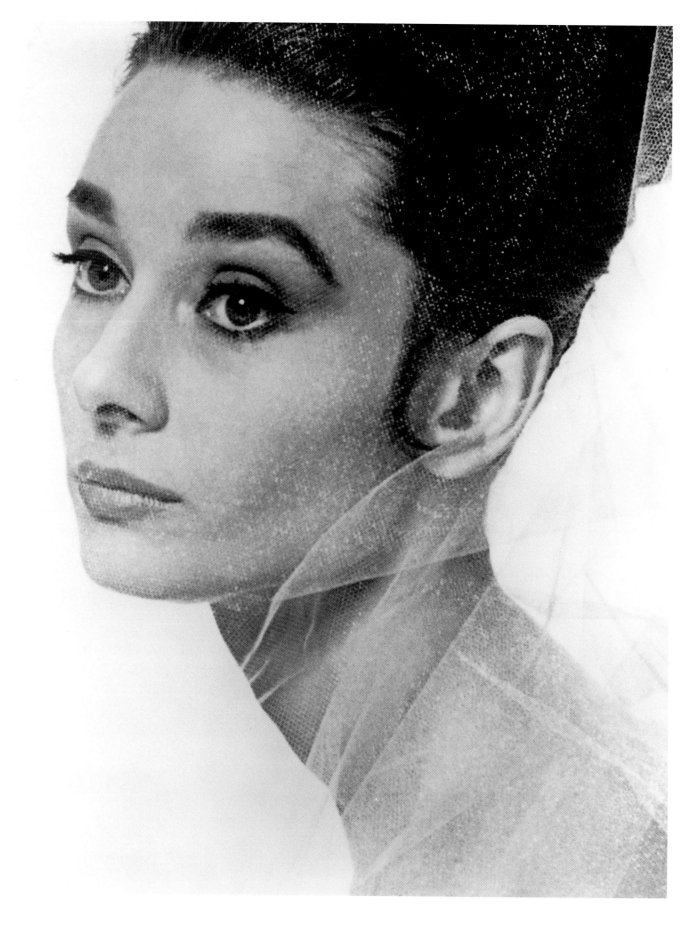

opposite Givenchy's L'Interdit ad. In 1967, Hubert de Givenchy created L'Interdit, his first fragrance and, due to his dedicating it to my mother, the first celebrity fragrance ever. This photograph was placed in magazines across the world for the release. In 2002 we relaunched a "modernized" version of the fragrance in cooperation with Parfums Givenchy. Photograph by Bert Stern © 1966.

below Audrey with Hubert de Givenchy at the "Haute Couture" show in Tokyo, April 1983. We all went to Japan as a family in 1983 to celebrate thirty years of Givenchy. None of us were prepared for the reception Audrey's first visit to Japan would generate. Today she is still the most beloved actress ever in Japan. Photographer unknown. Audrey Hepburn Estate Collection.

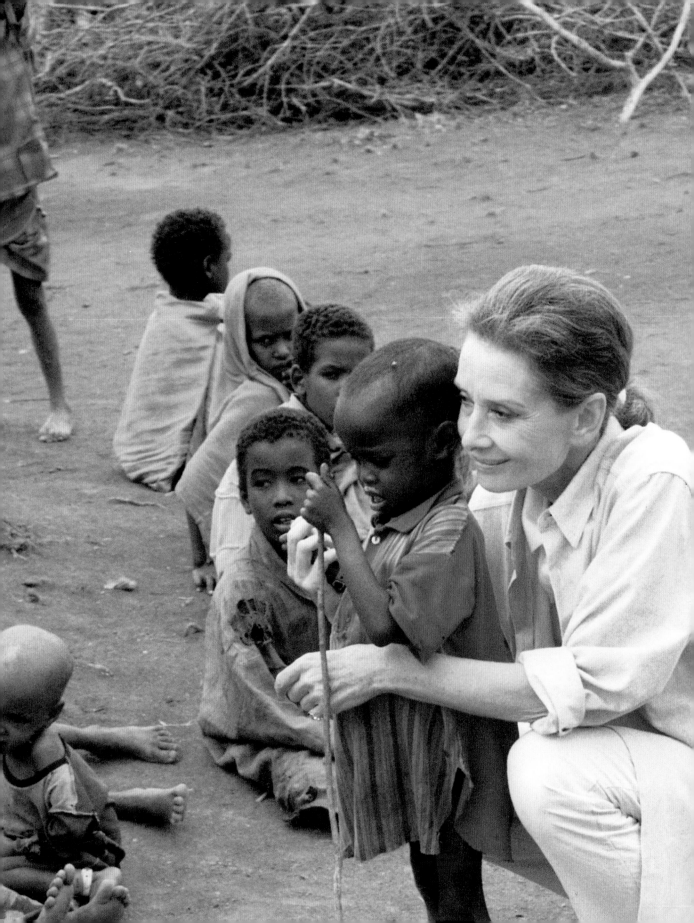

CHAPTER 5 THE SILENCE OF THE SOUL

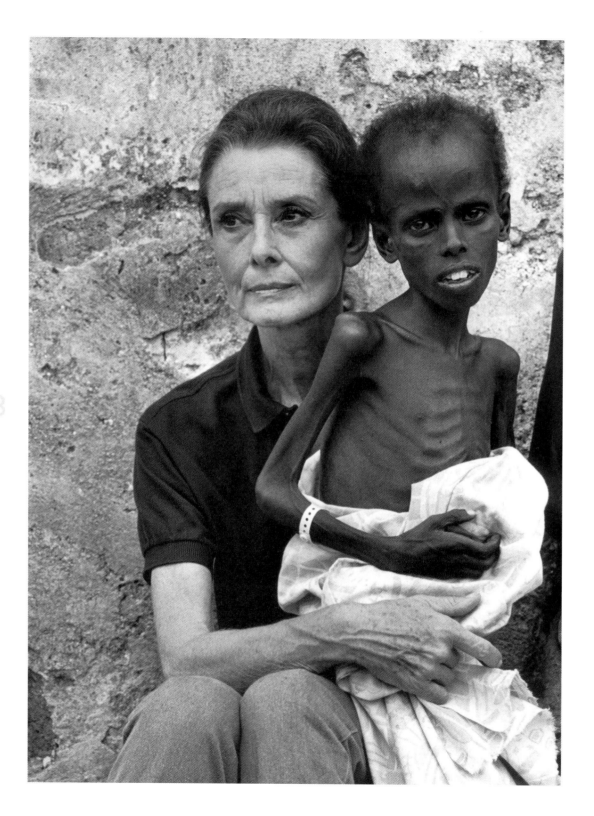

Somalia was my mother's last UNICEF trip, and probably the most important one. The situation there was at its worst. My mother and Robby had waited for a long time, maybe close to a year, for clearance to travel and for the funds to be gathered. But when she had asked who would be issuing the visas, the reply came with a smile: "There are no visas, because there is no government. You just fly in and hope you won't get shot down."

The world had not yet had an opportunity to get a firsthand look at the genocide or the camps filled with thousands starving to death. After my mother's trip, everything seemed to converge. Finally the world community took a few belated and misguided steps to try to stop this cataclysm, which I got a sense of upon viewing the extremely powerful images in the film *Beyond Borders*.

Despite the good her work had done, feelings of injustice toward our society and how it was treating its future generations reached a peak as a result of her Somalia trip. "I am filled with a rage at ourselves," she said in an interview. How could she not, after living through the war and hearing a repenting world proclaim, "Never again"? Unfortunately, it did, and still does, again and again and again.

At the same time, she felt she had been able to make the most meaningful contribution of her whole tenure: Because of the interest it still had in her, the press rallied in an effort to bring attention to the Somali cause.

We have sworn never to let the Holocaust take place again. Yet the sad truth is that every day, in Africa, the Holocaust is alive and well, she would tell us. Masses of refugees are not brought to the camps against their will; they arrive in desperate and exhausted droves, as a last resort, with empty shame in their souls for not having been able to provide for themselves or their families. Often they have lost most of their loved ones before they accept defeat and grow willing to leave the land of their ancestors, their roots, their only pride and treasure.

I wonder if some of us, secretly, sit in judgment and contempt, wondering how, after all these years, these people still don't have it together. But what is there to get together? In most of these developing countries—the term is actually an oxymoron, since there is no infrastructure and, by our standards, very little to develop with—once you leave the capital, there are few roads, schools, or hospitals. This is why one of the first things we did, after my mother's passing, was to create the Audrey Hepburn Memorial Fund at the U.S. Fund for UNICEF. She believed that the only way to change was through education, and so the Memorial Fund does just that. It implements educational programs in the four countries of Africa she felt were the most badly in need of infrastructure: Somalia, Sudan, Ethiopia, and Eritrea. After the fund's fifth year of existence, we added Rwanda. Today that commitment has grown and we have just entered into a new ten-year commitment to UNICEF's "All Children in School." This program seeks to bring a basic quality of education to 120 million children around the world.

Don't let anyone tell you that lack of development has anything to do with the colonies' end and that this therefore proves that they have no hope of ever managing themselves. "First you become free, then you organize yourself," she would say. Unfortunately, any infrastructure left behind by the colonies was only temporary, and those populations hadn't been educated. "A country like Vietnam," she used to say, "like Cuba, has a higher percentage of educated people than even the United States, and there is infrastructure, and they will recover by themselves."

"Is there anything more important than a child?" she would often ask as an opening to her interviews and speeches. She wasn't just being clever; she believed that at the core of that

question lay an indisputable truth. "Is there? Is there anything more important than the survival of our species? Is there another time in your life when love, care, tenderness, food, education, are more important than in childhood?"

Somehow the word *global* only seems to get our attention when it is associated with the word *economy*. When the economies of Brazil and Japan start to melt down and the precious savings we invest in the stock markets start to dwindle as a result of a world recession, we fret, worry, and wring our hands. All we do is wait and see. Yet we wouldn't be "waiting and seeing" if our own children were dying of thirst, hunger, or from the lack of a supplement that costs, she used to remind everyone, less than a dollar per capita per year.

She would also remind us that out of the 5.6 billion people that inhabit our planet, 3 billion live on less than $2 a day, another 1.3 billion live on under $1 a day, and 1.5 billion live without clean water—which means there are 900 million of us and 4.7 billion of them. They outnumber us 5 to 1. How long, she would contemplate, can we expect to keep this up? "Will it always be acceptable for their children to die of starvation and for our children to be fat?"

"Since the world has existed," she said in March 1988, "there has been injustice. But it is one world, the more so as it becomes smaller, more accessible. There is just no question that there is a moral obligation, for those who have, to give to those who have nothing."

She would constantly remind all of us that we could fix this nightmare with one-half of 1 percent of our (the industrialized nations') combined GNP. What will our children think of us when they discover that we missed this opportunity of a lifetime?

As I searched through her research materials, reams and reams of articles, hundreds of reports, I found the following quotes she had underlined, from Mr. James Wolfensohn, the president of the World Bank, and from UNICEF reports and newspaper articles.

These 4.7 billion Third World inhabitants cause 4,000,000 people to be employed in the U.S. The Third World's needs and their economies are growing at twice the rate of our own. If these 4.7 billion represent 18 percent of the world's GDP today, they will represent 30 percent in another 25 years. . . . Meanwhile struggling to make it, they are polluting OUR air and OUR water and environments. Who's going to pay for that? We will! Our children

will. It will start affecting our lives long before they will be in a position to do something about it. Actually, it has already started. The hole in the ozone layer is a perfect example. . . . So why should the U.S. bear the brunt of this problem? Because the U.S. represents 55 percent of the world's economy, like Japan represents 75 percent of the Far East's economy. If you add the GNPs of the industrialized nations I expect that they would represent close to 90 percent of the world's economy.

"Have you ever been in pain?" she would ask. "Well if you have, you'll remember what you did to get the proper pain medication. These 4.7 billion people," she would plead, "are in some form of pain or another: loss of their loved ones, hunger, disease, drought, war, prostitution, lack of human rights, torture. Yet they behave with dignity and nobility."

I can't help expressing a certain sarcasm toward ourselves, as I look at the magnitude of the cataclysm we are faced with. Yet I assure you that neither Mr. Wolfensohn nor my mother had sarcasm in their voices when these vital issues were addressed. To the contrary, they spoke of them with the same simplicity and nobility that they found in these people.

There is a wonderful Italian expression my mother liked: *Tutto il mondo è paese* ("The whole world is a village"); wherever you go, the issues are always the same. And this is precisely what Mr. Wolfensohn found out in the eighty-five countries he has visited over the last three and a half years, since he became president of the World Bank.

The first thing I've learned is that people are the same.

You go into a slum . . . or a village in the middle of Africa or if you go into the favellas in Brazil, the parents—when they're together—or the mothers care about the future of their children. The second thing that I've learned is that these people don't want charity. They want an opportunity. They want a chance.

People in slums and villages, in my experience, are the noblest people I meet. I spend 50 percent of my time in projects, slums and villages. This is not a group that you should feel sorry for in human terms. You may feel sorry for the conditions under which they live,

but they have enormous internal capacity. That's something I never understood before. I never understood the strength of the cultures in these places.

I used to travel, go to hotels, go to game parks, go to other things. I never went into a village. I never knew that in Mali, one of the poorest countries in the world, they had a 2,000-year-old history. They used to have an empire that stretched up to Egypt. I never knew that in Central America you had traditions going back 3,000 years. These people, if we give them a chance, respond fantastically. My concern is not about the people. My pessimism is that in the developed world, [among] people that have the capacity to make a difference, we're turning our back on a series of issues. I'm optimistic about the people much more than I ever was before. I believe in the people. But I have an acute sense of frustration about the debates in our congress and in . . . parliaments around the world where we put aside the longer-term issues for tomorrow's electoral promises. That's not just an American problem. There is a lack in the world of medium and long-term leadership. And most people don't care because they can't see it.

I may be a voice in the wilderness. My 10,000 colleagues at the bank may be voices in the wilderness, but I really tell from my life experience, which is 60-plus years, that what we're engaged in now is really what is going to make the difference for our kids and our grandchildren. I have absolutely no doubt about that.

These must be the parents of the children my mother met.

Interestingly, I feel she would never have taken her own conversation this far, although she was driven by these statements. She had too much respect for the politicians and economists she believed were at the helm of resolving these matters. She knew her place, and that, she felt, wasn't it.

But she knew what she was talking about. She spoke to us in terms of "humanity's internal capacity." She had read everything she could, educating herself until she was well informed; she felt that as an actress, she was at a disadvantage in this brand-new humanitarian world.

I would venture to say that she probably took it more to heart than some of the others who had made it their careers.

Yet she wasn't prepared for the profound emotional consequences of what she witnessed in Somalia. Can anyone be? Not even a professional nurse who had trained for a lifetime could be sufficiently prepared to witness so much pain.

She nevertheless found the elegance in her heart to encapsulate her raging feelings by saying, "I don't believe in collective guilt, but I do believe in collective responsibility." What did she mean by that? Are we all responsible for a single dying child in Africa?

Former first lady Mrs. Hillary Clinton used part of an old African saying to title her book: "It takes a village . . . to raise a child." My mother often used this saying, and she explained it in the following manner: "Parents are not enough, teachers are not enough, doctors are not enough, friends are not enough, but all of us together have a chance." My mother wasn't saying that it is our individual responsibility to take care of every child on the planet. Yet she believed that we must all find a way to drop our political and economical borders when the issues of human rights are at stake.

Corporations are merging to cut costs more than ever before in history; Europe is uniting; and Canada, Mexico, and the United States have a free-trade agreement. Visionary writers have romanticized the future of our planet as a federation. We dream of a future devoid of the diseases that plague us and fantasize of space travel. The Internet allows us to communicate and reach out to anyone who has a phone line. Yet 50 percent of the world population has never received a phone call.

My mother wanted us to keep at it, not be satisfied, not rest until we have changed the course of history—maybe not in our individual lifetimes, but certainly by the time our children or grandchildren take our places. Otherwise, they will have to pay for it with interest and penalties, and most importantly, whole generations of children will be lost: precious children, equally as precious as our own.

One-half of 1 percent of the combined industrialized nations' GNP is all it would cost to set up these developing countries so that they could take care of themselves, henceforth. What will be the cost of a shattered life in ten, twenty, thirty years? When a child has seen devastation around him, how can we expect him to participate in the future, to trust again?

My mother said, "If I may sum it up in a very short phrase, and this I will say as long as I have breath, for the people of Ethiopia, all they need is the assistance to help themselves, which they

are yearning to do. And UNICEF is giving them a spade, let us say, to dig their water wells. Let it not be to dig the graves of their children."

She never saw people with outstretched hands. She saw only the noble comportment of people unable to compete in a world we have only partially developed.

Robby and John Isaac, my mother's friend and photographer at UNICEF, both recount a moment they will never forget. No one in those camps knew who she was. They just knew that a plane or a helicopter would land, and out of it would emerge this woman: thin like them, gentle and caring, with something in her eyes they could connect to. At the end of one of these visits, they entered a rough structure where a long line of children had formed, all waiting for their one meal: a bowl of that porridge UNICEF uses in extreme situations.

My mother was deep in conversation with one of the officials when both Robby and John noticed a little girl in a long line of hungry children. She seemed transfixed at the sight of this unknown woman she had probably just seen be so compassionate with the other children. As the line kept bringing her closer and closer to her meal, it became apparent that a struggle was building inside this little girl. She would look at the head of the line, probably blind with hunger, and yet something was pulling her away from the food and toward my mother. You could see the struggle in the child's eyes. She was dealing with two of the most basic instincts in life: the need for food, for survival, and the need to rush into the arms of a woman offering inexplicable hope and the kind of reassurance you only get from a mother.

Finally their eyes met. Mother became very quiet. As the little girl reached the head of the line, she looked at the plate, the food, and in a flash broke out of the line and rushed into Mother's arms. The need for affection, to be held in the arms of this mysterious woman, had surpassed, for that short moment, her need for survival.

Both Robby and John had tears in their eyes as they told the story. John, one of the great photographers of our time, feeling the depth and the privacy of the moment, decided not to photograph it.

We often talked about the quality rather than the quantity of life. Mother felt proud of the role she played in the UNICEF chain. In many cases, although they couldn't save the life of a

185

child because malnutrition had taken its toll too severely or disease had set in, the souls could be held and the conditions of their passing made bearable.

Mother felt somehow that a child dying of malnutrition, in a camp yet in the loving arms of its mother, was less of a crime than one whose childhood is being stolen by abuse, child labor, prostitution, or war.

A child doesn't know how to fight for its dignity. Even adults have difficulty with it. This is why my mother fought so hard for the Rights of the Child Charter. She kept wondering why the United States hadn't signed it yet. How could it be that the most advanced country in the world hadn't ratified the same rights for children that its constitution so fiercely protected for adults? It was the dying wish of Jim Grant, UNICEF's executive director, that the United States sign it. And George Bush Sr. finally did, although much of it hasn't been fully implemented because apparently it somehow clashes with our constitution. Nevertheless, it was a step in the right direction.

My mother recounted, with much compassion, something that took place in Kismaiu, one of the first camps she had visited in Somalia. A little blind girl was working her way along the camp's fence, trying to find the medical facility. Simply clad in a piece of blue cloth and in a swarm of flies, she represented everything that Mother felt and knew to be most tragic about the plight of a child, lost in a world that no longer cared for it. My mother tried to comfort her, to help her find her way, but the little girl's smile was gone, replaced by a crushing feeling of disregard, the knowledge that you have been expended, the silence of the soul.

Often Mother qualified good manners as the practical way to "put yourself in the other person's shoes." Her ability to do just that was a muscle she had developed over her lifetime. It was an asset that she probably was born with but also one she honed throughout her life and career. This valuable emotional tool was a microscope that enabled her to see or imagine as an actress what others felt in the most private folds of their souls. Working for UNICEF, this ability became a loudspeaker, an amplifier of the pain and solitude of these children, as in the case of a little blind girl.

It was this "emotional hunger" as she described it, "the hunger that food cannot alleviate," and the panic and devastation of the child who had no one to relate to, that she felt the most

keenly. She wrote, "The neglect and humiliation of a child by adults is a killer of trust, of hope and of possibility."

My mother connected with this little blind girl, with her loneliness, her void. It was probably an emptiness and a sadness she knew all too well.

It was the sadness behind this spirit that enamored the world over. Even though she found peace and love in the end, this sadness dominated her life. Why did she become this icon of our most secret romantic notions, this Joan of Arc of the emotional world? It was the sadness in her eyes that said, "I know. I know how it really is. Yet let me dream, let me be your Antigone." She didn't adapt, instead keeping her dreams alive: the dream that one day her father would come back and pick her up in his arms, the dream that one day the soldiers would stop fighting and that the children would be safe, the dream that "each child has the right to health, to tenderness, to happiness, to life."

In our developed world, we protect human rights, yet in many developing countries life still carries very little value. So children, the individuals of tomorrow, stand even less of a chance.

My mother found comfort in the fact that television was bringing the children's suffering into our living rooms. When asked about the role of politics upon her return from Somalia, she replied:

> Politics are something which are very hard for me to understand, because their machinations are so complicated. Politics, by definition, are supposed to be for the people, for the welfare of people. Humanitarian means human welfare. And responding to human suffering, that's finally what politics should be, ideally. That's what I dream about. And that's why I use this example, and it may be unique in history: that it's humanitarians that are keeping this country [Somalia] afloat. I think, perhaps with time, instead of it being a politicization of humanitarian aid, there will be a humanization of politics. I dream of the day that it will be all one. And this is one of the reasons I wanted to come to Somalia, not because I can do very much, but there cannot be enough witnesses. If I can be one more, and speak up for one child, it's worthwhile.

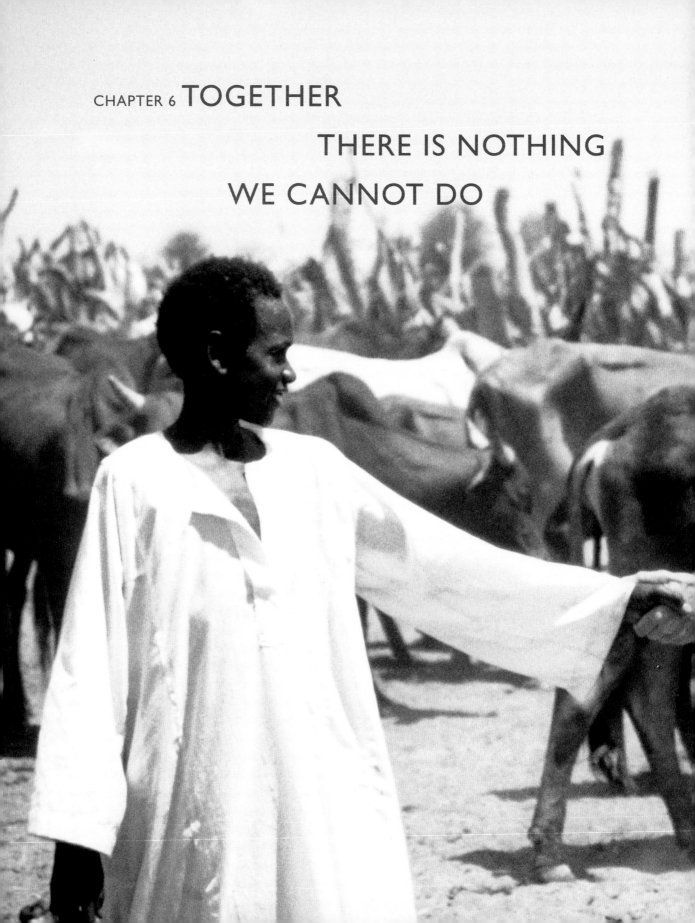

CHAPTER 6 TOGETHER

THERE IS NOTHING

WE CANNOT DO

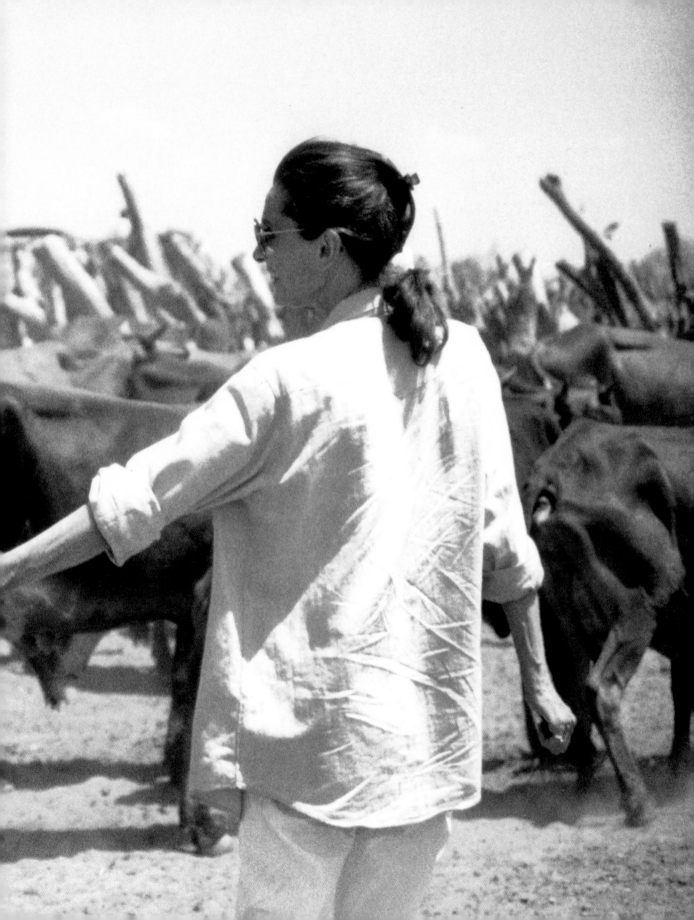

previous spread Sudan, 1989. Photograph by Jeremy Hartley. UNICEF/C-53 20/Jeremy Hartley.

below UNICEF event. Photograph by Ruby Mera. UNICEF/Ruby Mera.

following page Somalia, 1992. Photograph by Betty Press. UNICEF/HQ92-1194/Betty Press.

190

Looking back at my mother's life and all her achievements, the contribution to society I am most proud of is her work for children. Only eighteen months after she started with UNICEF, she wrote the speech that constitutes this chapter. In it you can hear her, her voice, her commitment, her soul, and her profound simplicity.

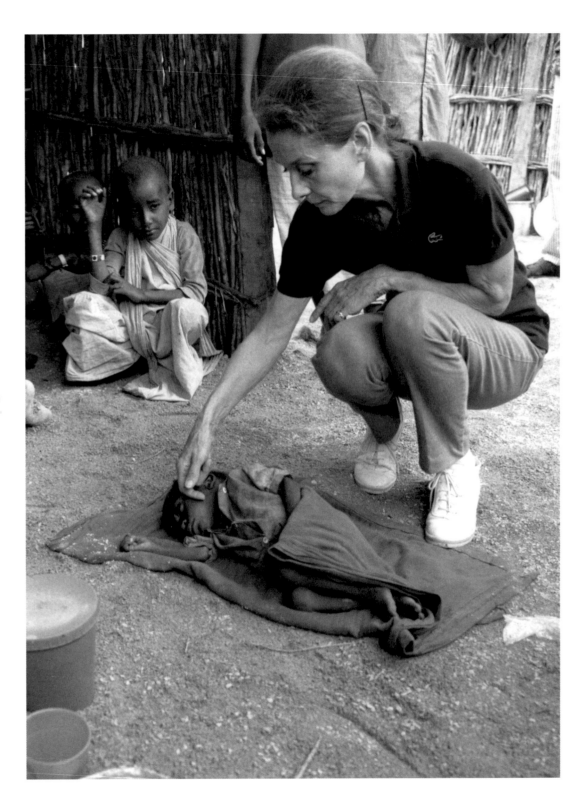

STATEMENT BY MS. AUDREY HEPBURN

UNICEF GOODWILL AMBASSADOR

TO MEMBERS OF THE UNITED NATIONS STAFF

AT THE INVITATION OF THE

1 PERCENT FOR DEVELOPMENT FUND

Geneva, 13 June 1989

Up until some eighteen months ago—before I was given the great privilege of becoming a volunteer for UNICEF—I used to be overwhelmed by a sense of desperation and helplessness when watching television or reading about the indescribable misery of the developing world's children and their mothers.

If I feel less helpless today, it is because I have now seen what can be done and what is being done by UNICEF, by many other organizations and agencies, by the churches, by governments, and most of all, with very little help, by people themselves. And yet, we must do more about the alarming state of the children in the developing world—many are only just surviving—especially when we know that the finances needed are minimal compared to the global expenditure of this world, and when we know that less than half of one percent of today's world economy would be the total required to eradicate the worst aspects of poverty and to meet basic human needs over the next ten years. In other words, there is no deficit in human resources—the deficit is in human will.

The question I am most frequently asked is: "What do you really do for UNICEF?" Clearly, my task is to inform, to create awareness of the need of children. To fully understand the problems of the state of the world's children, it would be nice to be an expert on education, economics, politics, religious traditions, and cultures. I am none of these things, but I am a mother. There is unhappily a need for greater advocacy for children—children haunted by undernourishment, disease and death. You do not have to be a "financial whiz" to look into so many little faces with diseased, glazed eyes and to know that this is the result of critical malnutrition, one of the worst symptoms of which is vitamin A deficiency that causes corneal lesions resulting in

partial or total blindness, followed within a few weeks by death. Every year there are as many as 500,000 such cases in countries like Indonesia, Bangladesh, India, the Philippines, Ethiopia. Today there are in fact, millions of children at risk of going blind. Little wonder that I and many other UNICEF volunteers travel the world to raise funds before it is too late, but also to raise awareness and to combat a different kind of darkness, a darkness people find themselves in through lack of information on how easy it is to reach out and keep these children. It costs eighty-four cents a year to stop a child from going blind—the price of two vitamin A capsules.

I have known UNICEF a long time. For, almost forty-five years ago, I was one of the tens of thousands of starving children in war-ravaged Europe to receive aid from UNICEF, immediately after our liberation. That liberation freed us from hunger, repression, and constant violence. We were reduced to near total poverty, as is the developing world today. For it is poverty that is at the root of all their suffering—the not-having: not having the means to help themselves. That is what UNICEF is all about—helping people to help themselves and giving them the aid to develop. The effect of the monstrous burden of debt in the developing world has made the poor even poorer, and has fallen most heavily on the neediest. Those whom it has damaged the most have been the women and children.

Unlike droughts, floods, or earthquakes, the tragedy of poverty cannot easily be captured by the media and brought to the attention of the public worldwide. It is happening not in any one particular place, but in slums and shanties and neglected rural communities across two continents. It is happening not at any one particular time, but over long years of increasing poverty, which have not been featured in the nightly news but which have changed the lives of many millions of people. And it is happening not because of any one visible cause, but because of an unfolding economic drama in which the industrialized nations play a leading part, which is spreading human misery and hardship on a scale and of a severity unprecedented in the postwar era.

In Africa, for instance, in spite of national reforms, improved weather conditions, and a surge of their agricultural output, all their hard-earned gains have been undermined by international economic trends and a drastic fall in commodity prices. They are now compelled to return four times as much money as they were loaned! But the poorest sectors of society in the developing world are also suffering as a result of all too frequent misappropriation of funds, as

well as the tremendous inequality in the distribution of land and other productive resources.

UNICEF's business is children—not the workings of the international economy. In its every-day work in over 100 developing nations, UNICEF is brought up against a face of today's international economic problems that is not seen in the corridors of financial power, not reflected in the statistics of debt service ratios, not seated at the conference tables of debt negotiations—it is in the face of a child. It is the young child whose growing mind and body is susceptible to permanent damage from even temporary deprivation. The human brain and body are formed within the first five years of life, and there is no second chance. It is the young child whose individual development today, and whose social contribution tomorrow, are being shaped by the economics of now. It is the young child who is paying the highest of all prices. We cannot therefore ignore the economic issues which for so many millions of the world's poorest families have made the 1980s into a decade of despair.

Today the heaviest burden of a decade of frenzied borrowing is falling not on the military, nor on those foreign bank accounts, nor on those who conceived the years of waste, but on the poor who are having to do without the bare necessities, on the women who do not have enough food to maintain their health, on the infants whose minds and bodies are being stunted because of untreated illnesses and malnutrition, and on children who are being denied their only opportunity ever to go to school. When the impact becomes visible in the rising death rates among children, then what has happened is simply an outrage against a large section of humanity. Nothing can justify it. The consensus now beginning to take shape is that the burden of debt must be lifted to a degree where the developing countries can cope with debt repayment, to the point where their economies can grow out of their overwhelming indebtedness, and set them on the road to recovery and real development.

World population growth is beginning to be brought under control. Change is in prospect everywhere—and if at this time there is the vision to use this opportunity creatively to see a brave new world and to dare to reach for it, there is a real possibility over the next ten years to begin to come to grips with the triad of fundamental problems which threaten mankind: the presence and the threat of war, the deterioration of the environment, and the persistence of the worst aspects of absolute poverty.

top Somalia, 1992. Photograph by Betty Press. UNICEF/HQ92-1179/Betty Press.

bottom Somalia, 1992. Photograph by Betty Press. The little blind girl in Somalia who symbolized to Audrey the silencing of the soul, that final loneliness. UNICEF/HQ92-1195/Betty Press.

196

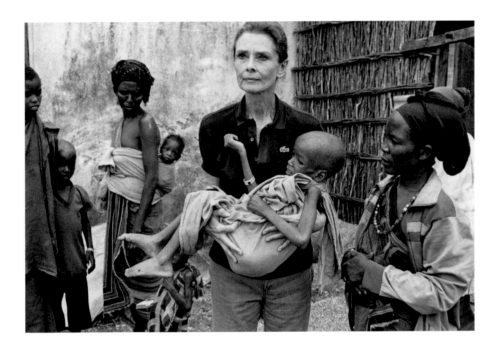

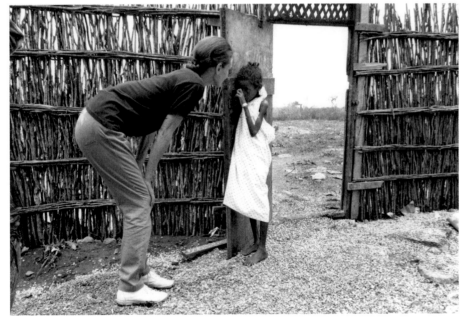

Many of the great social changes of modern history—the abolition of slavery, the ending of colonial rule, the isolation of apartheid, the increasing consensus on the environment, or the growing recognition of the rights of women—have begun with rhetorical commitment which has eventually turned into action. In the 1990s it may at last be the turn of the child, and our dream for an international summit for children and ratification of the Convention on the Rights of the Child could become a reality.

Forty thousand (35,000 in 2003) children still die every day—280,000 a week (245,000 in 2003). No natural calamity, be it flood or earthquake, has ever claimed as many children's lives—and this happens every week mostly in the silent emergency of preventable diseases like polio, tetanus, tuberculosis, measles, and the worst killer of all, dehydration from diarrhea caused by unclean drinking water and malnutrition. It costs five dollars to vaccinate a child for life, 6 cents will prevent death from dehydration, and 84 cents per year will stop a child from going blind. How is it that governments spend so much on warfare and bypass the needs of their children, their greatest capital, their only hope for peace?

I must admit to you that the magnitude of the task that UNICEF has undertaken sometimes overwhelms me, and I am saddened and frustrated when I stop to think of what we cannot do—like change the world overnight—or when I have to deal with the cynics of this world who argue, Is it morally right to save the lives of children who will only grow up to more suffering and poverty due to overpopulation? Letting children die is not the remedy to overpopulation; family planning and birth spacing is. Rapid population growth can be slowed by giving the world's poor a better life, giving them health, education, housing, nutrition, civil rights. These things are not free but available at a cost that developing countries can afford, given the assistance they need. China, Indonesia, Thailand, and Mexico have already proven that population can be slowed by working on public health education and family planning.

The World Bank now forecasts that by the early 1990s the world should reach the historic turning point at which the annual increase in global population begins to decline. It is also true that in no country has the birth rate declined before infant deaths have declined. In other words, parents can plan to have two children if they know they will survive, rather than having six in the hopes that two will survive. That is why UNICEF is also so dedicated to educating and

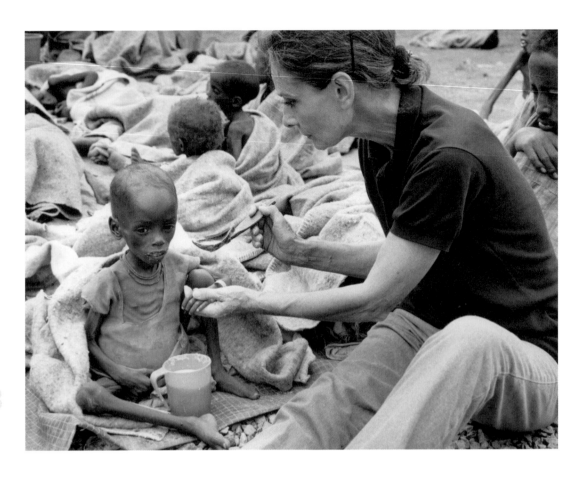

198

above Somalia, 1992. Photograph by Betty Press.
UNICEF/HQ92-1197/Betty Press.

informing mothers in child care. For it is the mother who is still the best "caretaker" of her child, and UNICEF supports any amount of educational projects for women in the developing countries that relate directly to health and nutrition, sanitation and hygiene, education and literacy.

So today I speak for those children who cannot speak for themselves: children who are going blind through lack of vitamins; children who are slowly being mutilated by polio; children who are wasting away in so many ways through lack of water; for the estimated 100 million street children in this world who have no choice but to leave home in order to survive, who have absolutely nothing but their courage and their smiles and their dreams; for children who have no enemies yet are invariably the first tiny victims of war—wars that are no longer confined to the battlefield but which are being waged through terror and intimidation and massacre—children who are therefore growing up surrounded by the horrors of violence for the hundreds of thousands of children who are refugees. The task that lies ahead for UNICEF is ever greater, whether it be repatriating millions of children in Afghanistan or teaching children how to play who have only learned how to kill. Charles Dickens wrote, "In their little world, in which children have their existence, nothing is so finely perceived and so finely felt as injustice." Injustice which we can avoid by giving more of ourselves, yet we often hesitate in the face of such apocalyptic tragedy. Why, when the way and the low-cost means are there to safeguard and protect these children? It is for leaders, parents, and young people—young people, who have the purity of heart which age sometimes tends to obscure—to remember their own childhood and come to the rescue of those who start life against such heavy odds.

Children are our most vital resource, our hope for the future. Until they not only can be assured of physically surviving the first fragile years of life, but are free of emotional, social and physical abuse, it is impossible to envisage a world that is free of tension and violence. But it is up to us to make it possible.

UNICEF is a humanitarian institution, not a charitable organization. It deals in development, not in welfare, giving handouts to those waiting with their hands outstretched. On my travels to Ethiopia, Venezuela, Ecuador, Central America, Mexico, and the Sudan, I have seen no outstretched hands, only a silent dignity and a longing to help themselves, given the chance.

UNICEF's mandate is to protect every child against famine, thirst, sickness, abuse, and death.

200

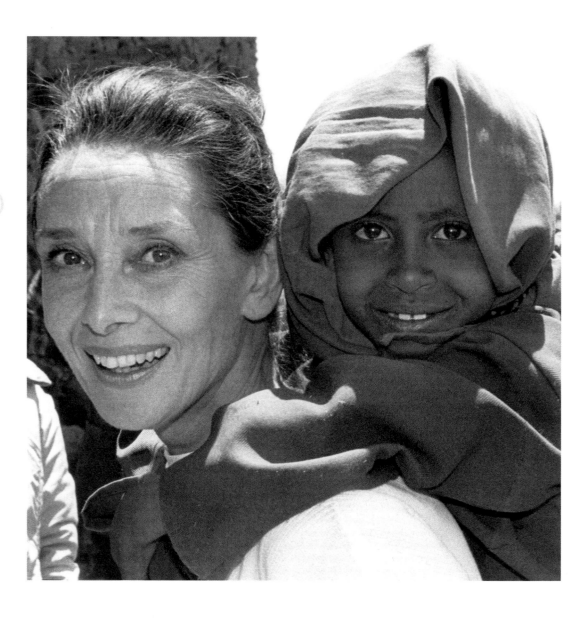

But today we are dealing with an even more ominous threat, "man's inhumanity to man," with the dark side of humanity that is polluting our skies and our oceans, destroying our forests and extinguishing thousands of beautiful animals. Are our children next?

That is what we are up against. For it is no longer enough to vaccinate our children, to give them food and water, and only cure the symptoms of man's tendency to destroy—to destroy everything we hold dear, everything life depends on, the very air we breathe, the earth that sustains us, and the most precious of all, our children. Whether it be famine in Ethiopia, excruciating poverty in Guatemala and Honduras, civil strife in El Salvador, or ethnic massacre in the Sudan, I saw but one glaring truth. These are not natural disasters, but man-made tragedies, for which there is only one man-made solution—peace.

Even if this mammoth Operation Life-Line Sudan were only to achieve half its goal, due to the countless odds it is up against—in a vast country with no infrastructure, few roads to speak of, no communication system—it will have succeeded. For not only will it have saved thousands of lives, but it will also have given the Sudan hope. The United Nations will have shown the world that only through corridors of tranquillity can children be saved, that only through peace can man survive, and only through development will they survive, with dignity and a future. A future in which we can say we have fulfilled our human obligation.

Your 1 percent is an example of 100 percent but all together a beautiful example to us of love and caring. Together there is nothing we cannot do.

202

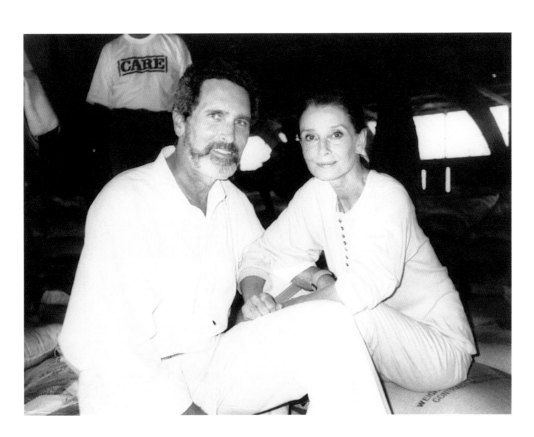

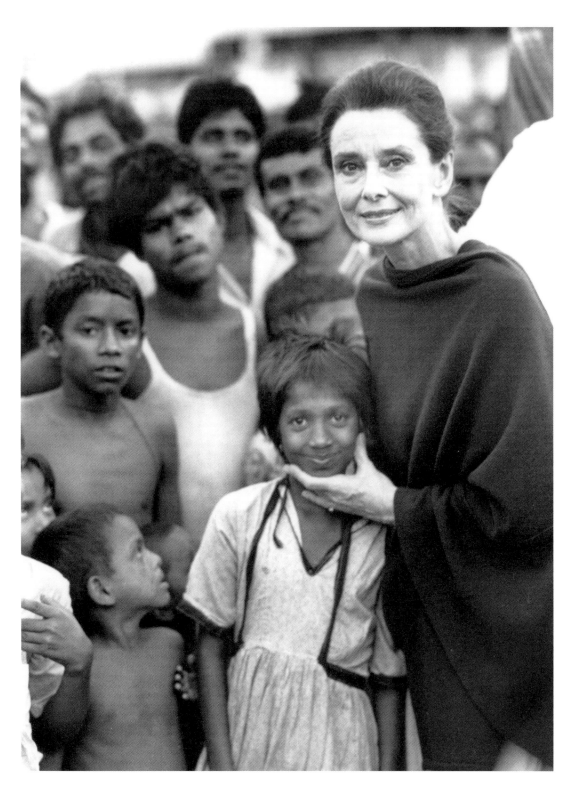

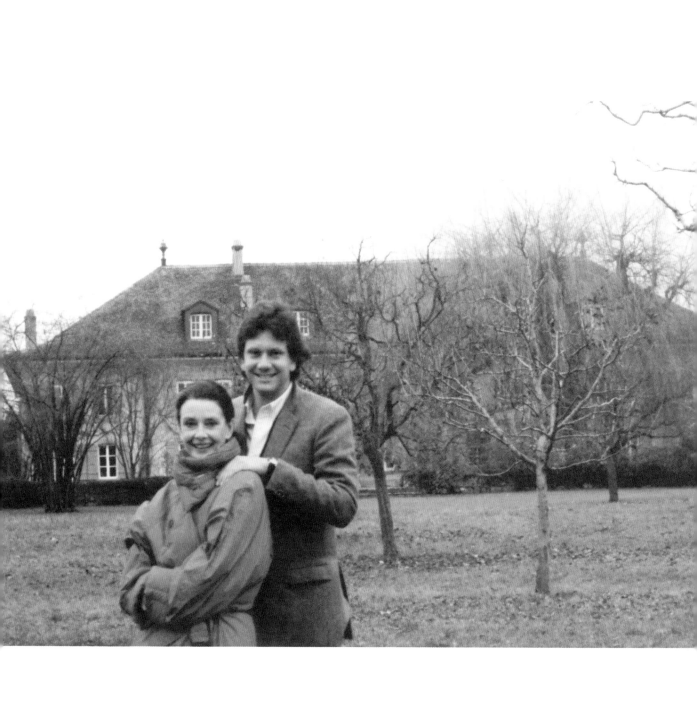

CHAPTER 7 THE PRICE OF FOREVER

December 19, 1992. As we prepared for the flight home, we were told by the doctors that my mother probably wouldn't make it, that the change of pressure in the cabin, as you take off and land, could rupture one of the multiple occlusions in her intestine and cause peritonitis. If that happens, they said, she will die of toxemia in less than an hour. Nevertheless, off we went to the airport after a final visit from her dear friends Billy Wilder and Jimmy Stewart.

When we were ready to get in the car, it was time for my mother and Connie to say good-bye. They both knew, somewhere, that this was it, yet they both knew how to do it well. So they kissed good-bye as though they were going to see each other soon. They were so good that we stood there for a second, on the front lawn, believing it. It was only a few instants later that I appreciated the understated power of their respective performances.

The pilot climbed very slowly, over hundreds of miles, and made a slow descent upon landing to make sure that any change in pressure would be as gradual as possible. We had to stop in Greenland for fuel, which doubled the risk. When the wheels touched the runway at the Geneva airport, she radiated, "We're home." I knew how much it meant to her. That private jet was probably the most useful luxury any of us had ever experienced.

We arrived in Switzerland on December 20. The next few days were spent organizing her care and trying to put together a last-minute Christmas. We were told that getting home-health-care assistance in Switzerland over the holidays was going to be difficult. So we asked Betty, a wonderful nurse who had cared for my mother during her stay at Cedars, to come back with us and help us get through the holidays. This was a hard decision for Betty and her family. I remember her husband coming to meet us at the hospital. He wanted to look in our eyes as he told us that they had decided that she would come with us. This was our first Christmas gift: they were giving us their Christmas.

Every day we would take careful walks in the garden of La Paisible, the house my mother had made her home for the last thirty years. After *Sabrina,* my parents had moved to the Burgenstock, a beautiful mountaintop village facing Lucerne, Switzerland, the town where I was born. But the rigorous winters soon had them looking for a more temperate area near Lake Geneva. My mother said they would make sandwiches, fill a thermos with tea, and take the train from Lucerne to Lausanne to go house-hunting. She said she never forgot the day she first saw the house. A friend had told her the house might be for sale, so she pulled up in a rented car at the bottom of the property and stood on its hood to see. It was spring. The house is an eighteenth-century farmhouse with two and a half acres of fruit trees around it. All she could see were the cherry blossoms, with just enough of the house through them to imagine it.

She remembered feeling butterflies in her stomach and felt she had come home. How often I have thanked those butterflies for flying around in her body for those few moments of perfect expectation.

Christmas had always been the time when our family would get together, and this year, more than ever, it was going to be just that, maybe for the last time. She always asked us not to get her expensive presents. Sometimes she would ask for pencils, erasers, and other office

sundries to last her the whole year. Other times, a scented candle or a particular kind of shampoo that came from America. She always wanted practical presents rather than what she felt were the useless silly things that seem to fill the stores at that time of the year. Shopping that Christmas was a difficult task for all of us. We didn't want to be away from the house, yet we didn't want to hurt the spirit of the holidays and our time together. How do you celebrate at a time like this? Nevertheless, we gathered around a quiet Christmas dinner. Some of us had thought it better not to have Christmas dinner, but my brother Luca felt strongly that Mummy would want us to continue the family's tradition. So we did. Since she couldn't eat, she remained upstairs and rested.

She told us that what she disliked most about her condition was the fact that she felt that it was going to be a burden on all of us.

My mother had stopped working when we started school because we couldn't travel and visit her on location during production. She considered the two or three months it would take to shoot a film too long a separation, so she decided to put her career on hold to be with us. Had she continued to work, she said, she could've made a lot more money. But what she had was enough not to be a burden on us later in life. She often said she was glad she hadn't overused her image, because when the UNICEF work was offered to her, the public still had an interest in her.

Therefore the press and the media were still interested in what she was doing and what she had learned and seen during her travels to the developing countries. What always fascinated us was that she never perceived herself as anyone special or worthy of all the attention she had gotten and still received. My wife accompanied her to a UNICEF lunch and vividly recalls how she shook like a leaf as she gave a speech in front of a few hundred businessmen and women. After all those years, she was still trembling as though it were the first time. She always cared and always wanted to do her best. She was basically a very insecure person whose very insecurity made everyone fall in love with her. Isn't that the true definition of beauty, like a fawn caught drinking from a creek? He looks up and just is. He doesn't know what he looks like, how svelte his body is, or how graceful his movements are; he is just a fawn, like all the others.

After Christmas dinner my mother came downstairs. We all gathered around and shared in the gifts we had for each other. Since she couldn't leave the house to go shopping, she had chosen things she owned to give to each one of us: a scarf, a sweater, a candle. This made it so touching and all the more valuable. Afterward, she read a short text that she was using in one of her speeches for UNICEF. It had been written by Sam Levenson, a humorist and TV and radio personality, to his granddaughter on the day she was born. Worried that, due to his age, he might not be there when she became a young lady, it was his way to pass on some of his wisdom. My mother had edited it into a poem and entitled it, "Time-Tested Beauty Tips."

Even though we were in Switzerland, the news of mother's illness had gotten out, and the paparazzi were once again stalking us. This is why, although the doctors wouldn't have recommended it, she didn't dare to leave the property. The paparazzi tried to steal a few shots through the hedge as she walked in the garden. They even rented a helicopter a couple of times and flew over the house in the hope of catching her. The first time they succeeded, we had to go back into the house, which angered her. Her twenty-minute strolls through the garden were a spiritual support to her: the fresh air, the smells of the village, the cowbells, the trees gently waving their undressed branches at the last few rays of sunlight still trying to burn their way through the afternoon haze.

On one occasion, as I walked with her, she pointed out which of the trees would need trimming in the new year. "This one will be good for years to come, but the tall fir needs securing in the mid-trunk. His branches are too long and won't hold the snow for another winter." These trees were hundreds of years old and needed care regularly. How diligently I followed her advice in the months to come, and how close it made me feel to her! It felt as if she still had a hand in the home that had meant so much to her.

After dinner I helped her upstairs, and we talked about healing. I had read over the last two months several meaningful books about spiritual healing and the will to live. It made me realize how hard it would be for her to do that, to choose to live for her own sake. Had life beaten her down? I wondered. Probably not. But the inner sadness she had always carried inside her had probably been reinforced by the pain and suffering she had witnessed through her work for UNICEF. Fifty years earlier, she had witnessed young men, friends, acquaintances, being dragged out into the streets of Arnhem and shot to death as a reprisal for the Dutch resistance's mea-

ger attempts against the occupying forces. Fifty years later she witnessed the same injustice, the same suffering, in a world that had sworn never to let it happen again.

So I had asked her to do it for us, to get better for all of us as a family. "That's easy," she said, "I can do that. It's just that I don't know how to reconnect the top and the bottom." How meaningful that comment was. How long had the top and the bottom been disconnected? Was the disease in her stomach the physical expression of the slow tearing of the soul from a body trapped in an unacceptable reality?

January 20 started like any other day. As the disease progressed, she slept more and more, and for the last two days she had been barely awake for a few minutes at a time. The anesthesiologist had put her on morphine the day before. I asked him why. He said that in her condition we couldn't be sure about the efficacy of the previous pain medicine. Morphine would guarantee that she would be comfortable.

"Are there going to be any side effects?" I asked, almost automatically. He looked me straight in the eyes and said gently that it could shorten her life by twenty-four hours or so.

I walked into her bedroom. We both knew the end was near. Everything was quiet. A soft yellow light poured in through the windows. I looked down at her. She seemed so peaceful that for a moment I forgot she was sick.

I had spent the night before watching over her. She had awoken in the middle of the night and lay there, staring in the distance. I had asked her about her thoughts and her feelings—was there anything that she wanted to talk about? Did she miss Granny? She didn't reply. And then I asked her if she had any regrets. She said, "No . . . but I cannot understand why so much suffering . . . for the children." And after a while she added, "I do regret something. I regret not meeting the Dalai Lama. He is probably the closest thing to God we have on this earth. So much humor . . . so much compassion . . . humanity."

Those were her last words before she fell back into sleep.

And there she was, still asleep. And then I felt it. It came over me all at once. I knew in that moment what I needed to do. I sat down on the chair next to her bed and held her hand in mine and told her how much I loved her. This was the same bed to which I had been invited as a little boy to spend the night. This was the bed that had felt like the safest place on Earth. And

then I realized how small the bed seemed and how meaningless it would be the day she would be gone. I told her I knew how much she loved us and that I also knew she didn't want to prolong this. And neither did we. I whispered that if she felt ready, she should let go. I put her hand to my cheek to let her feel the warmth of my tears. Somewhere, I felt she could hear me. I kissed her hand and told her that the little boy in me would go with her.

She had talked about "the others." We didn't know what she meant. She said that they were there, waiting for her. She described them as "Amish people in a field, quietly waiting, to the left of the bed." When we asked that she expand on this, she would gently reply, "You cannot understand. Maybe you'll understand later." It felt good to know that she had a strong sense of the other side, that she wasn't scared. We had had the chance to talk about her passing, about our fears, our anger, our hopes. She had told us not to be angry—that it was natural, that death was a natural part of life.

I stood up, caressed her forehead, and told her I would be back. In a trance I went downstairs and called the priest. He answered on the first ring. He was glad to hear my voice and had been waiting for my call. The man was in his eighties and had baptized me thirty-three years earlier. I felt as though I was floating between reality and the sky. He said he would be there at four o'clock. I thanked him.

I walked through the village to the cemetery. The crisp winter air burned my nostrils and reminded me of how painfully alive I was. She had told me she wanted to be buried for my brother's sake. He had always regretted our grandmother's cremation because it left no place for us to visit her. She had spoken of a peaceful view of the Jura, the low mountain range behind our house that hid a valley inhabited by a fiercely independent population of segregationists. They wanted their own country and were willing to fight for it—a sort of micro Basque struggle that the rest of the world knew nothing about. I guess Swiss discretion knows no boundaries. I thought about how solemn she had become. She truly was the patriarch of our family. The icy wrought-iron gate stuck to my fingers as I pushed it open. Leaning against the cemetery wall, behind the next available plot, was a lovely little tree. Although it was winter, I could imagine the blossoms adorning its knotted branches in the spring. This was the highest point of the gently sloping yard. I looked at the view. It was good.

I walked back through the village to our tiny city hall. On the ground floor was the post office, on the second floor the city hall offices, and above them the clock tower whose hourly tolling had reassured my sleep throughout my youth. The mayor was an old friend; I had gone to school with his children. He looked up and knew why I was there. He pulled out an old book from his library, and we looked at the plan of the cemetery. I touched plot number 63 on the little map. He said it would cost 275 Swiss francs, and it would be ours for five hundred years. I said, "Is there a price for forever?" He looked up and said, "That'll be 350 francs." I thought to myself how good it was that in this little eight-hundred-year-old village, the price of forever was only 75 francs. We shook hands, and I walked back to the house.

She hadn't moved. I sat down next to her and told her about the view and the cherry blossoms. I felt like she approved. The intercom rang; the priest, Pastor Eidinger, had arrived. I went downstairs to greet him, but once I held his hand, the words got strangled in my throat. We walked upstairs in silence. He stood by the side of the bed as we knelt at its foot. What he read was beautiful. His voice was full of compassion, the kind that matures when a man's soul distills purity and doubt for eighty years. I cried, and so did my wife, as we held hands and prayed with him. The sun broke through the clouds and came streaming through the windows. When the prayer was over, we held each other, kissed her tenderly, and then went back downstairs. Without being asked, he sat down in a chair and opened his Bible. I asked him if I could get him something. He said he had everything he would ever need. Did he want to go home? I would call. He said he would stay until it was time. So I sat everyone down, one by one, and told them about the plot, the view, the cherry blossoms, and the price of forever. They all listened quietly. When I was through, I asked if everyone was at peace. They said yes. The last one I sat down with was Robby. When I was finished, I asked him if he was at peace. He said yes. And as his lips closed, the intercom rang from upstairs. It was Giovanna, our mother's maid and friend for thirty-five years, calling. "Come quickly" was all she could say. We ran upstairs.

She was gone.

She was smiling, her mouth slightly open. A tiny tear was nestled in the corner of her eye. It glistened like a diamond. Giovanna was pale. She kept repeating that she had been cleaning the sink when Christa, our mother's friend and assistant at UNICEF, had gone into the room and re-

alized that she was gone. We held Giovanna tight; her whole world was ending. She had always been by Mother's side, had helped her in sickness and in health for better or for worse. Mother used to tell her that husbands would come and go, but that they would always be there for each other. I had often heard about how people choose to die when their loved ones are absent for a moment. My mother was alone.

Three days earlier, she had walked in her garden for the last time. On her way back up the stairs, she told us how tired she was. Right after Christmas we had talked about whether I should bring my dogs from L.A., since I was going to stay for a while, at least until she got better. She thought about it and asked me to give her a month. She was worried that my dogs, a black shepherd and a Dobie mix, would gulp down her tiny Jack Russells, "like hamburgers," she said. She always had a keen sense for dogs, a bit like her sense for fashion. She had owned several Yorkshire terriers in the 1950s before the fad started. Some say she may even have started it. In the early 1980s she bought a couple of Jack Russells, a new breed named after the country parson in England who bred them. They look like miniature versions of the RCA dog. They too became fashionable.

A month. Did she know? Could she feel it? Do we all have that clarity when the time comes? Do we hide this wisdom that only those of us who have a foot on the other side share? I thought that in a month we would know which way this was going to go. How powerful my denial had been. She hadn't even lasted the whole month.

Someone dried that last tear away. I lifted my hand, the word "no" got stuck in my throat. By now the room was full of family and close friends. Everyone was crying or wringing their hands. I felt as if I was standing in the middle of a freeway at night. I thought I saw her chest moving. I was told that it was normal. After the priest performed a simple extreme unction, the doctors arrived and confirmed what we knew.

I called my father, who had come to Switzerland to be near me. He drove over in the night to come and give me a hug and say good-bye to her. The last time they had seen each other was at my first wedding; almost ten years had gone by. I will never forget his face when he first entered the room and saw her lying there. He touched her hand, as if to reassure her, and then kissed her on the forehead. This was the end of a very important chapter in his life.

We kept her home for three days, and then, on the morning of January 24, we carried the coffin down the street, through the village, to the little church. I was told that 25,000 people lined the streets of our tiny 1,200-inhabitant village. But their silence filled the countryside. I remember Mother telling us that she would never forget her arrival at the first UNICEF camp she visited in Somalia. The silence, she said, was deafening. There were 15,000 starving men, women, and children, and nobody said a word. Having spent years in Italy together, we both joked about what 15,000 starving Italians would've done in that situation.

I guess, the way all children do when they feel a sadness in a parent, I had always made her laugh. I would play these funny roles as a little boy, or imitate an accent, and she would laugh from the belly, so hard sometimes that she would bend over. Her keen and dry sense of humor had always been there, even in the gravest of circumstances. While still in the hospital, she had sweetly referred to her seven visiting physicians as the seven dwarfs: "After the seven dwarfs have come through, then we'll read so-and-so's letter or call so-and-so."

She received many moving letters, but one of them sticks in my mind. When first under contract with Paramount, my mother had attended a Screen Actors Guild luncheon. They had seated her at the center of the table, next to Marlon Brando. As they were sitting down, feeling terribly shy, she said hello to him. After that, he didn't say anything else to her for the rest of the lunch. Since Kurt Frings, her agent, represented them both, she confided the story to Marie, Kurt's present wife. Kurt had died a few years earlier, which had hurt Mother as much as when Abe Bienstock, her business manager, died. They had both been in her life forever and had become like family, like father figures.

Marie must have told Marlon, to whom she had been married years before, the story of the lunch and how Mother had felt about it, because a letter arrived from him. In it Marlon told of how in awe of her he had felt and how speechless it had left him. For forty years, she had thought that he had shunned her, when it wasn't that at all. He was just awestruck, just like she had been.

She never forgot watching those Somali families as they waited calmly and quietly in line for a turn that many never got. How hurt had she been by the sight of children dying in their

215

mother's arms? How had she slept at night, knowing that what was being done was not enough, that what could be done was limited and couldn't undo the relentless growing roots of injustice and war? How did she look at us at our dinner tables, our restaurants, and café terraces, laughing and letting life gently pass by? Had this started an irreversible process of separation from life as we know it? Why did the executive director of UNICEF die of the same disease only months after her? Is our will to die, once fired up by our compassion, as strong as our will to live? Does it even know the difference, and does it just follow the flow, like sheep jumping off a cliff?

We walked slowly, as every step made the coffin's hard edges dig deeper into our shoulders. I looked up and the sun blinded me, but I smiled. After the incident with the paparazzi and their helicopter, I had called an old friend of the family who was a retired colonel in the Swiss Army. I told him of the helicopter incident and how much it had hurt Mother's feelings. He listened. I asked him if there would be a way to stop them from flying overhead on the day of the funeral. He was silent for a moment and then said he didn't know. I was asking a man who had never bent a rule in his entire life to do it once. This wasn't Italy or France, where such miracles are possible with a little political vigorish. This was Switzerland, where nothing like this ever happens. Although he came to the funeral, he never called me back to confirm whether he had been successful or not. The sky was clear. I later found out that an order had come from above—we'll never know how high—and a no-fly zone had been decreed between the hours of 10 A.M. and 4 P.M. over the whole area. I smiled. This time we had stopped them. And the sun was out, after weeks of a cold and gray sky.

The service was lovely and short. I spoke last, and this is what I read:

Sam Levenson, the teacher, author, and famed humorist, wrote a letter to his granddaughter when she was born. Mummy loved it so, she read selections from it this last Christmas Eve. From a line in the letter, she entitled it:

TIME-TESTED BEAUTY TIPS

For attractive lips, speak words of kindness.

For lovely eyes, seek out the good in people.

For a slim figure, share your food with the hungry.

For beautiful hair, let a child run his fingers through it once a day.

For poise, walk with the knowledge you'll never walk alone.

We leave you a tradition with a future.

The tender loving care of human beings will never become obsolete.

People even more than things have to be restored, renewed, revived, reclaimed, and

redeemed and redeemed and redeemed.

Never throw out anybody.

Remember, if you ever need a helping hand, you'll find one at the end of your arm.

As you grow older, you will discover that you have two hands: one for helping yourself,

the other for helping others.

Your "good old days" are still ahead of you, may you have many of them.

Mummy believed in one thing above all: She believed in love. She believed love could heal, fix, mend, and make everything fine and good in the end . . . and it did. She left us with peace and serenity, and her passage was almost devoid of any pain. She said many things in these last few weeks . . . so simple and good, we'll never forget them. But one remains . . . so clear and fine. The last time we all walked in the garden, Giovanni, our gardener, came up to her and said, "Signora, when you get better, you'll come and help me . . . to trim and to plant again."

She smiled and said: "Giovanni, I will help you . . . but not like before."

The coffin felt even heavier from the church to the cemetery. But my heart wasn't. We had lived and died as a family. She told us that it had been the best Christmas of her life.

When later I asked her why, she simply answered that this time she was sure. . . . She was sure that we loved her.

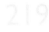

opposite top Aerial view of La Paisible. Every year
the village had a small fair in the summer. One of
the rides was provided by the local construction
company and consisted of riding in a cement bin to
the top of their highest crane. This is how I took this
picture. Photograph by Sean Ferrer.

opposite bottom Spring at La Paisible. Family photo.

top View of La Paisible and Lake Geneva.
Photograph by Sean Ferrer.

bottom La Paisible on a snowy winter morning,
the view from Audrey's dressing room. Family
photo.

220

above and opposite Family photos.

above and opposite The flowerbeds Audrey loved so, in the garden of La Paisible.
Family photos.

224

opposite and above Spring 1987: The garden side of La Paisible,
with wisteria in bloom. Family photos.

below June 1992: Penny, sitting in the window of my mother's bathroom.

Family photos.

227